China
in a Mirror

China
in a Mirror

ROLAND AND SABRINA MICHAUD

PREFACE BY CYRILLE J.-D. JAVARY

Flammarion

To my brother Jean-Claude Michaud,
who first shared his love of China with me.

To our son Romain,
in memory of his first journey to China,
along the Silk Road.

To Ji Dahai,
the ideal traveling companion on our journeys
to the heart of deepest China.

To Dr. Jean-François Masson,
in gratitude for his "pills of eternal life."

"But China obscures," say you; and I answer,
"China obscures, but there is clearness to be found; seek it." Pascal, *Thoughts* [IX], 593

 China offers us the opportunity to widen, deepen, and clarify our view of the world. It also provides the photographer with a way of seeing things from another "angle" and—just as the chemical bath reveals the silver image—reflects some unexpected and challenging points of view. The "optics" and the light may change; the sky, the earth, and man do not. Transcending space, the mirror links the past with the present. It has, for us, long emphasized resemblances rather than differences and remains a fascinating tool for self-analysis and knowledge about the world. As we grow, we find it reveals further secrets and allows us to go beyond the image to the origin, teaching us that the Creator, the creature, and the creation are one and the same.

We have devoted half a century of research to this theme and have already published two works, *The Orient in a Mirror* (Boston: New York Graphic Society, 1981; London: Thames and Hudson, 2003) and *Mirror of India* (London: Thames and Hudson, 1990). While the first looks at Islamic civilization and the second at India, both books explore the theme of permanence. *China in a Mirror* represents the third part of a triptych devoted to three great civilizations. This book was an ambitious, arduous, and time-consuming project, the result of ceaseless curiosity and of twelve years spent crisscrossing China. Born of our dual interest in art and life, these books attempt to show that, beyond changes and fashions, beyond even the extraordinary upheavals of today's world, traditions can endure.

To bring out the correspondences and parallels between the past and the present—between our photographs and the paintings, sculptures, ceramics, rubbings, woodcuts, and paper cutouts of China—we sometimes started out from the most ancient artwork we could find, at others from something contemporary or from a photograph. For certain paintings, we searched in vain for an equivalent in everyday life; conversely, we did not always find a correspondence in art for some of our photographs. The gap in time between the views depicted was more variable, sometimes amounting to several years. The photograph on page 158 depicting a stretch of earthen wall was taken in the province of Shanxi in March 1999 to evoke a tail of a dragon, a mythical beast with which the Great Wall of China is often compared. This dragon's tail gave us the idea of looking for a head, from a painting obviously, in the hope of demonstrating a relationship or equivalence to illustrate our theme of the mirror. But it took six years before we came across the famous scroll of the Nine Dragons painted by Cheng Rong in 1244 (p. 159)—that it to say, 755 years before our photograph was taken.

It goes without saying that we have resisted all temptation to manipulate or doctor any picture since that runs counter to the very raison d'être of our approach. In fact, the speed of change is such that many photographs taken a few years ago could never be reproduced today. The photo of junks in the Bay of Macau (p. 88), for instance, taken in August 1965, now belongs firmly to the past. The junk, which had been part of maritime history for centuries, no longer has its place on Chinese seas. In the same way, photographing people gathering water chestnuts on Lake Hangzhou in Zhejiang (p. 83), as we did forty-three years ago, is no longer conceivable. Our Chinese friends tell us that this method has fallen into disuse.

In the field of art proper, we cover more than two millennia, from the period of the Han and Wei, through the successive dynasties of the Tang, Song, Yuan, Ming, and Qing, right up to the present day.

The monk in the cowl (p.199) provides a photographic counterpart to the limestone sculpture of the Wei period (p. 198) in the caves of Maijishan in Gansu province. Over some sixteen centuries, the gesture of greeting has not changed one iota. The girl photographed in March 1988 near the tomb of Li Shuang in Shaanxi (p. 177) has the same features, the same complexion, and indeed the same beauty as the young woman represented on a mural fresco of the Tang era (p. 176) in the same place twelve hundred years previously.

Tireless research in museums and libraries led us from Beijing to San Francisco, not forgetting fieldwork throughout China, from the big cities to the farthest reaches of the countryside. We trod mountain paths, even the most sacred, weighed down by our knapsacks as we had made our own the Chinese proverb, *"Dù wàn juǎn shū, xíng wàn lǐ lù"* ("Read ten thousand books, travel ten thousand leagues").

Conscious of how right the Chinese traditional masters were to teach that no painting is possible without poetry and vice versa, we were determined to include poetry and calligraphy in our book since in China they are placed on the same level as painting. In the ninth century, the poet Po Kin Yi declared, "Every time I look at a beautiful landscape I feel I have to recite a stanza of poetry." Paintings in China are called "poems without voices," and travelers are struck dumb by the alluring power of the Chinese mountains. More than the mountain itself, China shows us the spirit of the mountain, the breath that flows through it and appears everywhere in the Ten Thousand Creatures, from birds to flowers, and in the very rocks and rivers.

To appreciate a culture other than one's own, the traveler must initially learn to forget what he has learned. He has to learn how the fog dancing or the clouds playing hide-and-seek is a spectacle richer than a peak shining forth out of an azure sky. The Chinese put it more simply: "Without clouds, no mountain." And they invite us to become a child again and, like a little Chinese boy, see in the moon a rabbit under a cassia pounding the elixir of eternal life in a mortar.

Some of the mirrors in this book are more than simply literal ones. They are mirrors in spirit.

Nature often creates works of art superior to any painting. Traversing the Loess Plateau, a territory southwest of Beijing the size of France, we were struck by the unique character of the landscape and its inhabitants. The loess, fertile silt, can be up to 650 feet (200 meters) thick. Carried in on the wind from the *gobis* of Mongolia, it settles in the tiniest crevices. Erosion and rain have turned it into a gigantic Swiss cheese, which has spawned some phantasmagoric scenery. The paths are dug into deep ruts where with each step you send up a cloud like face powder, so fine that a bead of mud forms in the corner of your eye.

Everything is yellow: the ground, the sky, and man. It is the land of Lord Millet, a cereal charmingly known in Chinese as *xiǎo mǐ* ("little rice"), whose bland taste at breakfast in the countryside took us some time to appreciate. Man becomes a mirror of the land. The faces of the peasants (p. 148) are lined by the same furrows as those of the fields they plow (p. 149). Such mimicry makes one think. Geographers tell us that certain fields cultivated here for millennia have yielded perhaps five thousand harvests. Such continuity has more meaning for us than the superficial changes ushered in by the cell phone that peasants in the middle of nowhere will suddenly whip out of their pockets.

What we see in our looking glass stands outside time. Bearing witness to an eternal present comforts us and puts us in harmony with the cosmos because the confrontation between past and present does not divide, it unifies. Our images offer not a transitory but a permanent reality—that of an authentic civilization, one that knows how to give meaning to life. After all, the word "image" is nearly an anagram of "magic."

In the area surrounding Longshen in Guangxi, we spent a long time standing in front of a panorama of hills with terraced rows of rice paddies. The place was aptly named Longji ("dragon's backbone"), (p. 45). It had just snowed and the place looked enchanted. We learned that this only happens once every ten years or so, and christened this magical event a "gift of heaven." We discovered the painting (p. 44) fourteen months later.

Sensitive to number symbolism, we fixed the number of our mirrors at eighty-one. Indeed nine is the the digit that best expresses the multiplicity of forms: nine times nine equals eighty-one, so there are nine chapters of nine mirrors each. Moreover, nine symbolizes the mystery of numbers as when one adds the two digits of the result of multiplying it by any number, one always gets nine. So, $9 \times 9 = 81$; $8 + 1 = 9$; $9 \times 2 = 18$; $8 + 1 = 9$, etc. Also, in Chinese, nine is pronounced *jiǔ*, which has a homophone *jiǔ*, another word meaning "long time."

The magic square of nine by nine boxes, which we call the Square of Saturn, belongs to the moon. However, the moon is maya—the supreme power by which the unique hides and is expressed by an infinity of forms—the illusion of reality as much as the reality of illusion. In China, this square is called Luo Shu (a drawing of the River Luo), the tributary of the Yellow River from which the tortoise emerged. This animal was the source of Emperor Yu's discovery since it was the lines and points inscribed on its shell that, once deciphered, gave the Great Yu the model for the nine articles of the Great Plan by which he laid down social laws in harmony with the cosmic principles. This all occurred over four thousand years ago.

Examples of the importance of the number eighty-one are legion. According to the Chinese lunar calendar, the winter solstice falls on the shortest day of the year and winter comes to an end eighty-one days later, when sowing begins. One saying speaks volumes: "Nine times nine days will pass and the cold will cease." Finally, the *Dao De Jing* (the Way and the Virtue), the famous work ascribed to the great philosopher Laozi (old child), comprises eighty-one chapters, an allusion to the fact that he stayed in his mother's womb for eighty-one years and was thus born old, wise, and complete.

China, as Claude Roy rightly wrote some fifty-five years ago, "does not resemble anything else: there would be no use *being* China." But then a miracle occurs. With just a camera bag and a pilgrim's staff, with a healthy store of goodwill and no less patience and confidence, all mixed with a dash of humor, we discover a China that resembles China and we can hardly believe our eyes. As the Chinese proverb has it: "Whatever one believes exists, and whatever one does not believe does not exist." So China exists: a few moments of joy snatched from passing time, a continuously renewed creation. China, like the sea, always beginning again.

But is it so simple? Nonplussed, we, like Zhuangzi, can no longer tell if the traveling photographers Roland and Sabrina Michaud truly crisscrossed China—or whether all our journeys through that great land were but a dream.

Roland and Sabrina Michaud, Paris, January 2008

Extracts from the 1,750 pages of travel notes taken by Roland during twelve years of traveling China.

First excursion to the Yellow Mountain (Huang Shan) of which the celebrated traveler Xu Xiake (1586–1641) left such enthusiastic descriptions that I soak them up in the splendid translation of his travel diaries by Jacques Dars.

Xu Xiake's encomium has become proverbial. "Back from the five sacred mountains, one can no longer bear to look at mountains; returning from the Yellow Mountain, one can no longer bear to look at the sacred mountains!" This prince of the travelers added: "No mountain anywhere between the four seas can equal the Yellow Mountain. It is the acme of perfection."

And here I am in turn. At a place called Beihai (Northern Sea). I feel I have been shipwrecked and scribble a short poem that I dedicate to my traveling companion, Dahai (Great Sea), who is a painter.

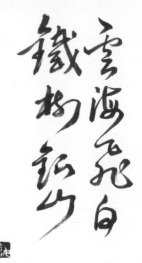

Gray are the peaks and black the pines
Is this rain or ocean?
Brush borne off by the wind,
Mist that rises and falls,
The white of the clouds, flying white,
Iron gray flecked with silver
Painting the void, black on white,
Chinese ink that fades.

November 21, 1997, Huang Shan

Searching for flowering plum trees in the snow or for the call of the crane out of a clear blue sky, tramping through the mountains of China has brought us unforgettable adventures. Before all this natural beauty, we understand better the Chinese ideal of the true man (*zhénrén*)—sincere, spontaneous, and unfettered by convention—as well as the concepts of the Taoist Immortals who look back to the origin and the source.

In the Wuling massif of northwest Hunan, we watched spellbound as the landscape changed from minute to minute.

When the wind blows and the rain drizzles,
When the mists of summer and the fogs of winter
Play hide-and-seek to mimic the sea,
The rocks become islands, the shipwrecked man
Can no longer tell winter from summer,
Nor hill from water, nor the earth from the sky
Nor the moon from the sun—nor yesterday
from today.

April 17, 1999

Beyond the thousand and one annoyances of all traveling and the unprepossessing face China often presents today, with its contradictions, its frenzy for destruction and consumption, its bluffing and nouveau riche tastes, and its pollution, one can still experience the immense privilege that is an encounter with the Other, with the Chinese, with their incredible art of living and extraordinary love of life.

Still, how heavy my camera bag weighs down on my aging shoulders.

> On the slope of the monkeys, I strain my back.
> My calves tremble with the effort.
> Far is the terrace of the sky, the sky so high.
> But why is one so out of breath?
>
> November 17, 2003, Wulingyuan

The traveler, a photographer-poet on a quest for wisdom, armed with a stick and a faith that could move mountains, knows the delight of "going to an audience in heaven," but also knows full well that there is a price to pay.
Is it easier to take photographs than to write?
Photography is the mirror of literature, and vice versa. I try to write with light.
I learn to appreciate withered lotus leaves, the yellow wine, and the music of the crickets that play the violin so well—they are tickled with hare or rat whiskers attached to the end of a stick to encourage them to sing.

Why does the Wuding River with its banks of willows express such deep melancholy?

> The willows cry tears of snow; the river
> overflows with sorrow.
>
> March 15, 1996, near Yulin, Shaanxi

Houses in the town of Fenghuang (Phoenix), Hunan province, have round mirrors attached to their façades. Their purpose is to frighten off demons that, according to the inhabitants, take fright and run away when they see their reflection.

In China, the mirror has a prophylactic function. Protection was also the motive behind the construction of the Great Wall, that symbol of a double mirror reflecting two worlds: on one side, a supposedly civilized people; on the other, the so-called barbarians.

The room in the local inn was nondescript, and I would have liked to have turned off the television. But the wild mushrooms and the wheat flatbreads at dinner were so tasty. The bedroom above was dreadful, but the pillow stuffed with millet bran proved relaxing for my neck.

The path on top of the Wall through the Silver Mountains had been tough and exhausting, but the scent of the nearby Mongolian steppe, that "sea of grass," was a joy to my nostrils. From afar, the Wall had already impressed me; but now, close by, it impressed me even more.

It is commonplace to remark that it is the only man-made structure visible from the moon. But it has to be admitted that it's not because one can see the moon from the Great Wall that one can see the Great Wall from the moon.

January 9, 1997, Gubeikou, Hebei

The seasons come and go, and we grow old.

The mountain clad in fog
Catches cold.
A pine sneezes and shivers.
Autumn.

November 30, 2004, Wudang Shan

On the back of a ladybug,
I see a passing Immortal.
It's spring.

March 21, 2007, Xiling

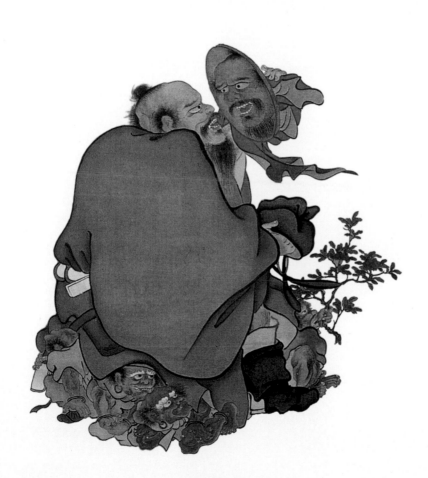

"Man uses bronze as a mirror. Man uses antiquity as a mirror. Man uses man as a mirror."
Tang annals

China is going through great changes at the moment, but China is a country that is used to change. China has long made change one of the foundations of its continuity. This may seem like a paradox, but it's actually a sign of Chinese pragmatism. "The only thing that never changes is that everything always changes." This sentence, traditionally attributed to Confucius, is found in the heart of the *Yi Jing*, the most important of China's classic books. The title of this book, which, in China, holds a place similar to that of the writings of Aristotle and Descartes for Western thought, means: Classic *jīng* 經 of Changes *yì* 易. In Chinese thought, change, which is the only fixed law of living organisms, is seen as the most natural and vital principle that exists. The Chinese character that signifies change, *yì* 易, is made up of a combination of an image of the sun (日) and that of rain (勿).

In the history of civilizations, times of change are moments of rebirth that provoke a rejection of all that has aged, and that open the way to new eras that will eventually become classical epochs. Every civilization has experienced this type of change.

What is unique about our current era is that the winds of modernization are gusting across all the countries of the world at the same time. It's as though all of the world's pasts are disappearing in front of our eyes.

If there is one part of the world where the flow of seasons is clearly delimited, it is in the valley of the Yellow River, in China. The summer is hot, the winter is harsh, and the intermediary seasons overlap. This is probably why a unique perception of the world was born in this area, and no place else on earth; one that describes life as a circle of seasons. We Westerners do not appreciate seasons in the same way. There are some we fear and others we prefer. Roland and Sabrina Michaud prefer winter; they find it enchanting. In winter, they say, "the sky is more beautiful than in summer, and the light more pure." In the theater of the sky, Saturn, the master of Capricorn and Aquarius, rules over the winter. Its wintry light, unlike that of the dazzling heat of Leo, which struts about in summer, is capable of crossing the vast blackness of interstellar space, because it is not made of fire but of photons, the magic ink of photographers. Saturn is also able to hold on to that which life carries away in its uninterrupted flow. He is the god of those who preserve, maintain, and archive the things of the past. It is hard to imagine how many hours Roland and Sabrina Michaud spent consulting books, visiting museums, and examining reproductions to discover, among this huge reservoir of Chinese art, the gifts they offer us in the pages that follow.

For travelers like Roland and Sabrina Michaud, journeys are their everyday life. Their voyages have always been slow discoveries punctuated with coincidences that are gifts from heaven. They don't go off seeking adventure; they seek encounters. They aim to discover countries, of course, along with the light that shines on them and the poetry that this combination radiates, but they especially want to meet the people who live in these places. This is another reason why they love winter; it is the season of meetings, the favorable time to establish solid relationships with people who live close to the land. In summer, farmers are busy from dawn to

dusk. In winter, the rhythm changes: everyday tasks are less vital, evenings are longer, time reasserts itself, and traditions take their rightful place. "In pastoral societies," they say, "people are more beautiful, and, because of the cold, they dress in wool and skins."

When traveling, you can constantly meet people, if you allow these meetings to occur. You need patience, and you must especially want to meet others. This is an art of the hunter, as much as it is an art of life. With their eyes and their hearts lying in wait, Roland and Sabrina Michaud succeed in capturing the ineffable moments, just as Chinese calligraphers and painters do as they draw their brushes across paper, creating unique and unregretted strokes. Time has become a luxury in our modern era, but only time can allow journeys to become meetings.

But can one go off in search of beauty? Does it exist on its own, or is it simply the fruit of meetings?

Is there a particular type of beauty in China that seduced this couple, who, during their many journeys, has seen so many stunning spectacles? "There are so many mountains around the world," they told me one day, "yet when we discovered the Huang Shan mountains, tears filled our eyes. What makes these tortuous peaks so hugely poetic? Why are the landscapes of the Yellow Mountain more beautiful than those of the mountains in Ethiopia or in Kashmir?" Is beauty distinctive or is it simply human?

François Cheng, the great Chinese author, answers this question in his book *Cinq méditations sur la beauté* (Five Meditations on Beauty): "A sunset cannot be beautiful if no one is there to see it. Heaven and earth care

nothing about the clouds that make the sunset gleam; only those who contemplate them make their beauty exist." And he also says, "Cézanne's *Mont Sainte-Victoire* is much more than a Provençal landscape seen by a great painter. It is above all a dialogue between Cézanne and the mountain."

When Roland and Sabrina Michaud look at things, they see them with sharpness and precision. *To look* is to pay attention to what's in front of one's eyes. Looking is passive; it is neither intuitive nor introspective. But when Roland and Sabrina Michaud *see* things, they take pictures of them to try and discover what lies behind the images. Seeing is active; it involves comparing what is in front of one's eyes with what is within. It is a process that involves a meeting between the inner and the outer, and one that is born of that ineffable line that lies between the two.

Intuitively, they discover the great secret of classical Chinese painting, especially that of landscape painting: it is an invitation to the viewer to continue the process of creation by filling in the empty spaces that exist between two images of a particular representation, such as that which flows from the body of the dragon to the humps of the Great Wall (see p. 158–159). "The ideal behind Chinese poetry can be summed up in this manner: the spirit of the emptiness of the middle is a *three*, which is born of a *two* and, attracting the best of both, creates their meeting and their exceeding," says François Cheng.

Roland and Sabrina Michaud's "mirrors" make the viewer reflect. They build bridges between the moments caught by their lenses and the eternal, which is encapsulated in the works of art displayed on the facing pages.

Mirror is an astonishing word. It comes from the classical Latin *mirari*, which means to wonder. From this word come such ideas as *mir*acles, *mir*ages, and other ad*mir*able words. In popular Latin, the word became *mirare*, and it took on the meaning of looking at something intensely, such as the way farmers would look at eggs held up against light to see how fresh they were. This attentive way of looking can be seen in the word *mirador*, or watchtower, a place from which soldiers look very carefully to see if there are any threats on the horizon.

A noun was derived from this verb, and it was used to name all the utensils that reflect light and reproduce the images of people or things, both literally and figuratively. Since this word is used for reflective surfaces, it is no surprise that the metaphor came full circle and people began saying that "the eyes are the mirror of the soul." This curious expression transformed the organs of sight to creators of images with which it is possible to perceive the invisible that lays hidden within the depths of each of us.

In the "civilizations of the Book," the mirror is a symbol of the manifestation that reflects the divine creative intelligence. In Hindu texts, the mirror represents delusion. Covered with dust, it is a symbol of the mind obscured by ignorance and foolishness.

In Chinese, there are two characters for mirror: *jiàn* 鑒 and *jìng* 鏡. The first specifically designates metallic mirrors. It is made up of the symbol 金, which is common to all metallic objects, and here, is a bit compressed in the bottom part of the character. On the top is a complex character: 監, which originally represented an official leaning over to carefully examine a set of omens. This mirror is therefore a metallic object used to read the symbols that are a reflection of the invisibility of the present moment.

The second character used to designate mirror is much more common than the first one.

It also contains the symbol for metal 金, but this time it is combined with the character 竟, whose original meaning is border, limit, or end. The common usage of this character has extended its meaning far beyond that of a mirror, and it is currently used for the lenses of eyeglasses, contact lenses, and camera lenses.

More than simple reflectors, Chinese mirrors are objects that allow one to cross the border between reality and its reflection, between visibility and invisibility. This is why mirrors cannot only reflect images but can also protect against evil spirits. One can often see mirrors hanging from the lintels of front doors in old Chinese houses; these mirrors are placed there to protect the homes from wandering demons. As soon as the demons see a reflection of their image, they are frightened by their own hideousness and they run away as fast as they can.

The Mirror of Wisdom, a Tibetan Buddhist text, states that the ultimate secret is that the world of forms is nothing but a manifestation of emptiness. Discussing the concept of "grasping the moon in the water," a dictionary of symbols says that such perception belies the very concept. "Light reflects on water but does not penetrate it."

But the Chinese see things differently.

A four-character idiom, which has been drawn by calligraphers for so many generations that the creator of this sentence is forgotten, literally says, "Water flows, clouds remain." These four characters describe a natural landscape. This water is not held in a motionless basin, it is rather the water of a calm stream flowing into a gentle valley. The clouds are those that slide across the sky, but the phrase describes their reflection on

the surface of the stream. The calm, unceasing movement of the water makes this stream a mirror, and fixes the image of the floating clouds on its surface. It is the constancy of movement that allows impermanence to display continuity.

While this phrase may seem paradoxical, it helps us understand the work of Roland and Sabrina Michaud. An emblem of Psyche, a character who represents knowledge and wisdom, the mirror has fascinated this inseparable couple for fifty years. As they said in the first volume of their trilogy, *The Orient in a Mirror*, "The mirror is the very symbol of symbolism itself." They put this symbolism into practice elegantly in their books, each of their Mirrors being organized around the key symbolic numbers of the civilization they reflect. *The Orient in a Mirror* contains ninety-nine photos; ninety-nine is the number of beads in a string of Muslim prayer beads. *Mirrors of India* contains 108 photos, as many beads as there are in Hindu and Buddhist strings of prayer beads.

This book contains eighty-one photos. A product of nine, the number of the culmination of yang, eighty-one is the ultimate imperial number, and the perfect number for *China in a Mirror*. Omnipresent in the Forbidden City, it is especially visible in the nine rows of nine golden nails that decorate and protect all of the gates of this tremendous palatial compound. It is also the number of verses in the *Dao De Jing* (the Book of the Way and Virtue) by Laozi, as well as the number of chapters in the fundamental treatises that explain the art of acupuncture.

Looking closely at the fascinating mirrors that Roland and Sabrina Michaud present in this book, we can see that they contain an additional dimension: an evocation of that which endures opposite that which has,

in some cases, already disappeared. In China, this resemblance, which highlights the permanence specific to this civilization, takes on a unique aspect.

Today's Chinese are not very nostalgic about their recent past. Their grandparents' memories contain images of the violence of the Sino-Japanese War and the country's own civil war. Their parents recall the brutalities of triumphant Maoism. It is only for today's generation, those in their thirties, that the recent past bears tinges of happiness. When *China in a Mirror* is translated into Chinese, the elderly might see traditional reminders of past times, but the younger generations will see something other than the endurance of their culture, this mighty permanence that has been rooted for millennia in the valley of the Yellow River, which was its birthplace. They will see in the faces and the eyes that illustrate these pages the inexhaustible vitality of the Chinese people, the endless love of life that animates this age-old people and its unlimited ability to change.

Today's China is on a headlong rush into the future. But it does so without renouncing its past; quite the contrary, it flaunts it. What it searches for, what it hopes to recover, is the dignity and grandeur of this past. China draws on its eternity in the confidence that its future will connect to its traditional past. This is why *China in a Mirror* is important for all of us.

Roland and Sabrina Michaud's view of China and the Chinese awakens the China that is within us.

Cyrille J.-D. Javary, Paris, February 2008
Translated from the French by Kirk McElhearn

SPRING AND AUTUMN

Wheat covers the slopes in gold.
Fit men on the Southern hills,
Their feet cooked by steam from the searing earth,
Their backs scorched by the fiery rays of the sun.
They are so exhausted they forget the heat,
But still find this summer's day too short.

Bai Juyi (772–846)

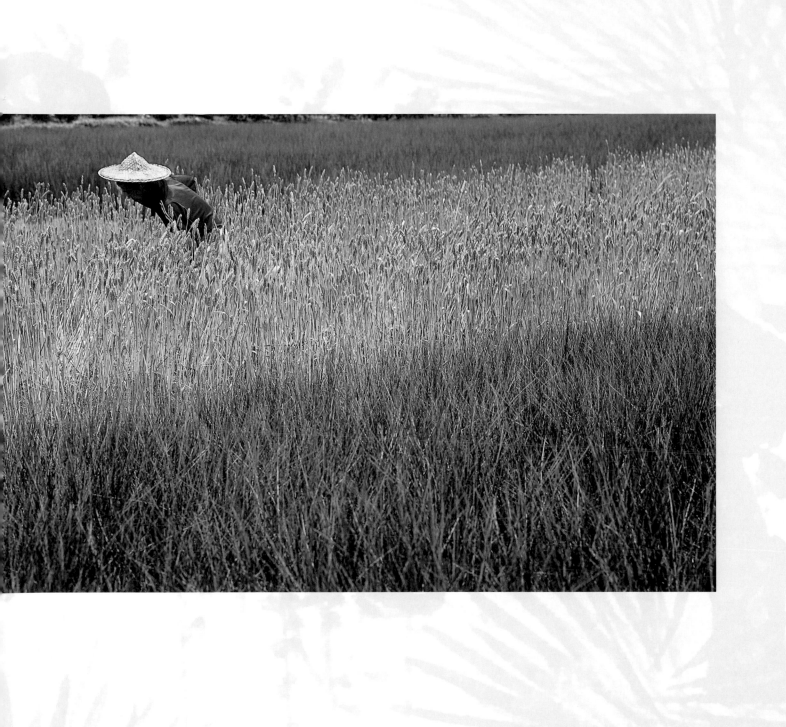

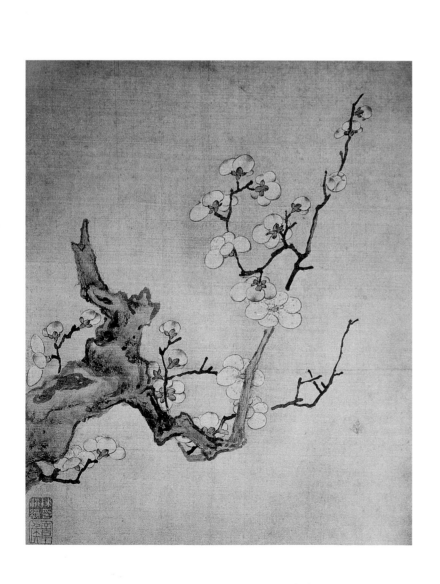

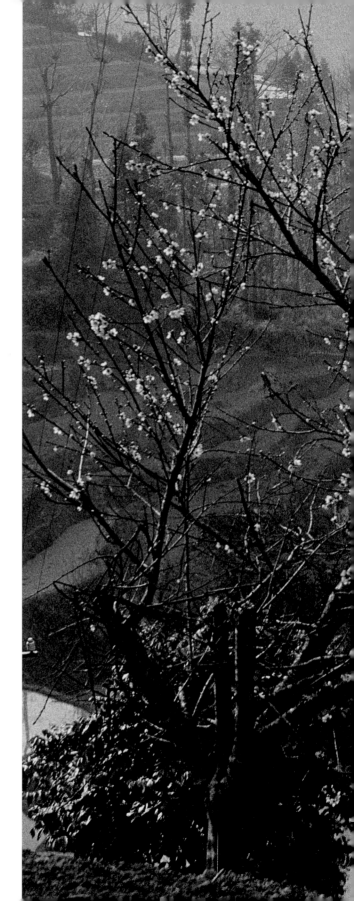

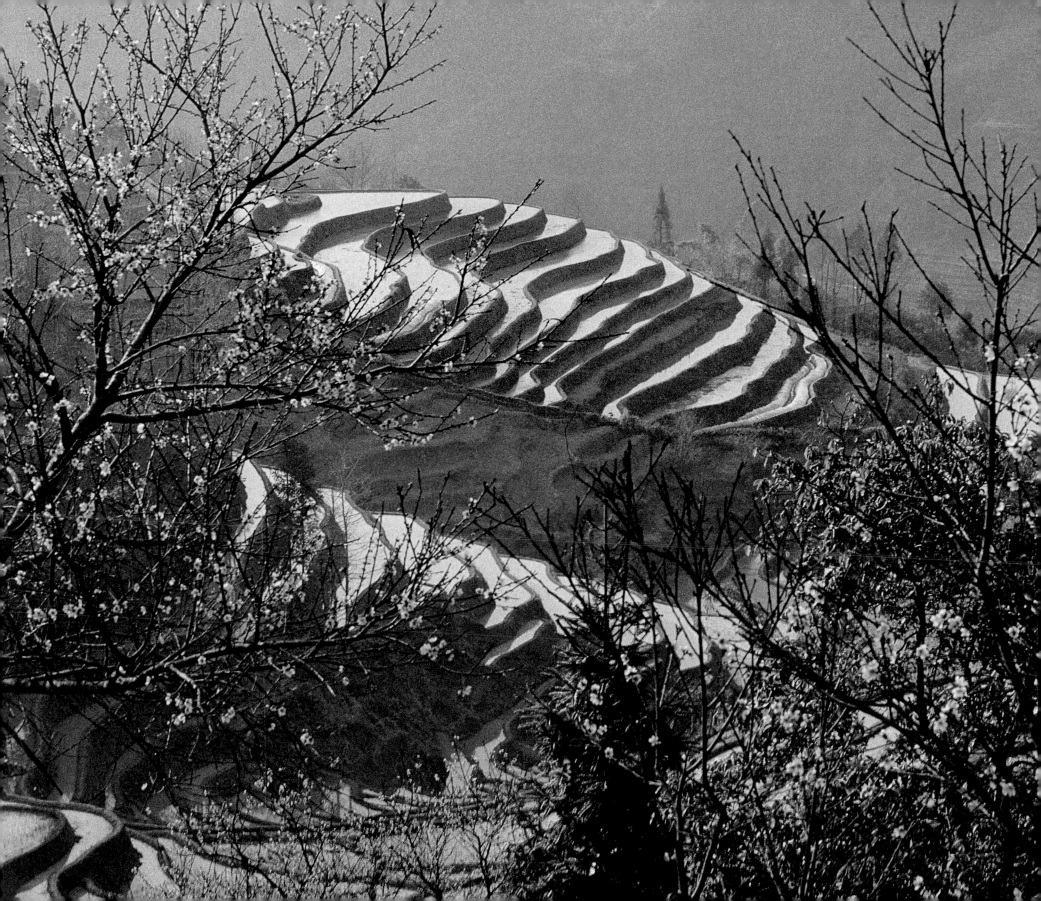

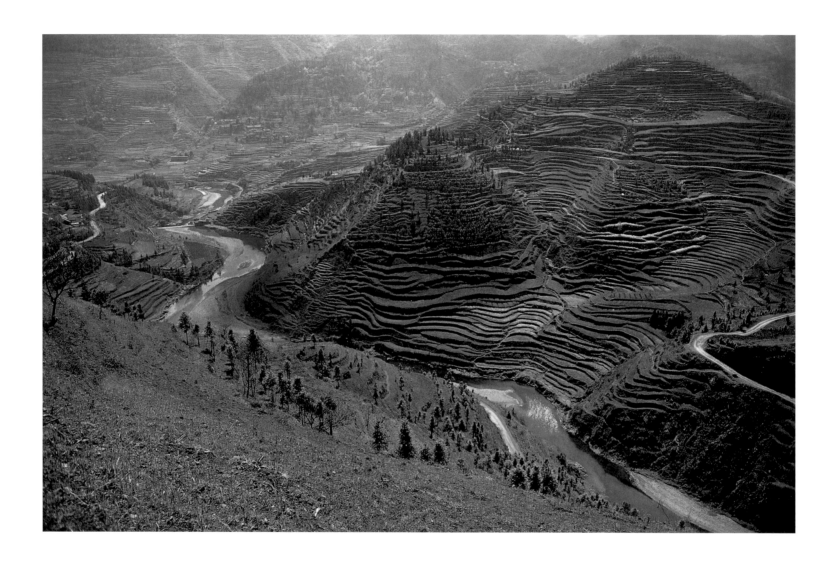

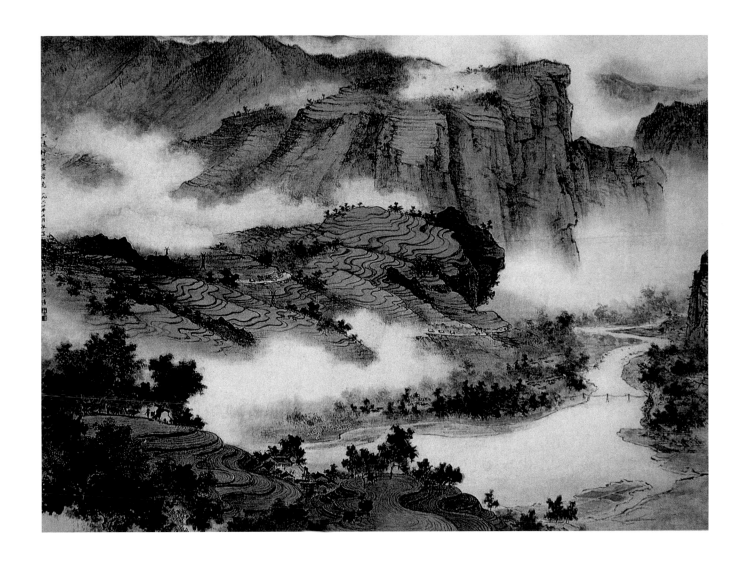

At the sixth moon, the farmhands
haven't a moment's respite.
Bent double the whole day,
they have to pull up the tares.
The sun burns me, sweat runs down
my shoulders to my feet.
When I take my shirt off,
I'm pricked by the beard of the wheat.
I put my shirt back on
because my skin is getting cooked.

Folk song

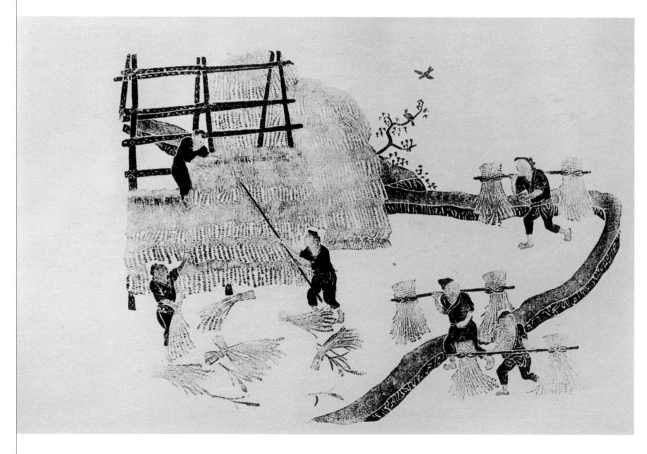

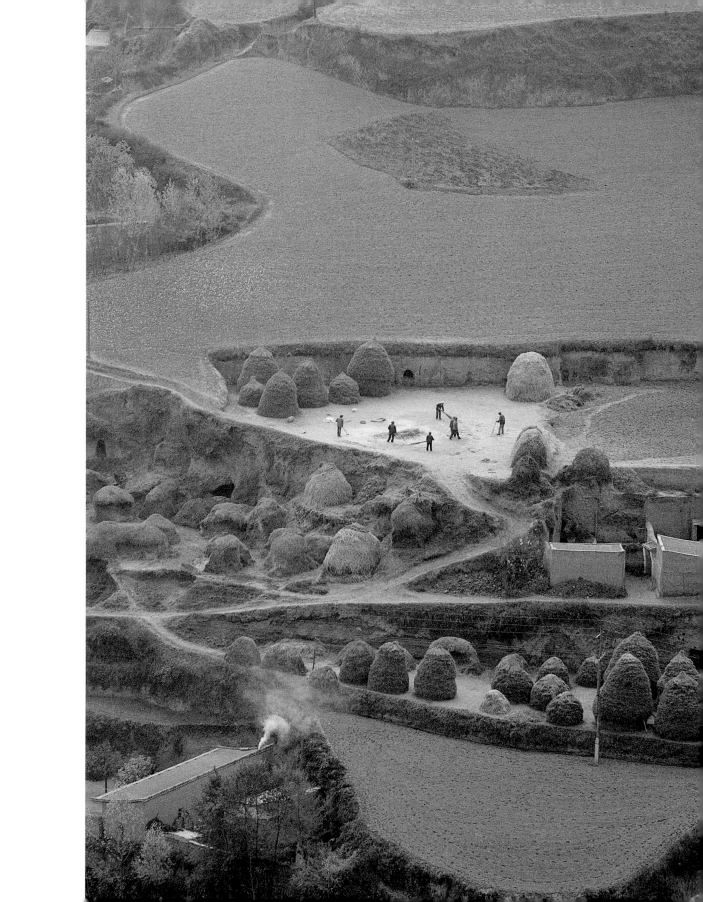

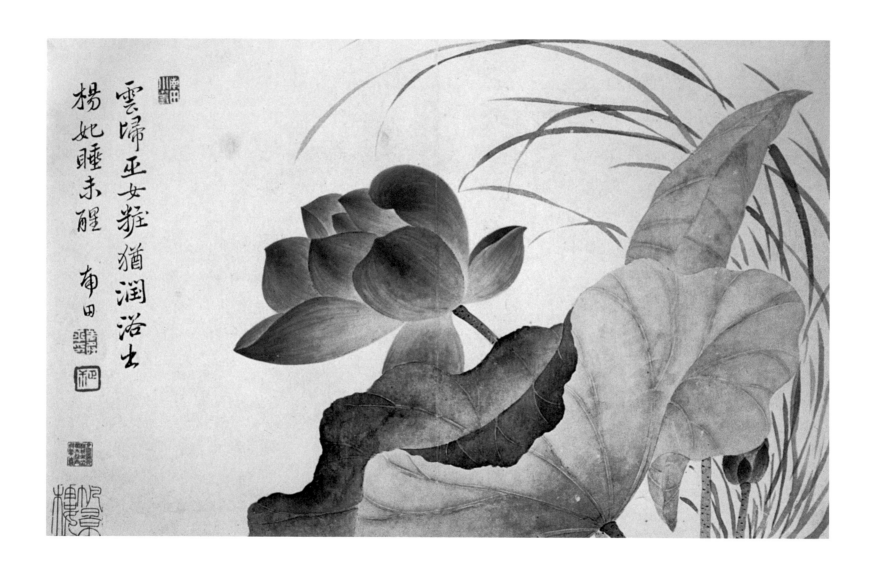

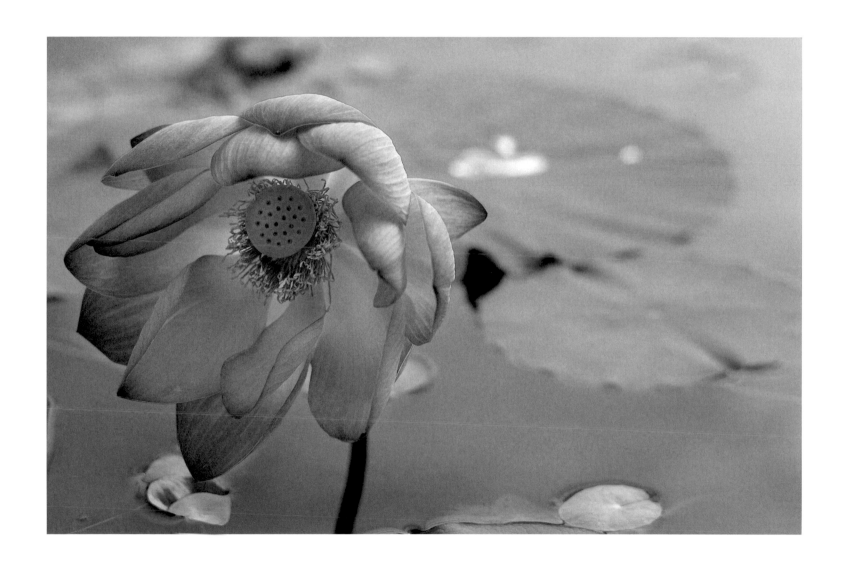

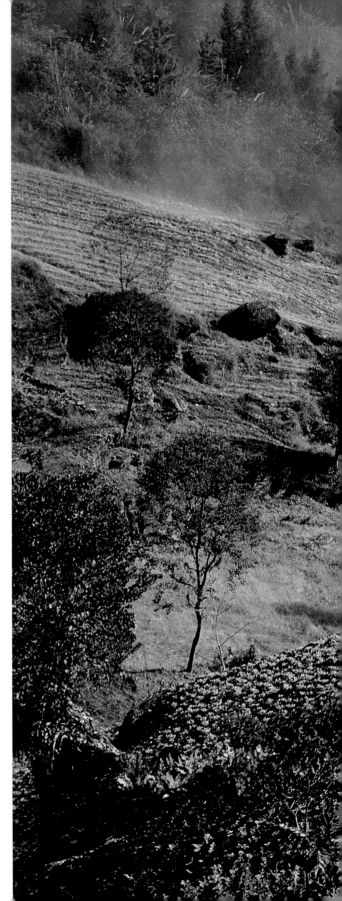

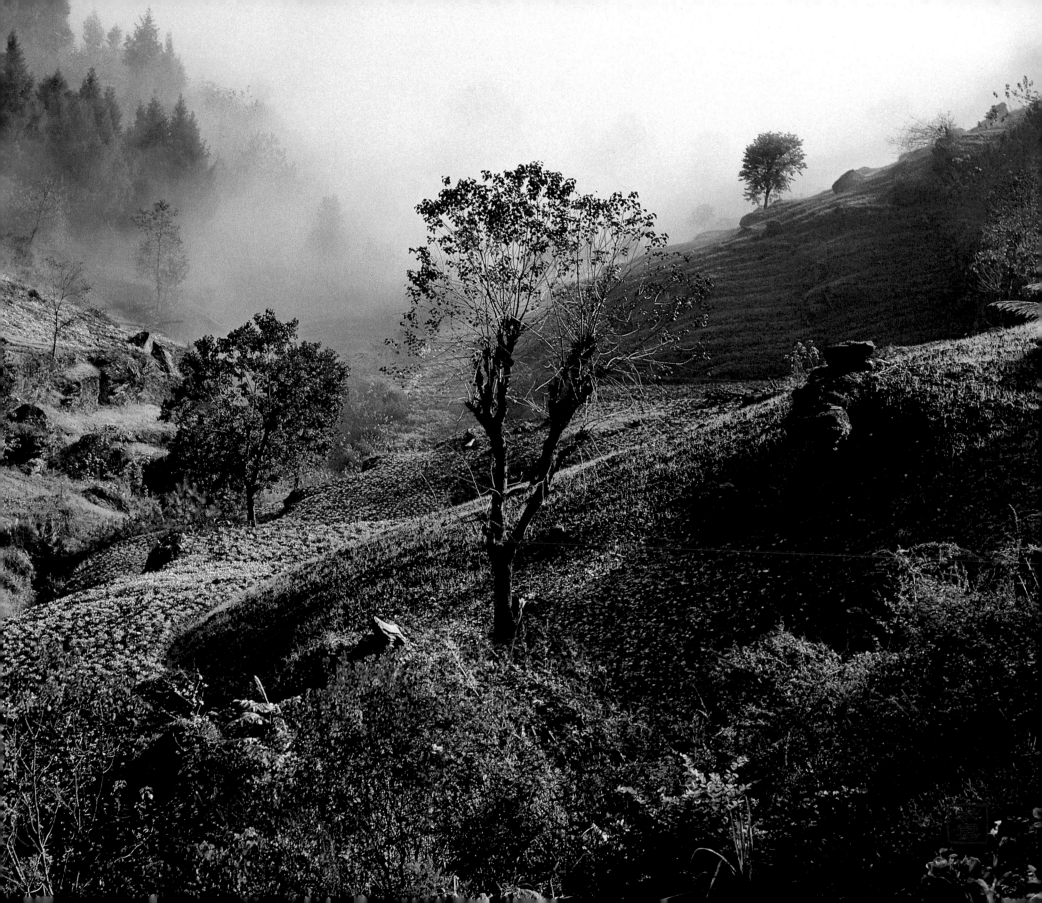

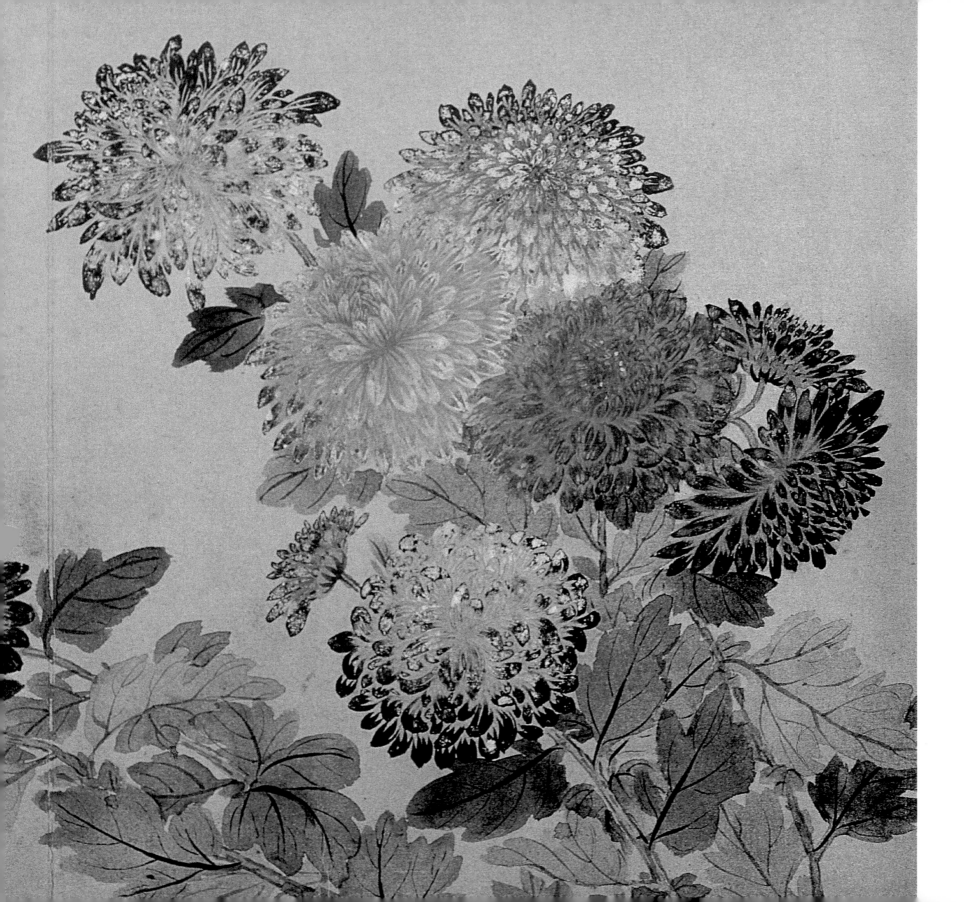

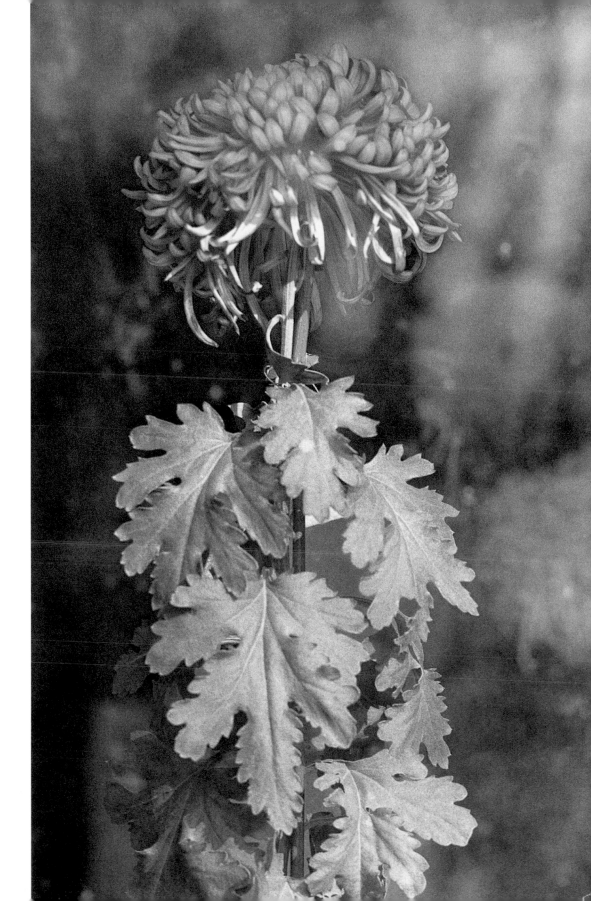

The table is laid before the open court.
Goblet in hand, the talk is of mulberry and hemp.
It's settled then: on the feast-day of Double Nine
I'll come back to delight in the chrysanthemums.

Meng Haoran (689–740)

At the Rock Gate
no trace on the snow;

Only the incense still mixes
with the mist in the valley.

Leftovers in the courtyard.
Down flies a bird.

His rags dangling from the pine,
the old bonze is dead.

Wei Yingwu (736–830)

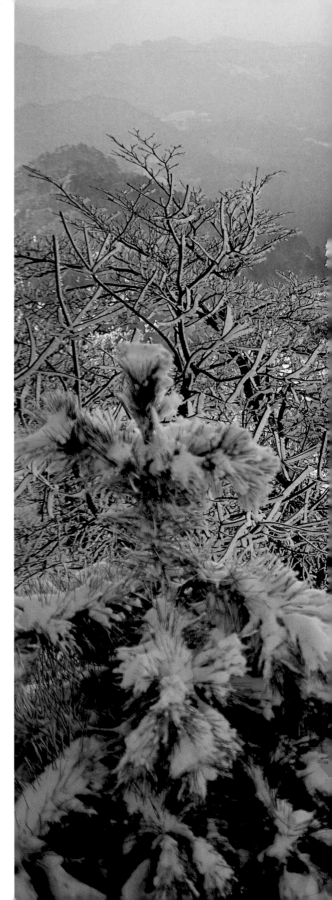

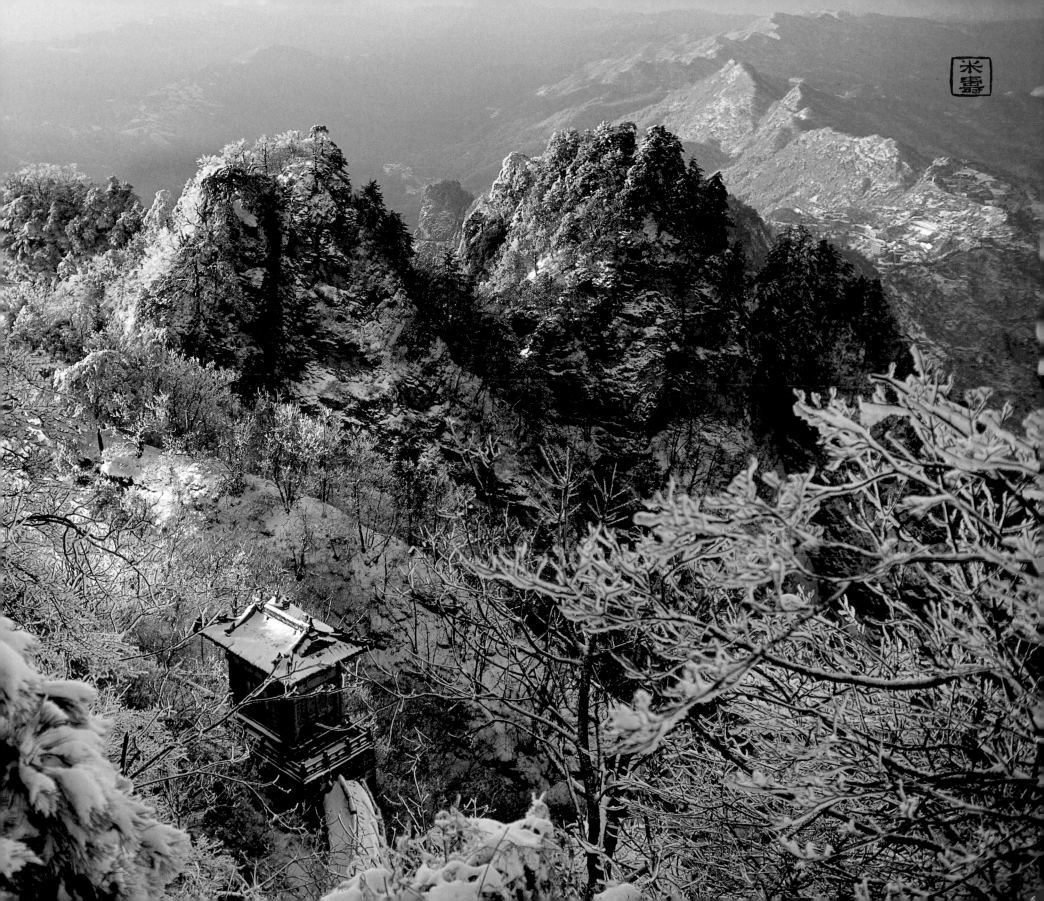

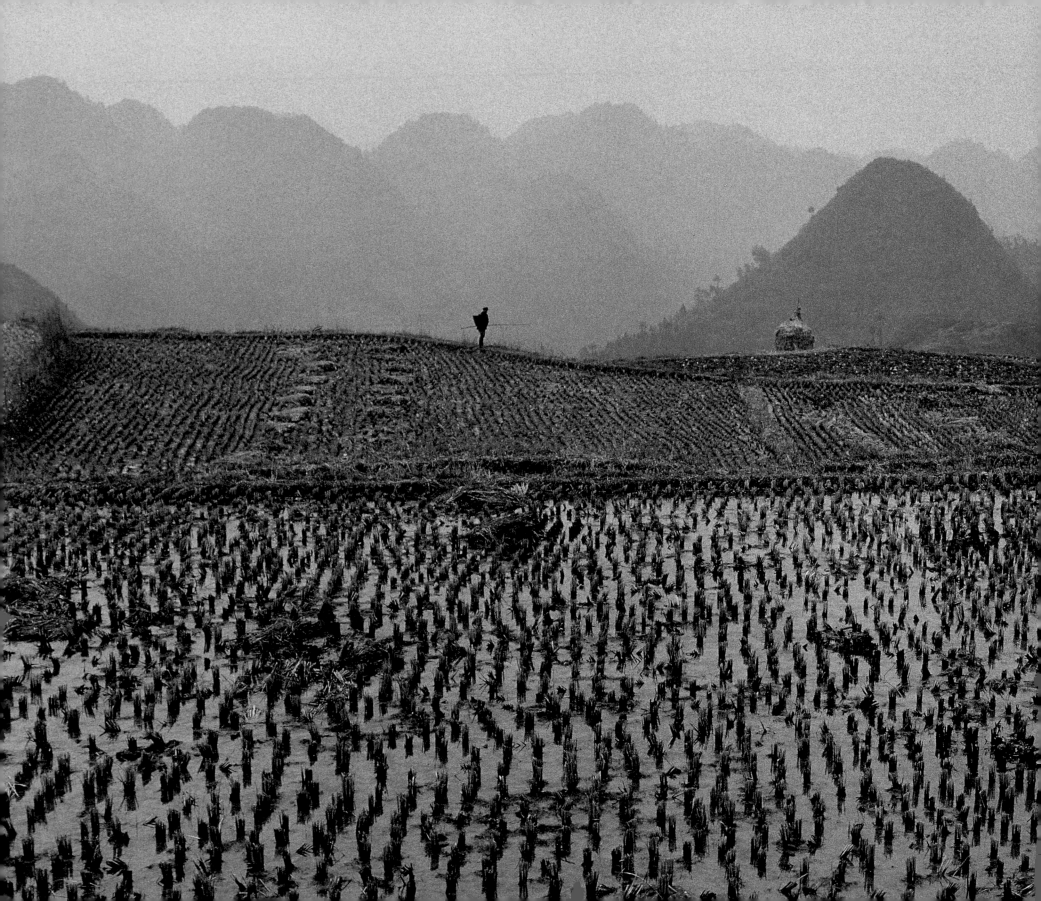

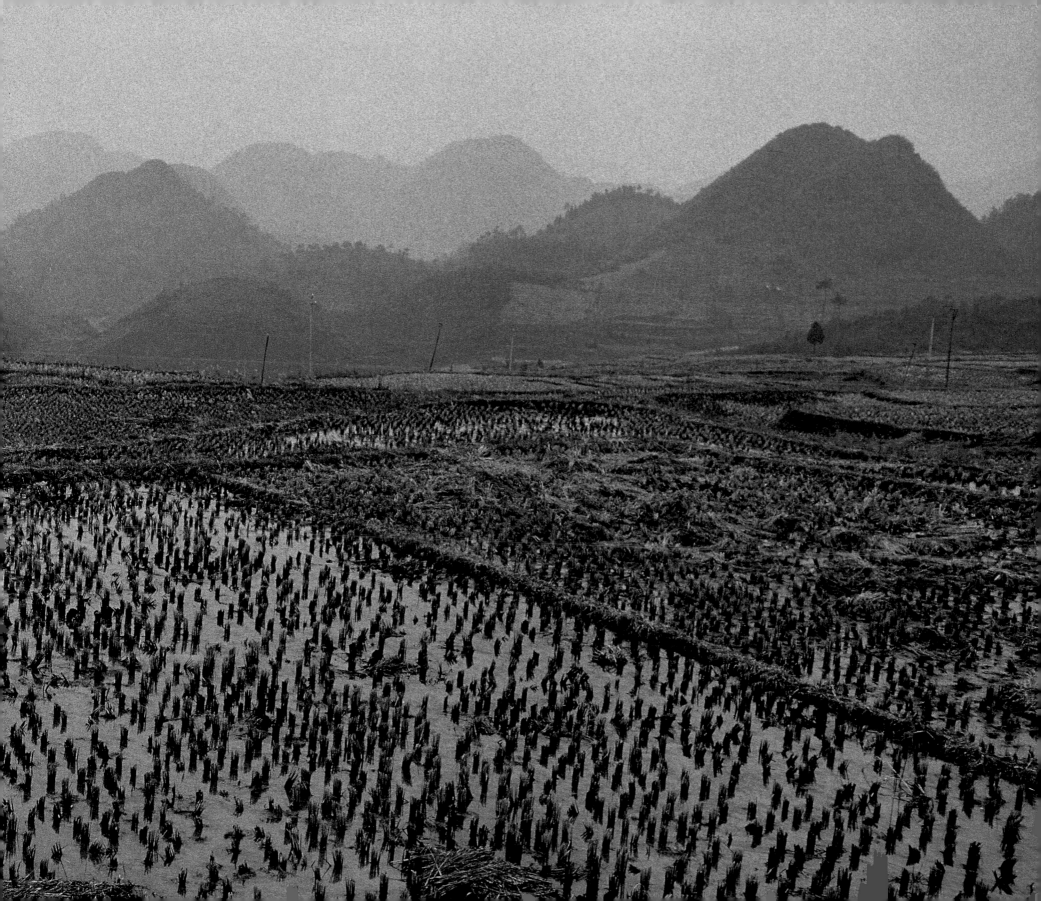

天之鏡

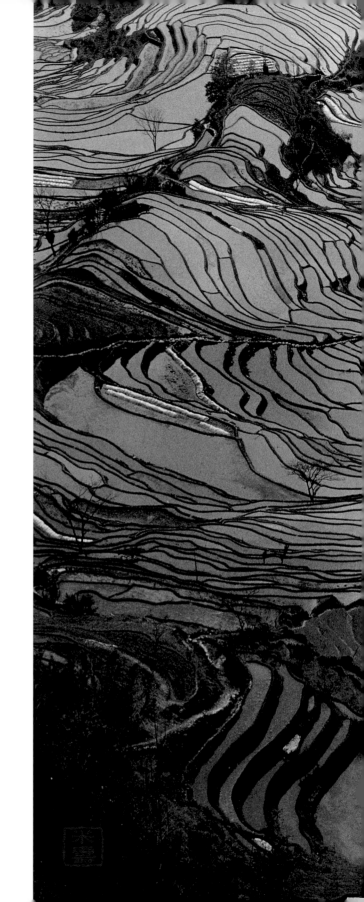

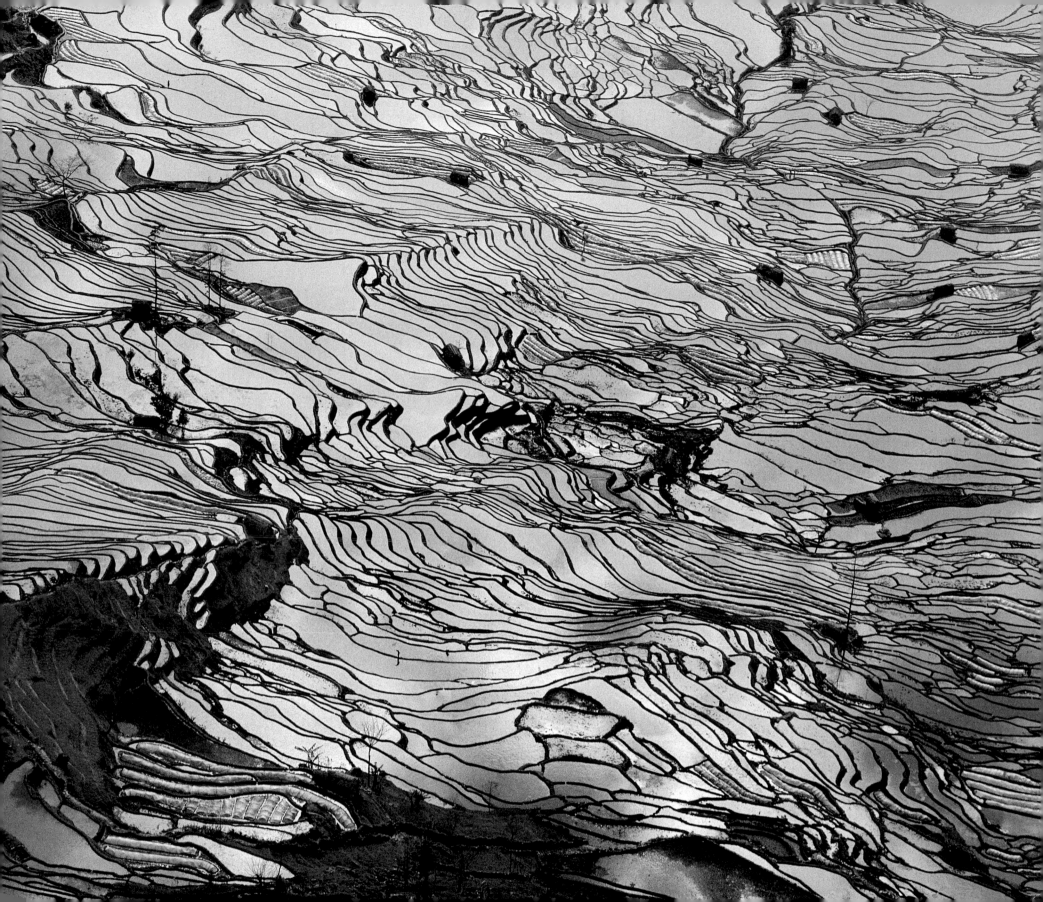

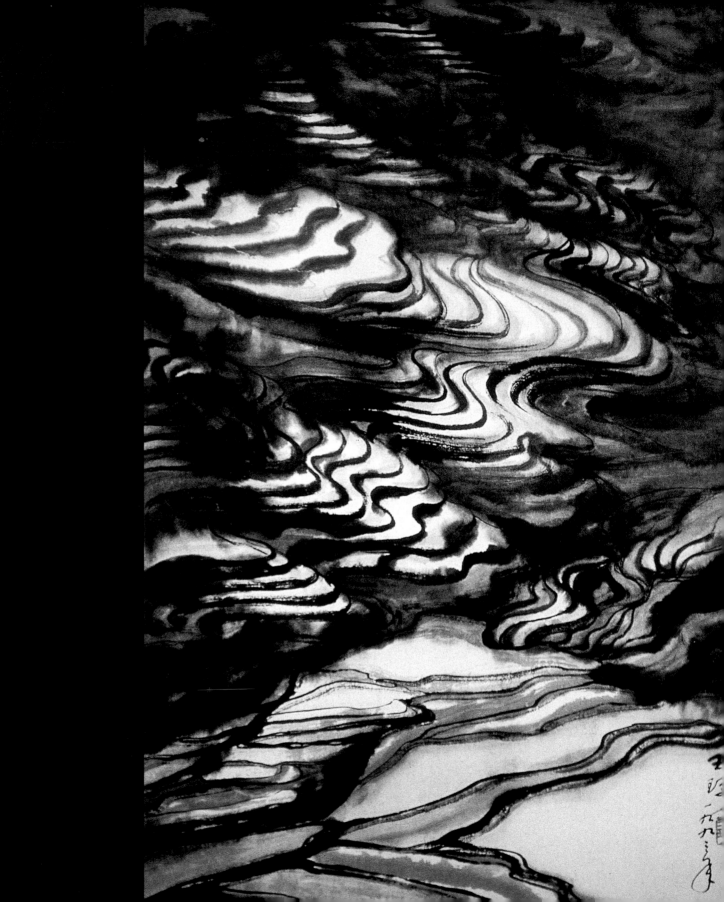

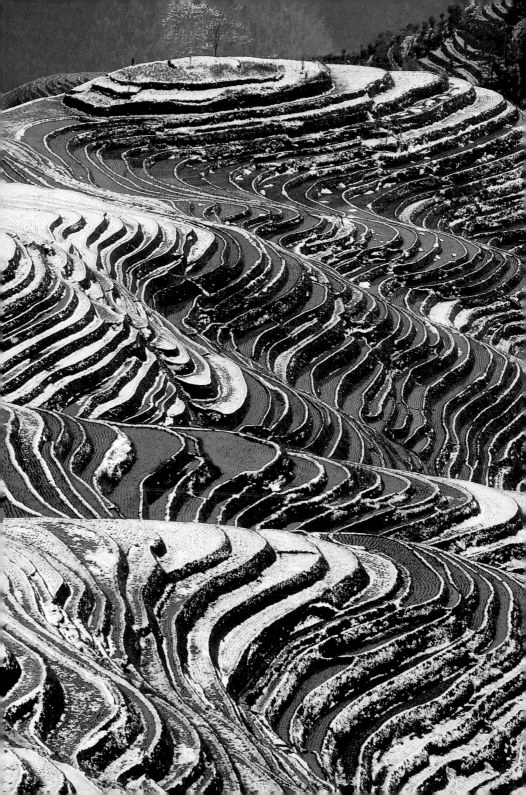

AS THE DAYS GO BY

On the Siu Cheng road,
the people of the Mountains of the West
know how to be happy:
a good melon soup and fried bamboo shoots
after the spring sowing.

Su Dongpo (1037–1101)

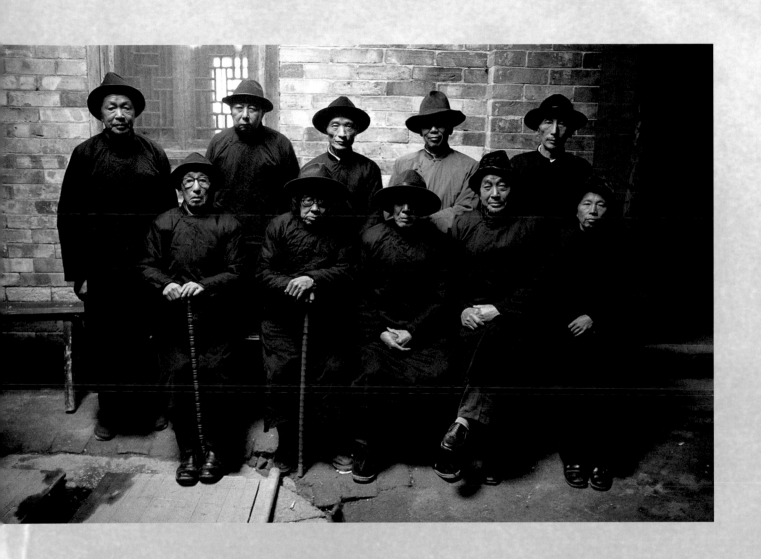

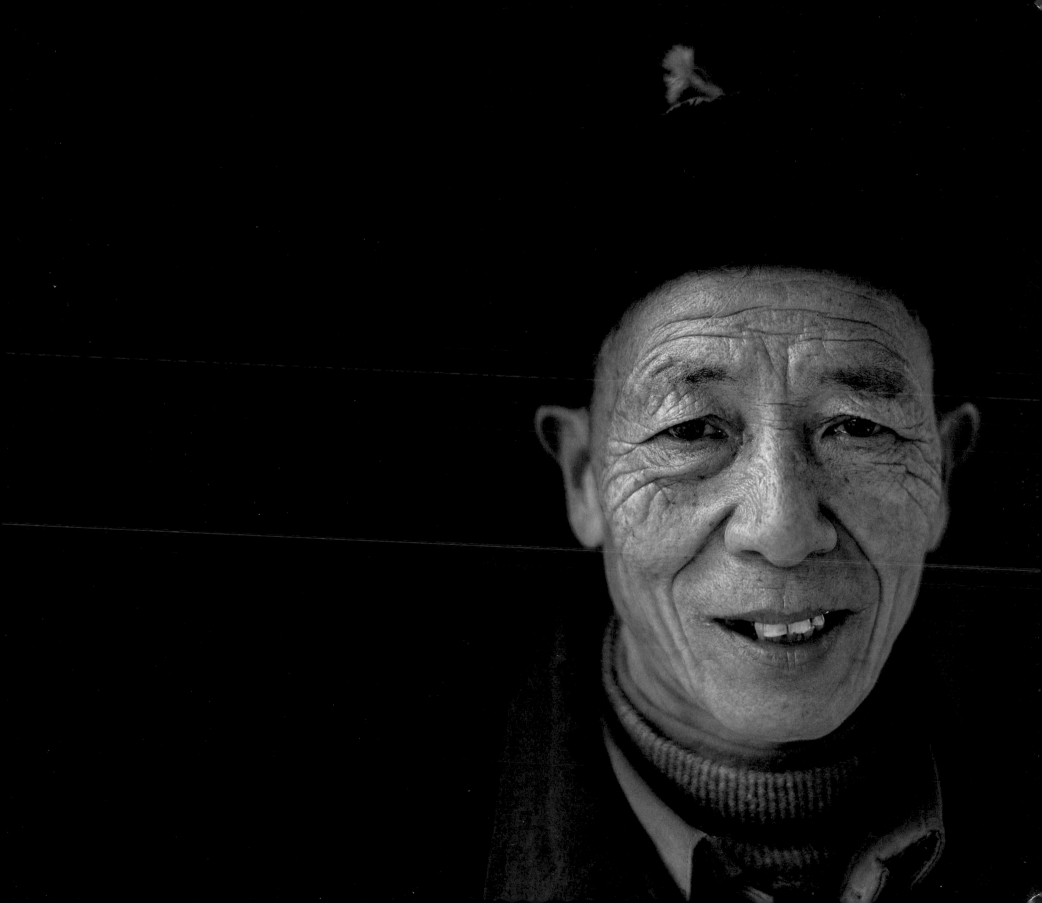

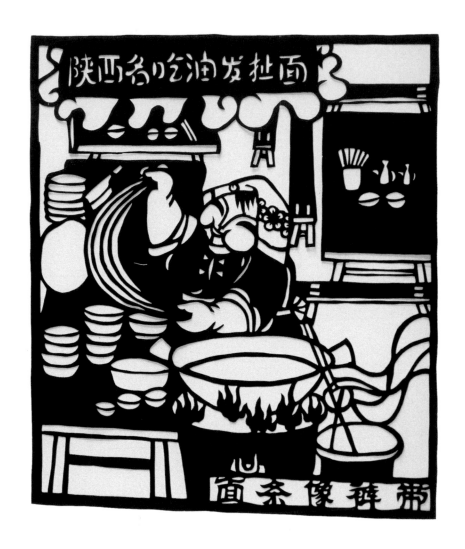

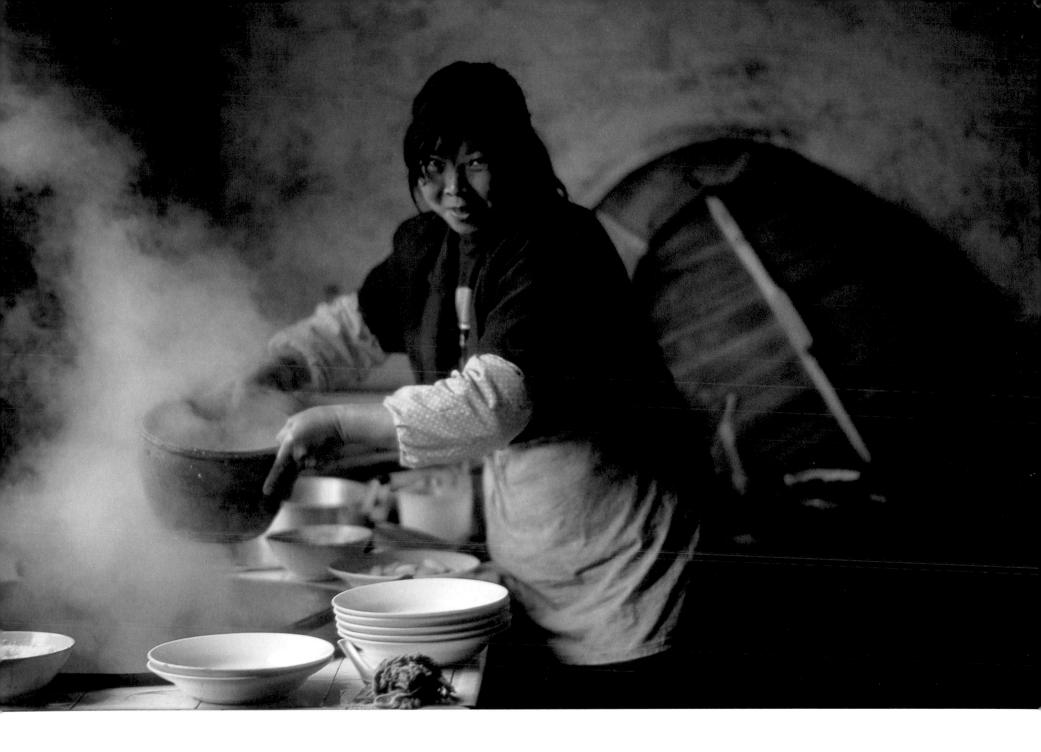

Among the flowers, a jug of wine.
Drinking alone, without companion
I raise the cup, invite the bright moon,
And my shadow makes three!
The moon knows nothing of drinking
My shadow merely follows me.
But I'll play with moon and shadow,
Joyful till spring ends.
I sing as the moon dances.
I dance as my shadow tumbles.
Sober, as when we found our joy;
Drunk, each goes his own way.
Forever bound, to ramble free,
To meet again in the River of Stars.

Li Bo (701–62)

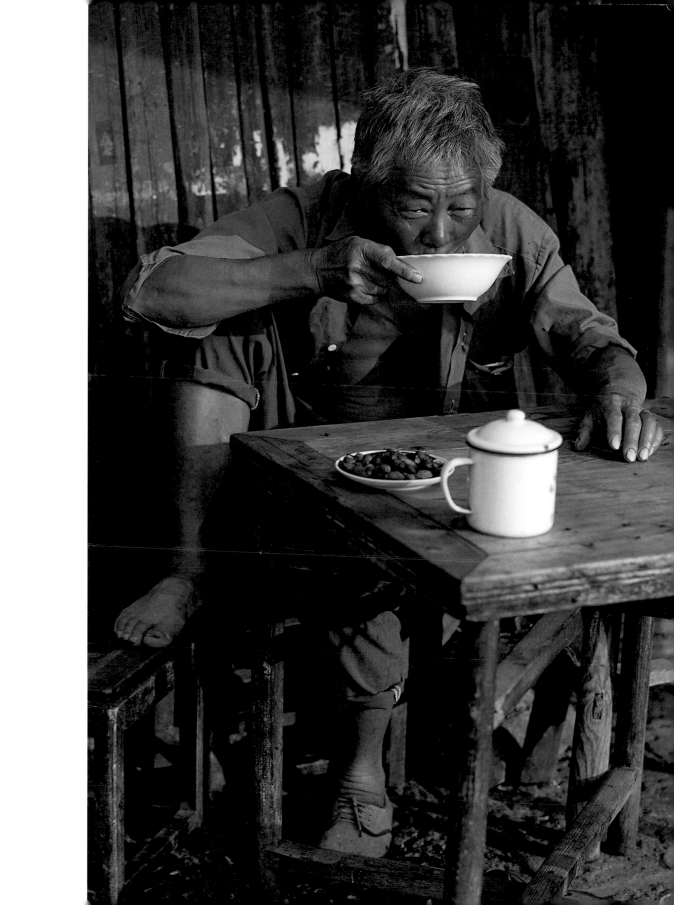

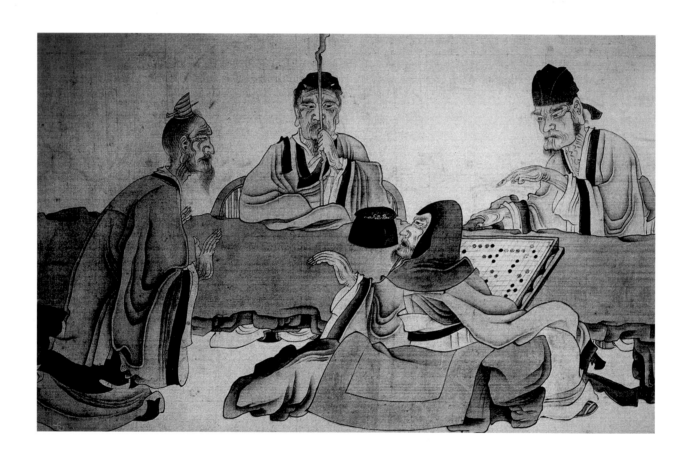

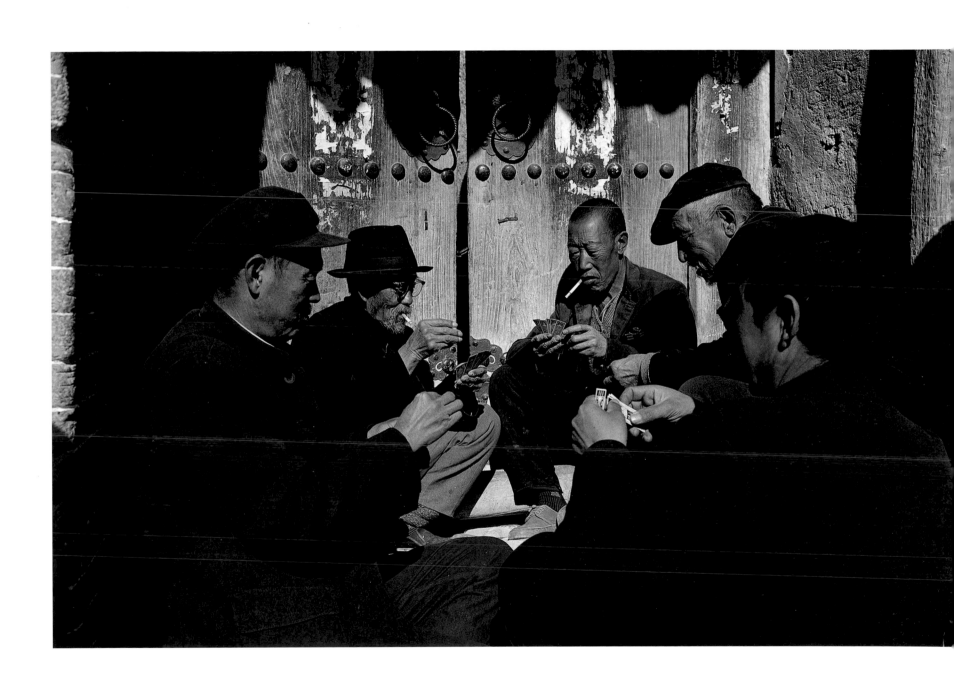

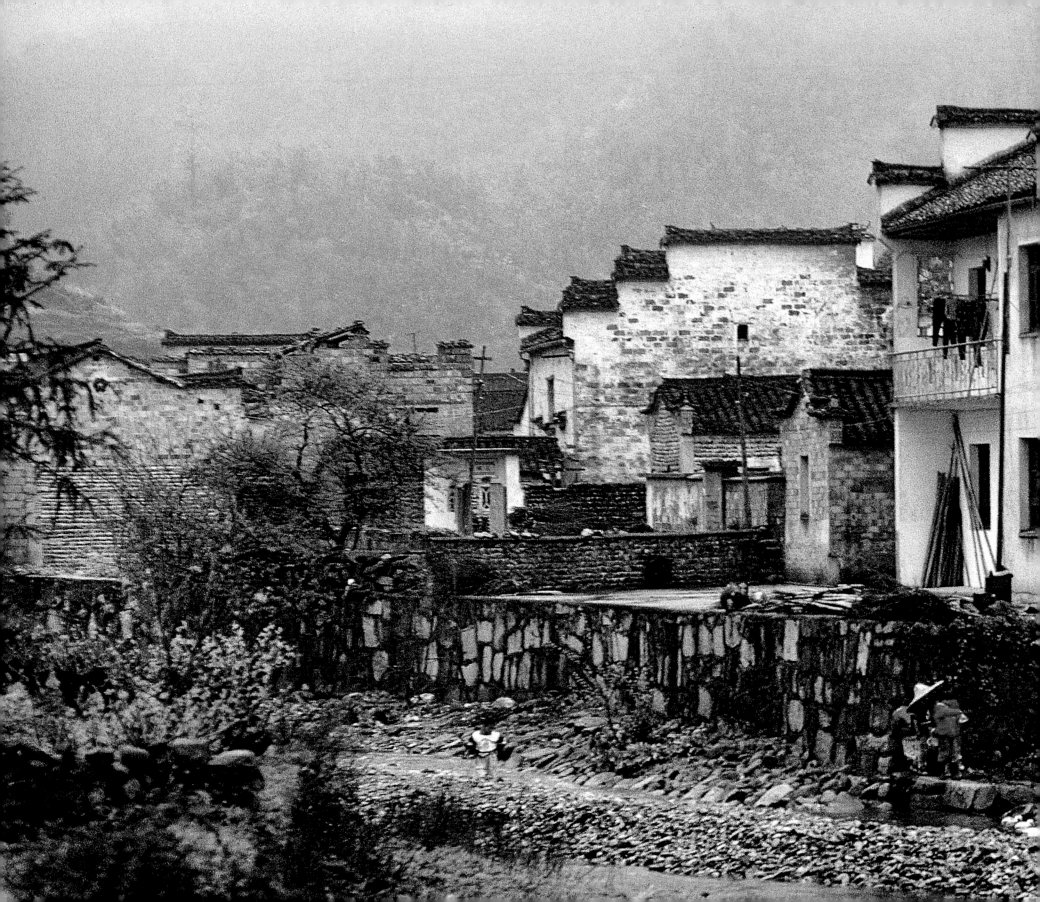

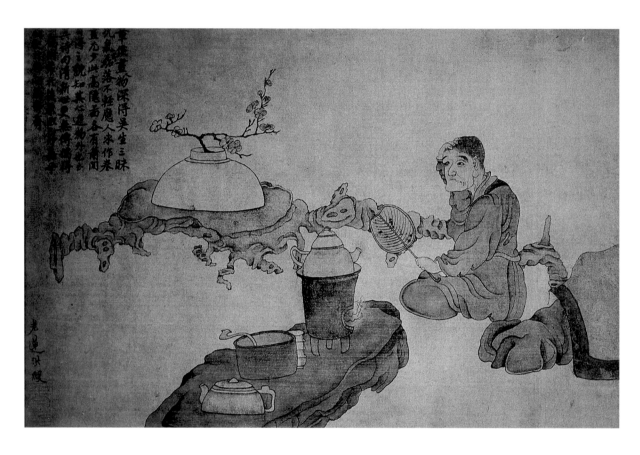

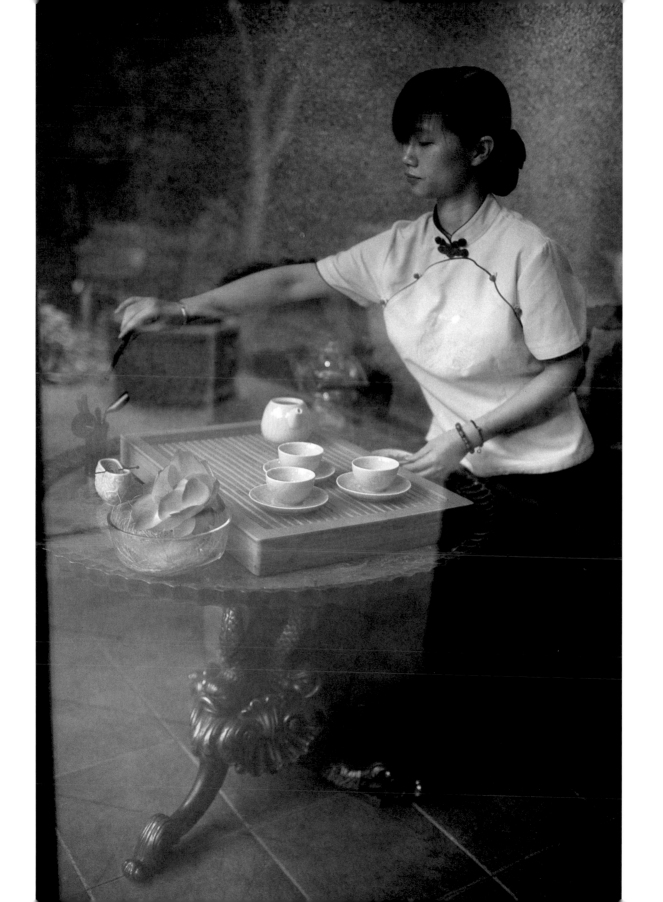

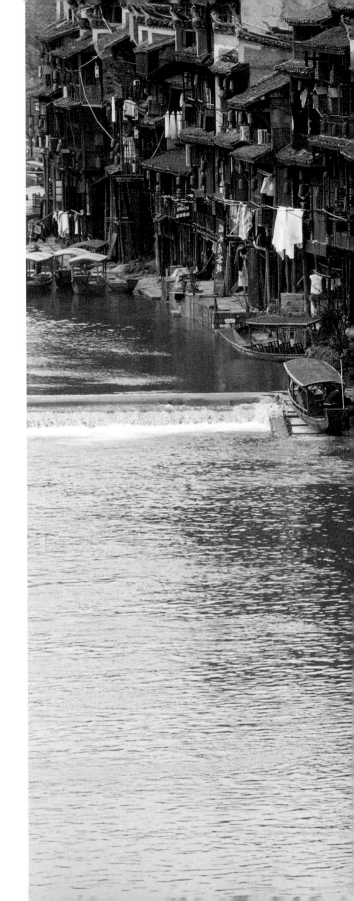

鳳凰

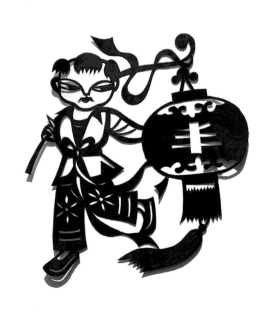

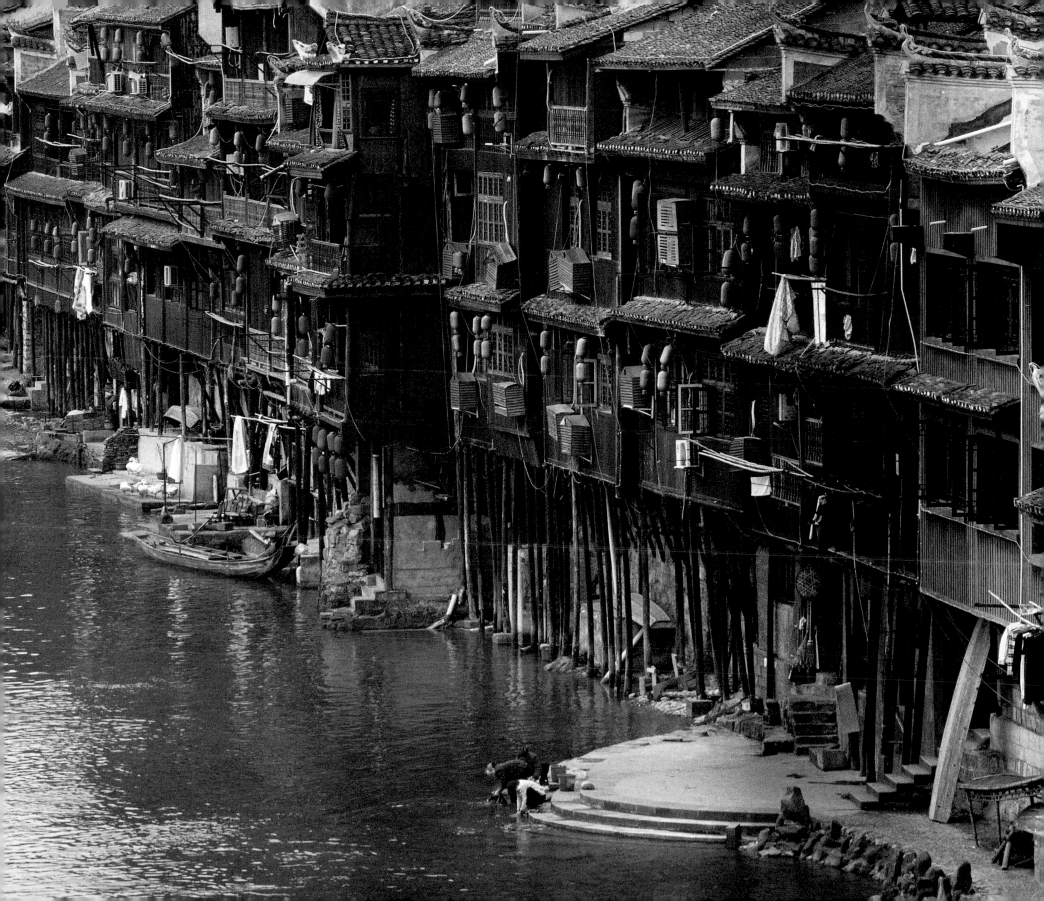

My husband sweats in the fields, I toil at home…
I cook the rice, I allow the tea stand.
You hoe and dig, sow and reap.
When I eat an egg, I leave you the yolk.
We shall grow old together.

Folk song

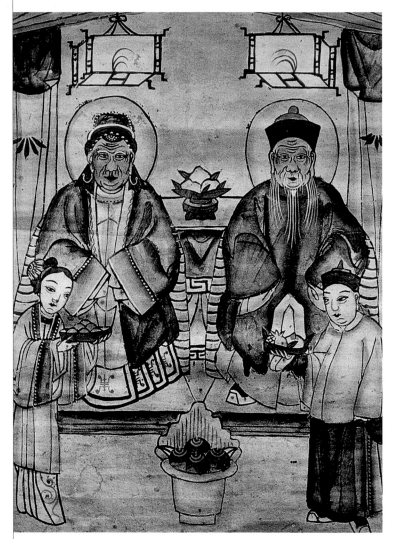

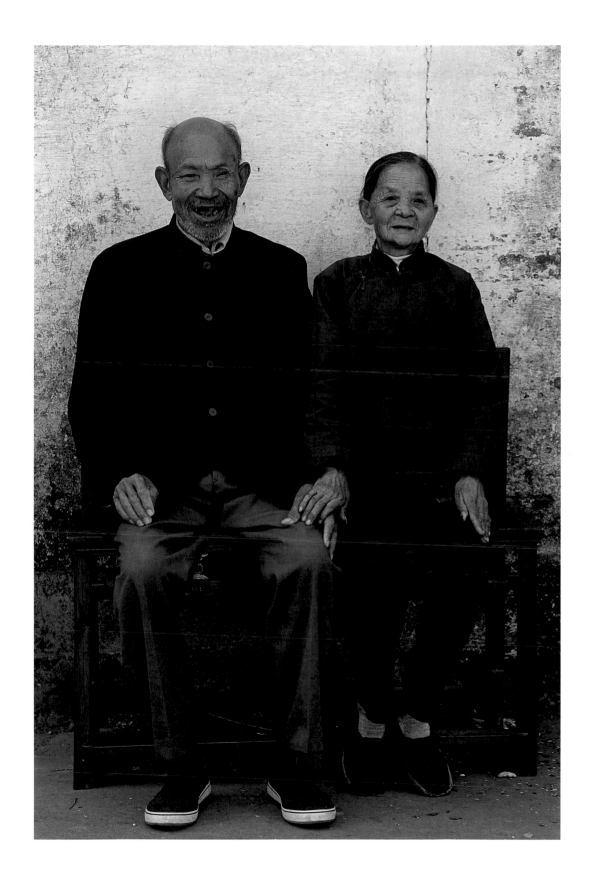

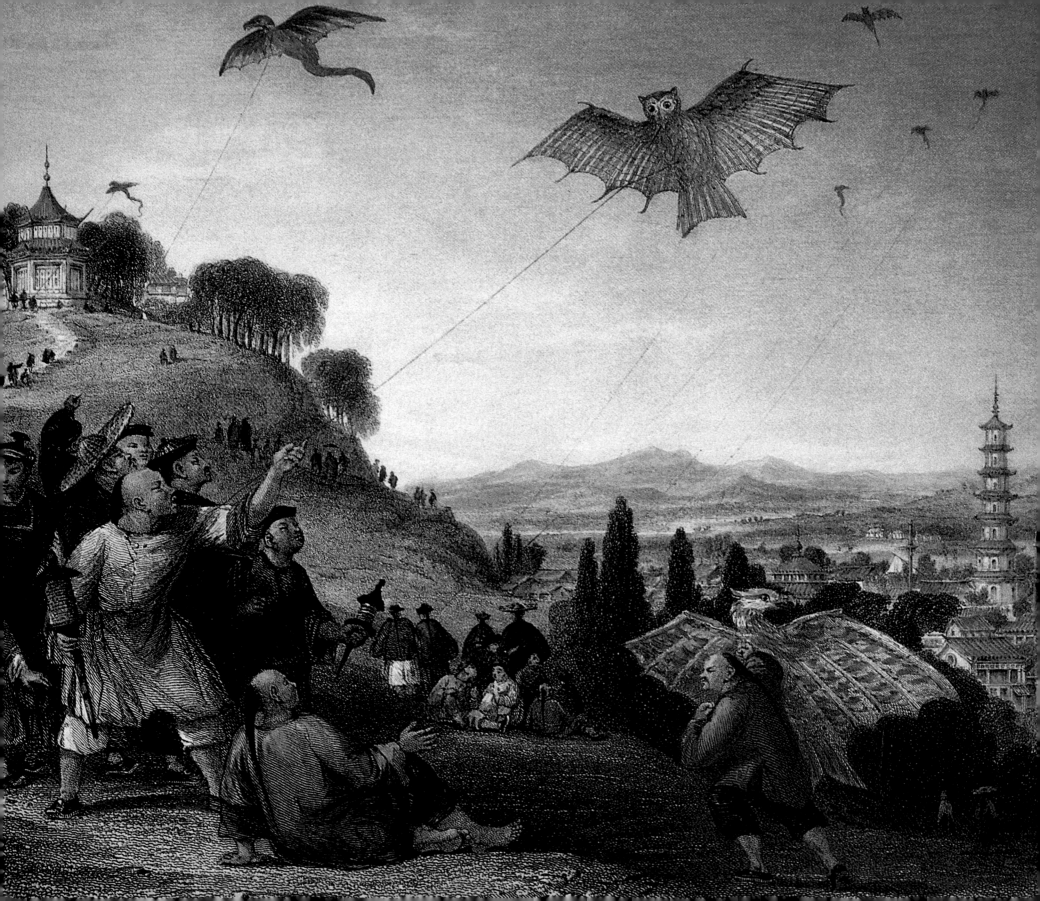

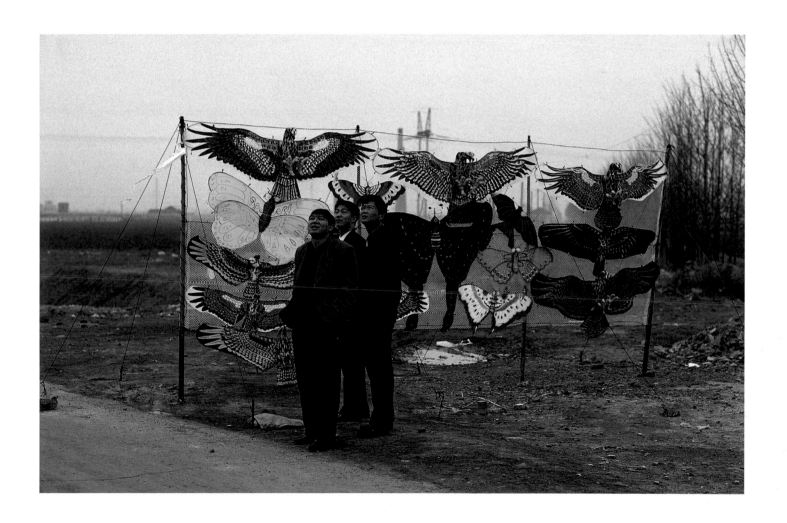

The blaze of coral
in the emerald waves
pales before her
splendor.

Li Bo (701–62)

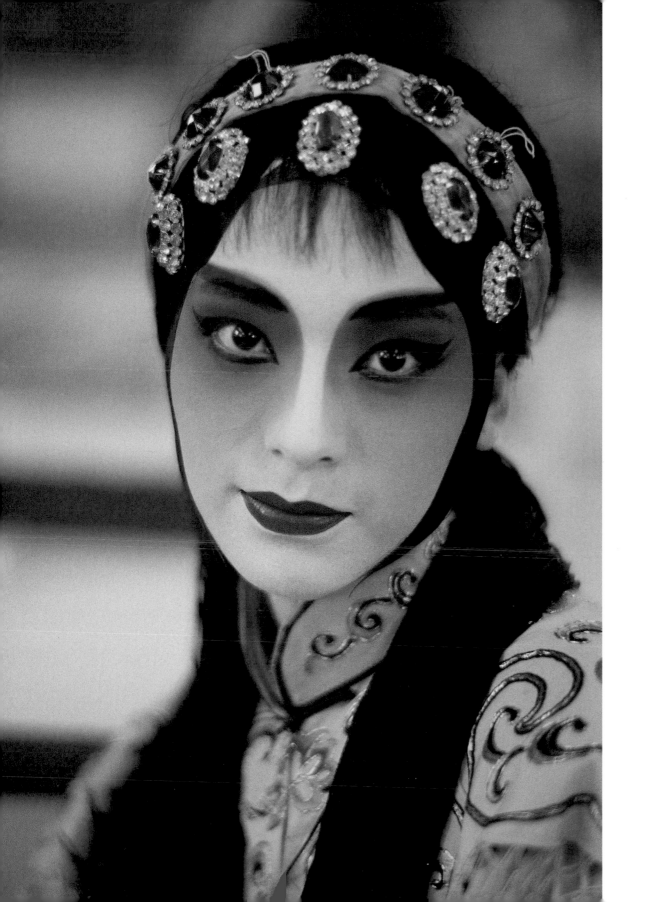

SKILL AND INGENUITY

The Chinese are born craftsmen.
Everything that can be cobbled together has
already been discovered by the Chinese.
The wheelbarrow, printing, engraving,
gunpowder, kites.

The Chinese is a craftsman and a skilful crafts-
man at that. He has the fingers of a violinist.

Henri Michaux (1899-1984)

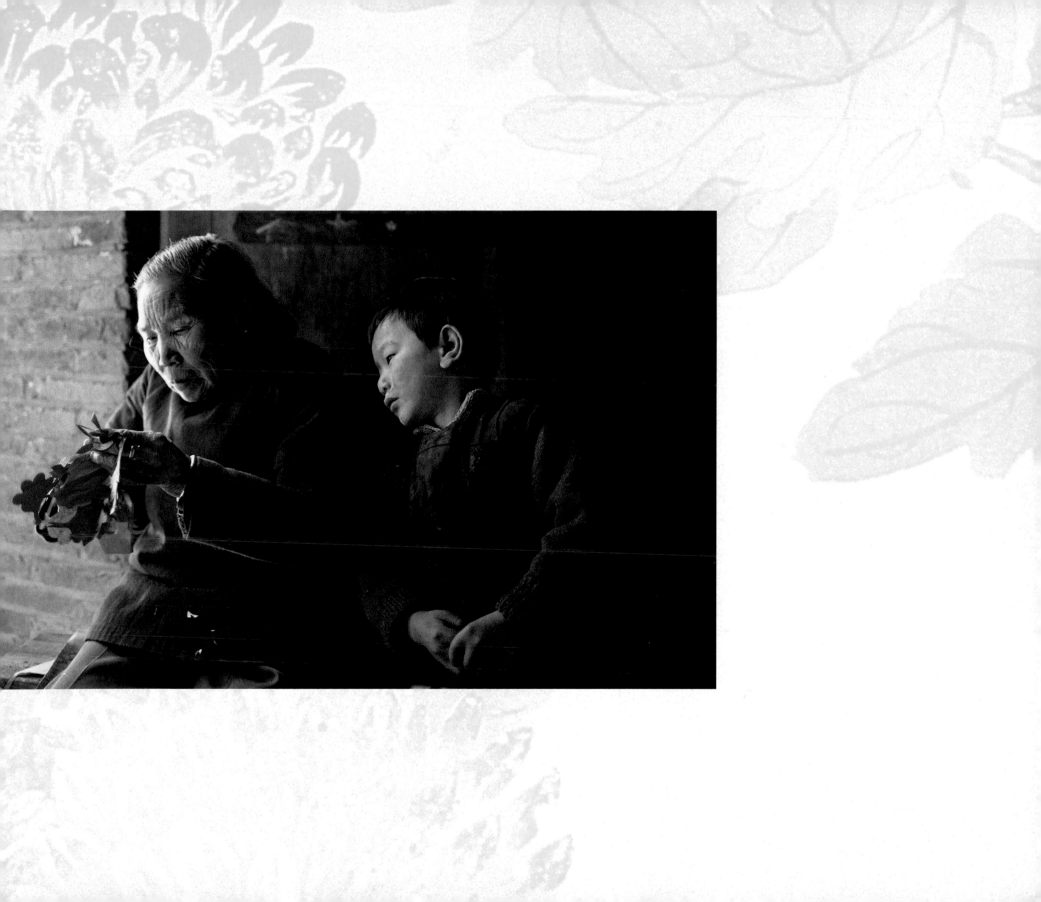

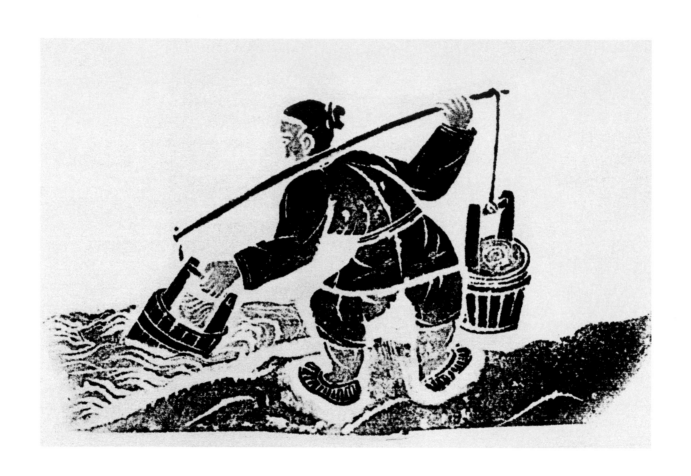

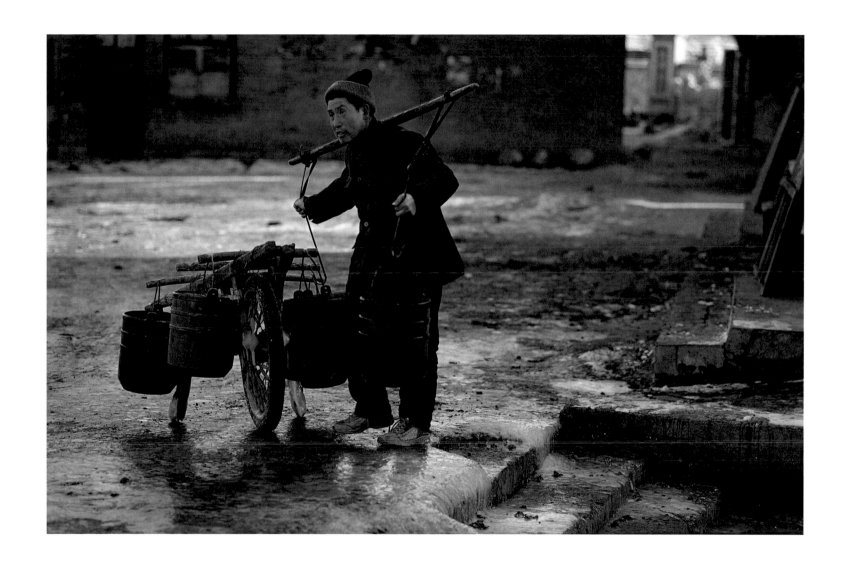

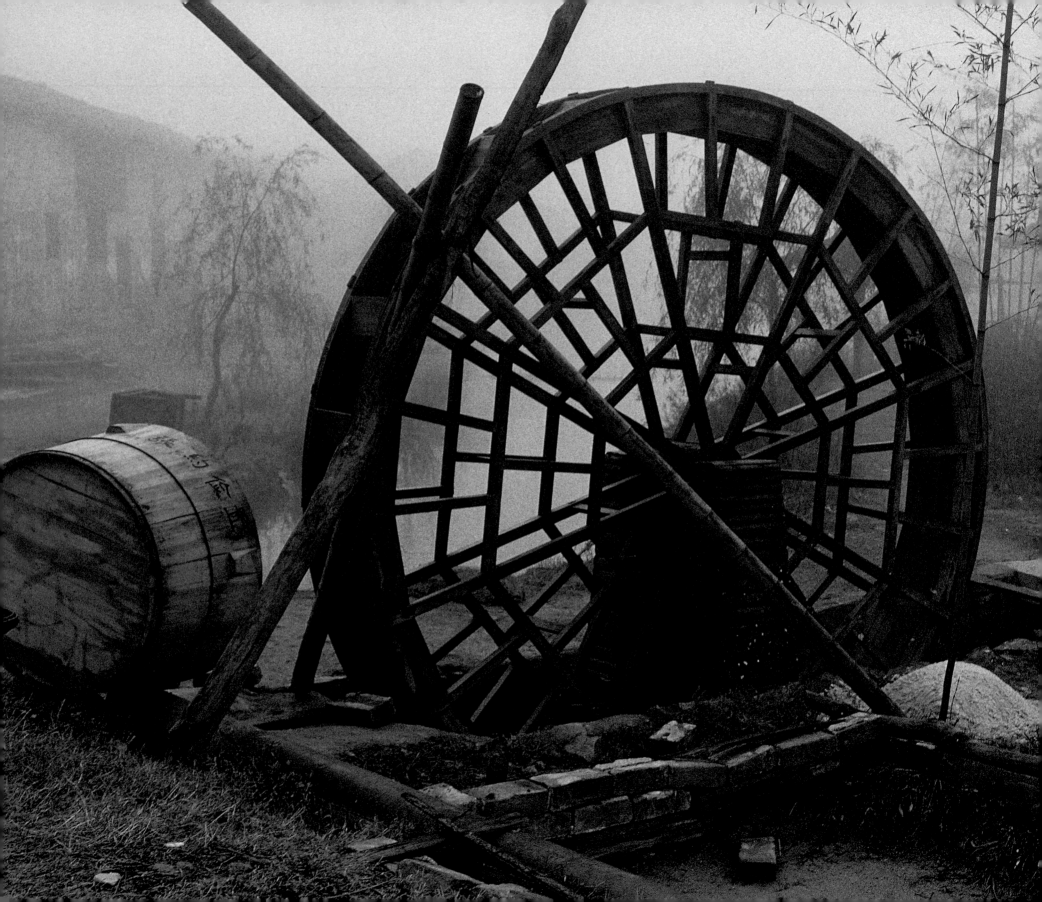

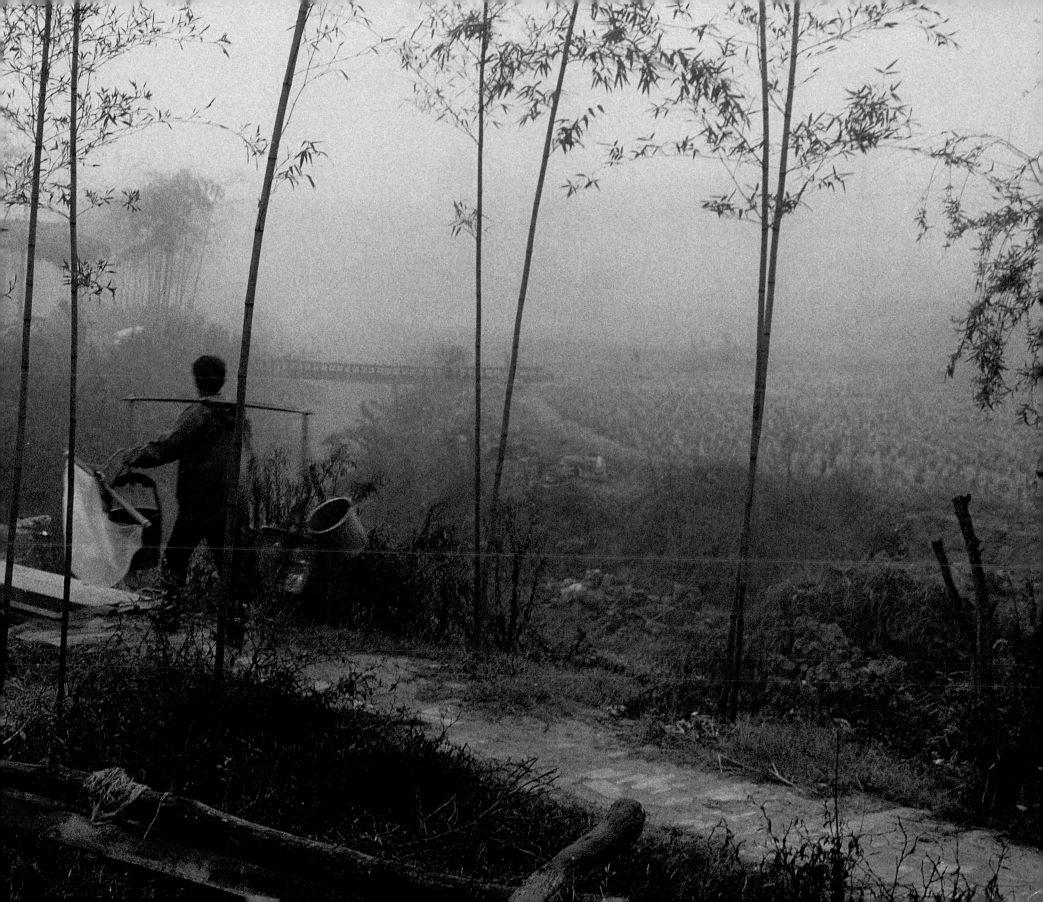

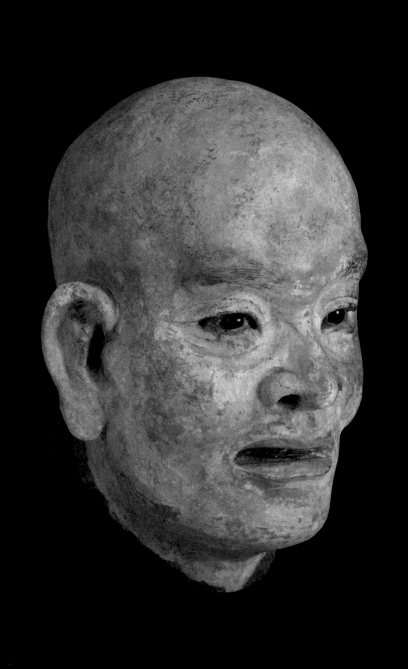

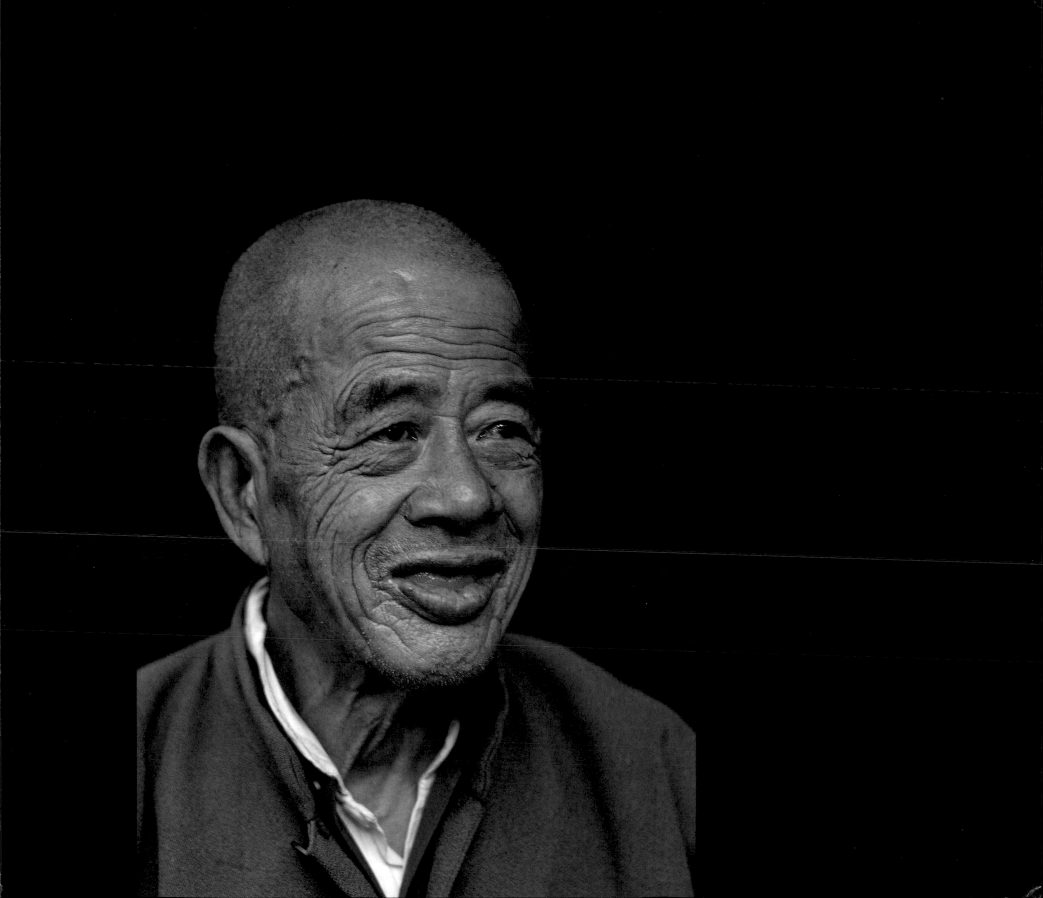

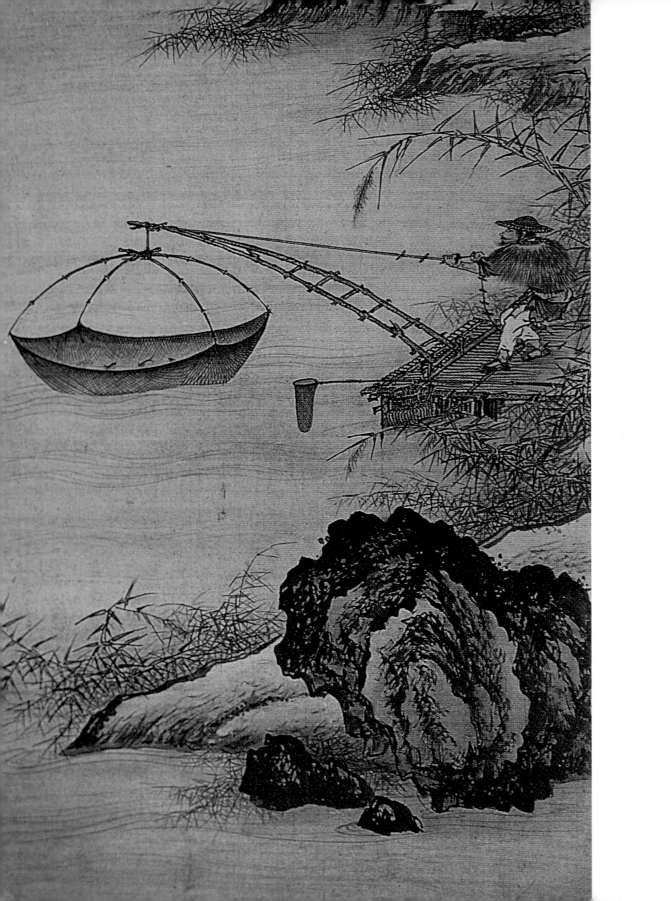

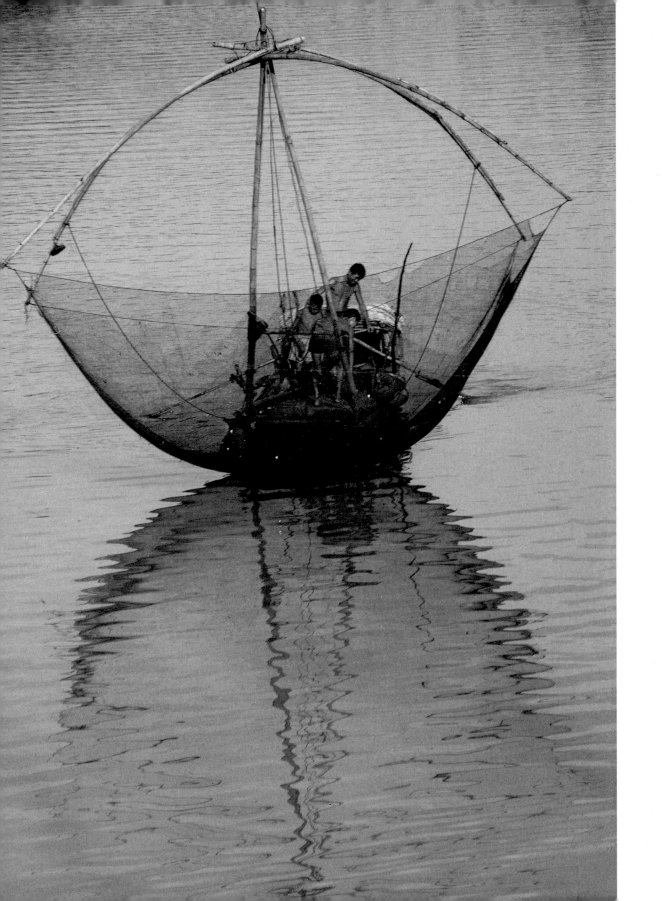

孤舟蓑笠翁
独钓寒江雪

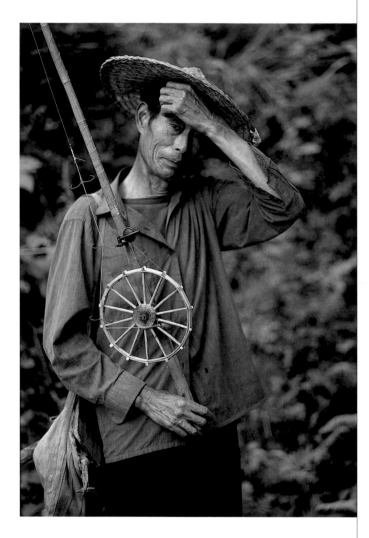

You ask, what is the ultimate truth?
A fisherman's song in the rushes, fading away…

Wang Wei (701–61)

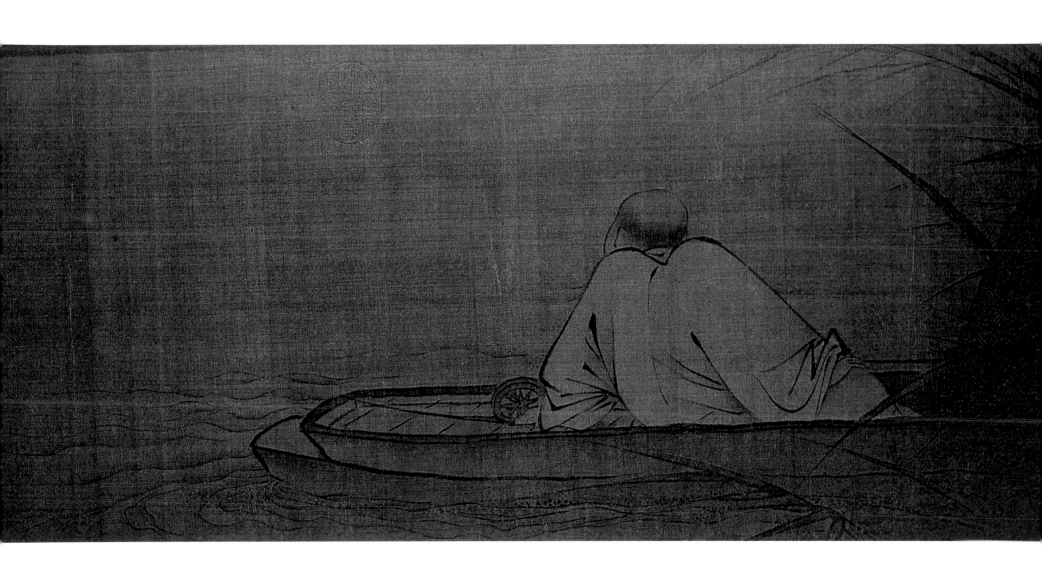

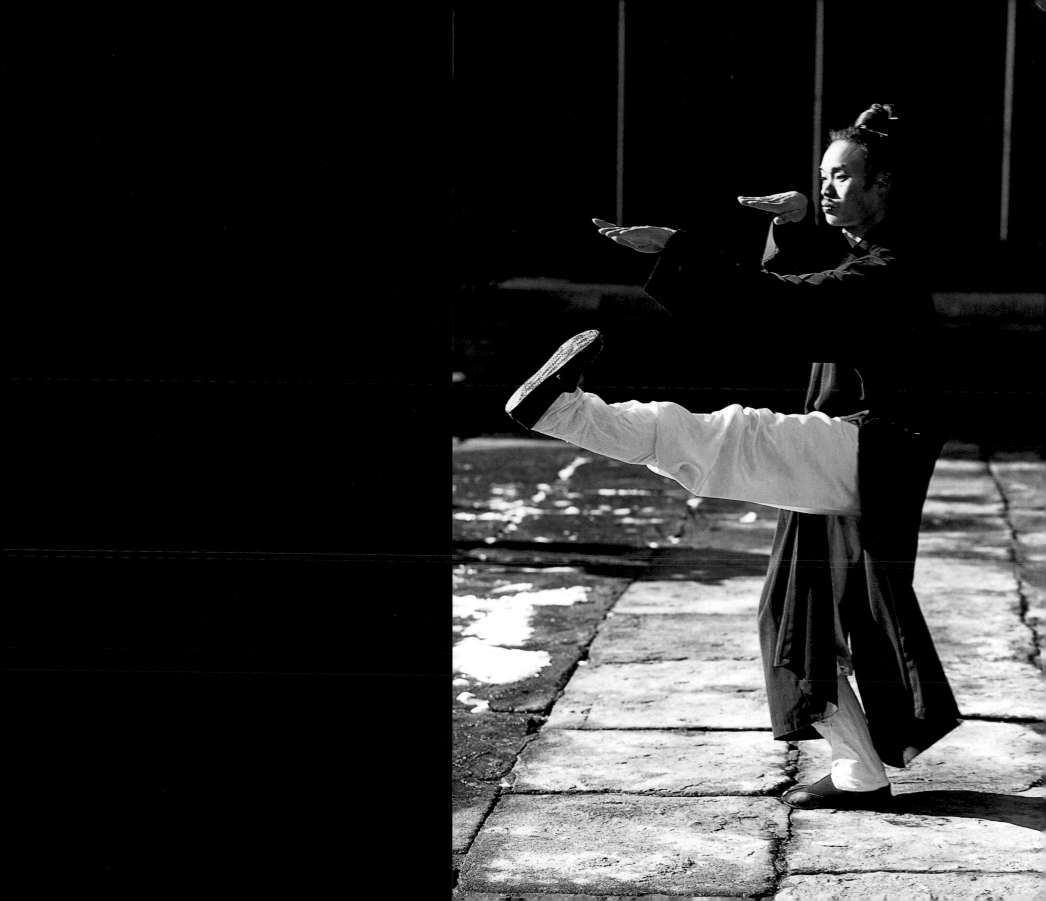

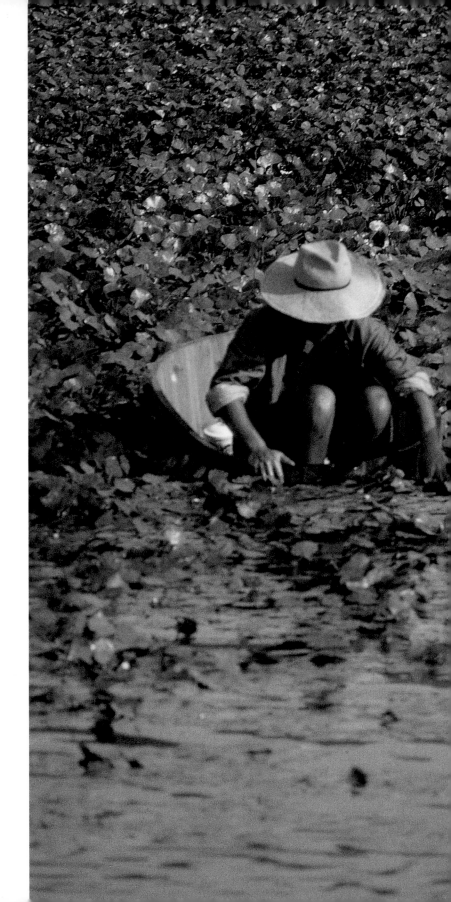

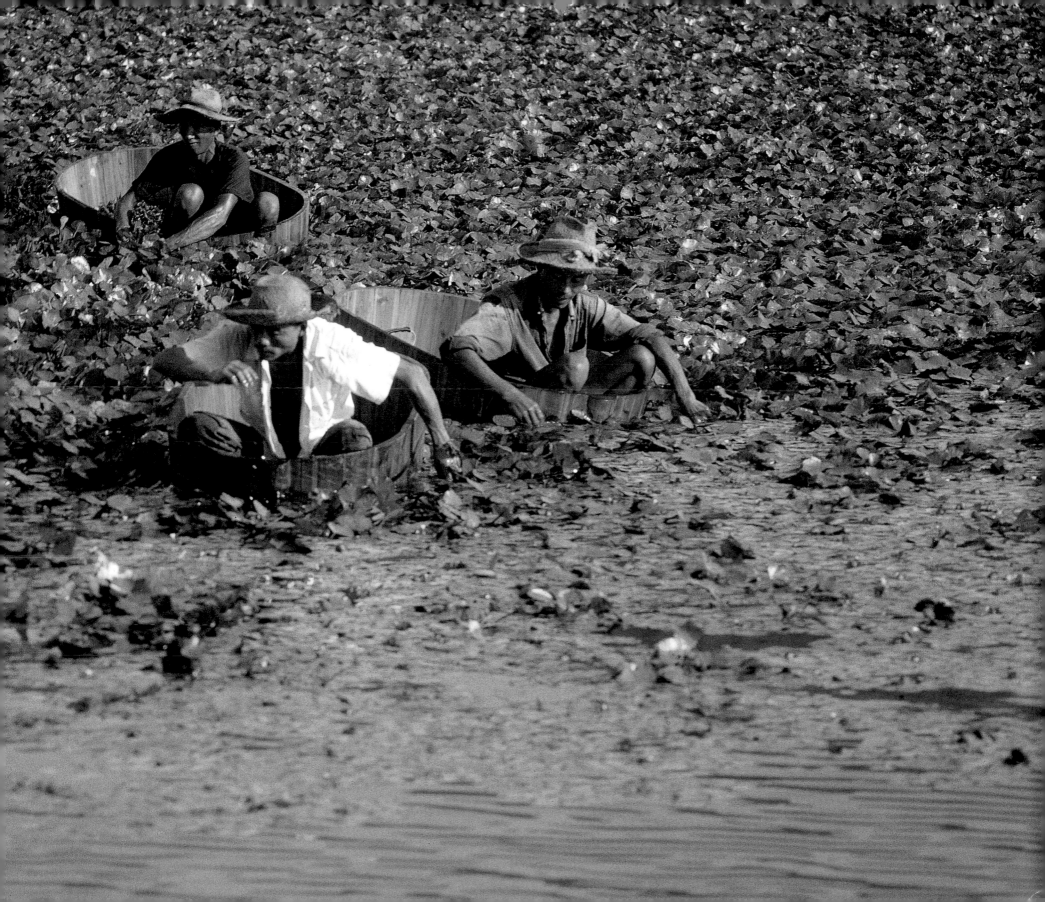

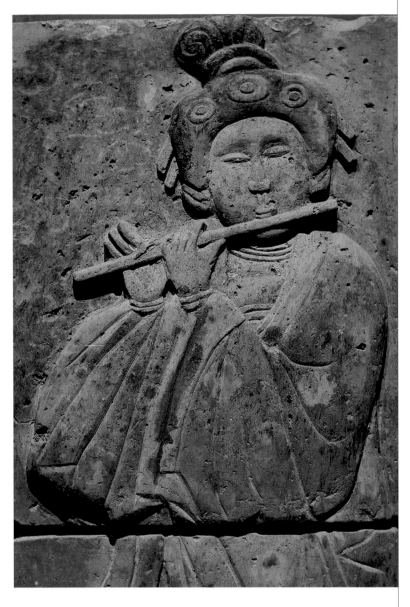

With flute song, to the shore:
The setting sun and I see you off.
On the lake, you looked once more.
White cloud embracing the green.

Wang Wei (701–61)

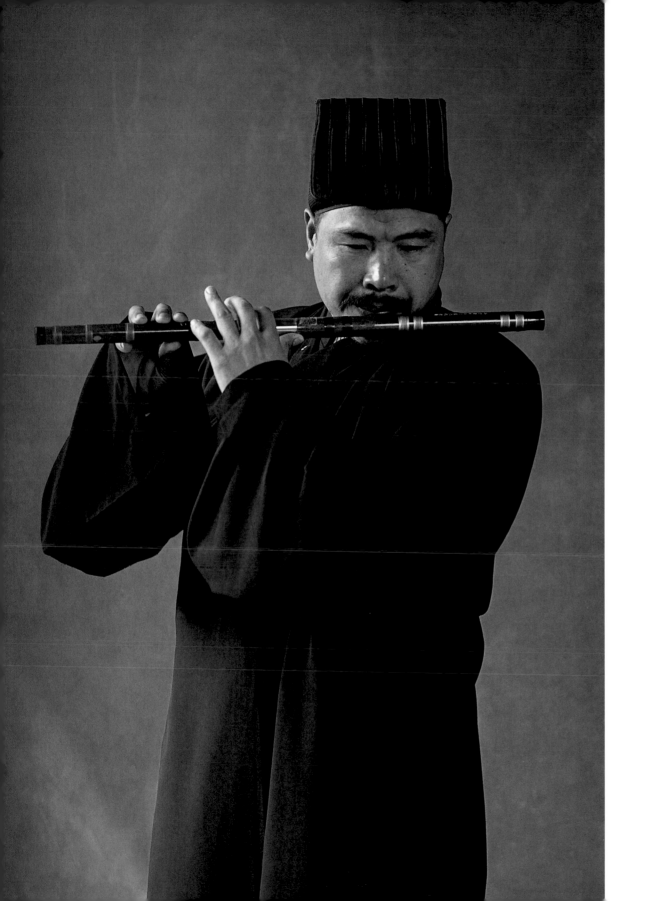

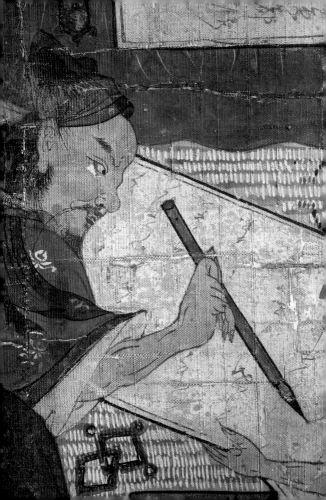

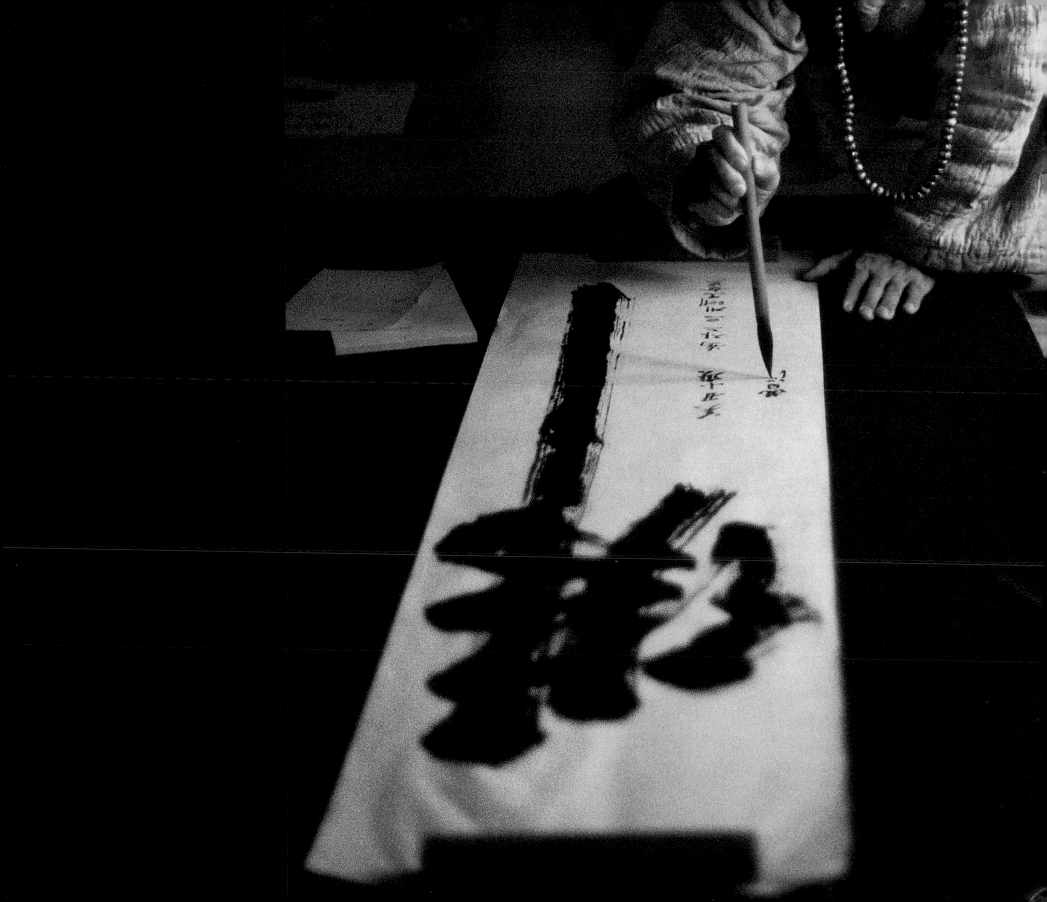

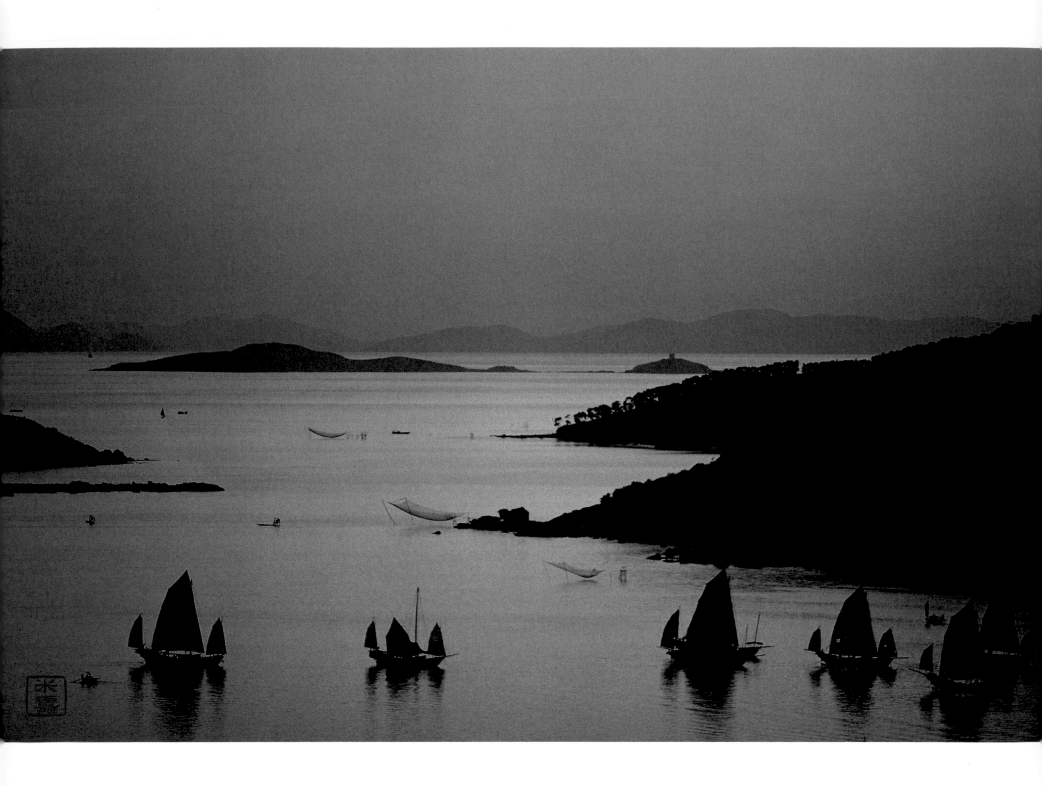

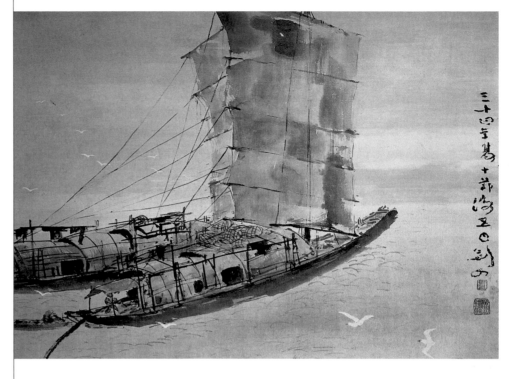

On the way to Qinqku
the sails of the junks crisscross
staying in port
until that moment
when scents and colors evaporate.

Weng Tingyun (Ninth century)

CHILD KINGS

What heaven can do:
give birth to the Ten Thousand beings.

What man can do:
allow the Ten Thousand beings to thrive.

Liu Yuxi (772–842)

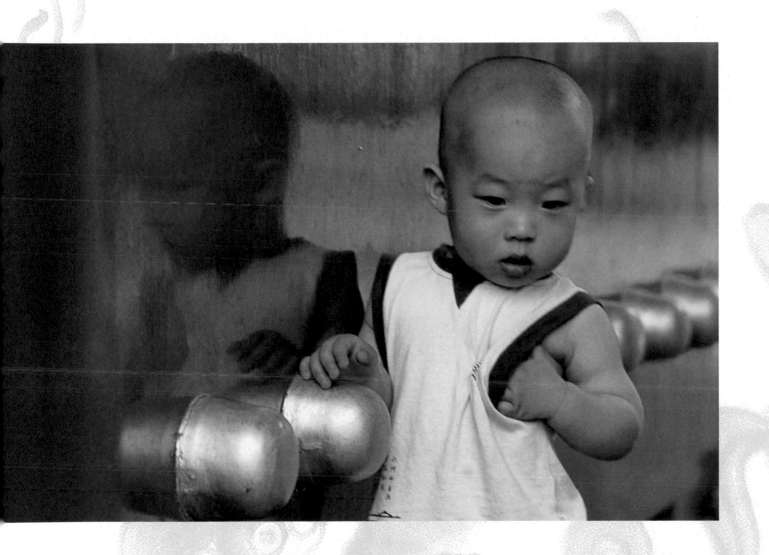

On leaving the city, I came across two crickets
arguing in their cricket tongue.

"For lunch, I eat a weeping willow,"
said the first playing the violin.

"For dinner I eat a big dead donkey,"
said the second playing the violin.

A cock passed by gobbling to himself
and spied the two crickets squabbling away.

He ate the first, he ate the second,
and still they haggled in his stomach.

Children's song from Shanghai

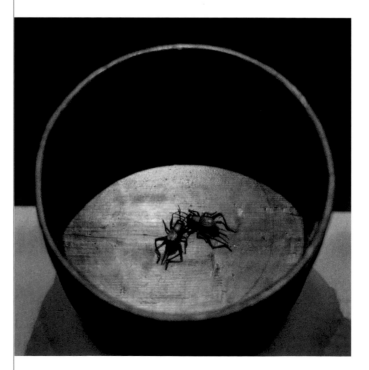

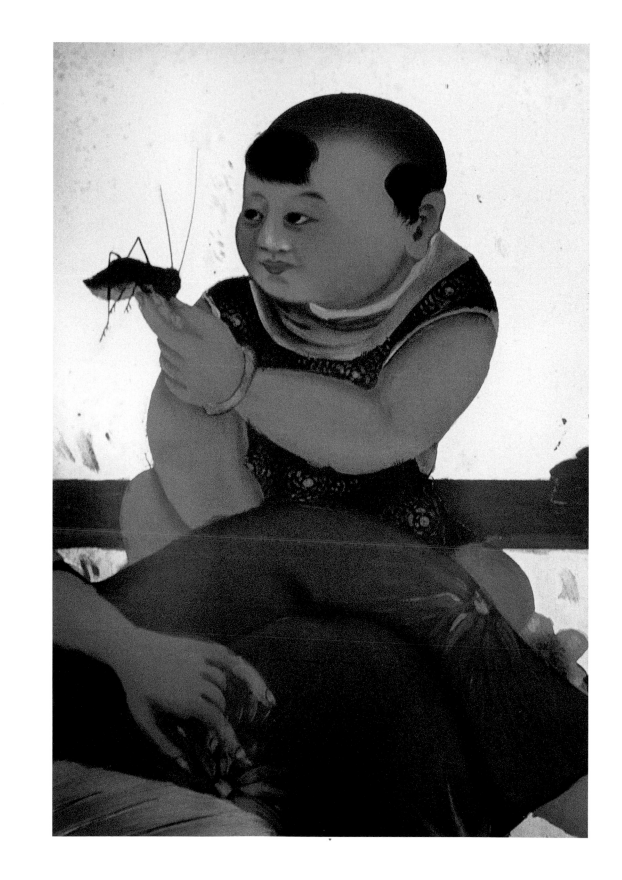

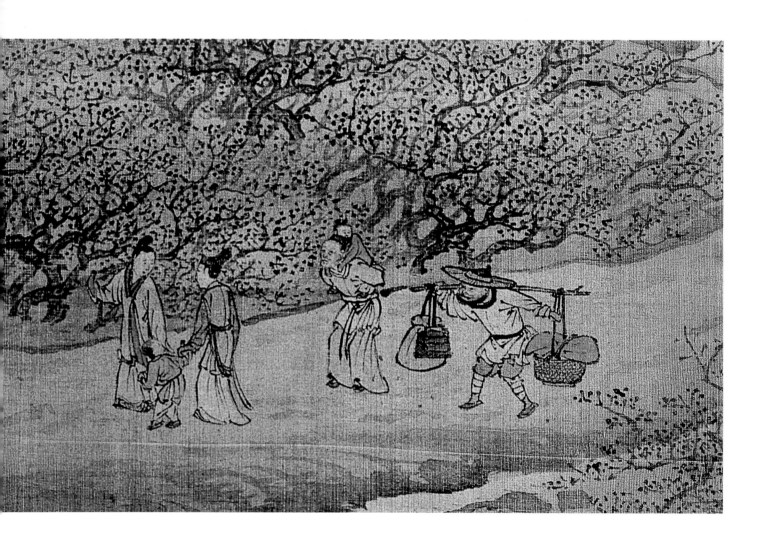

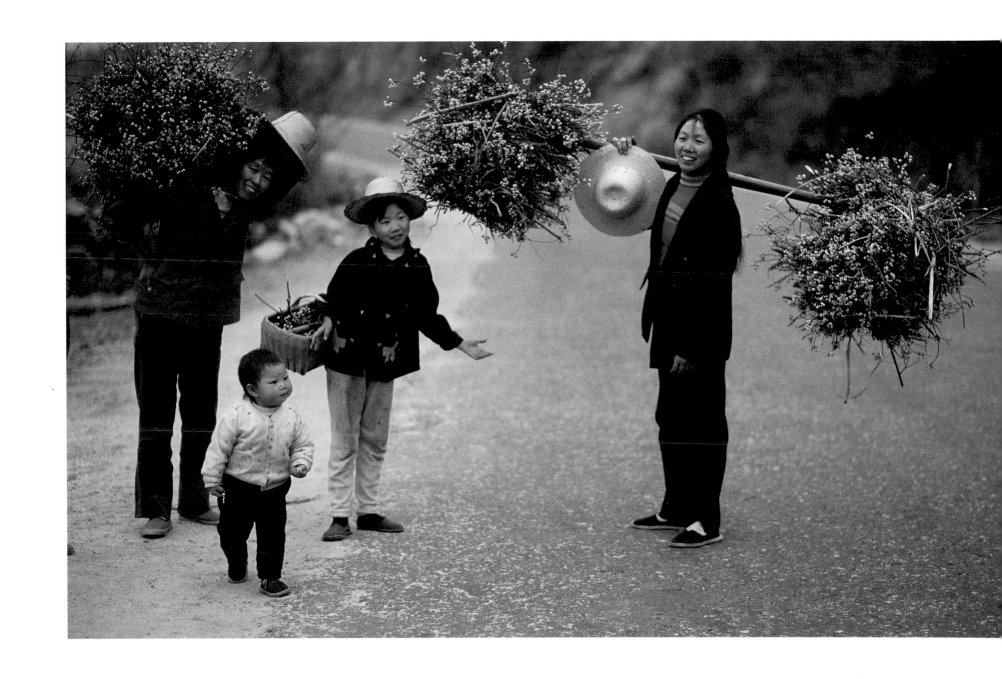

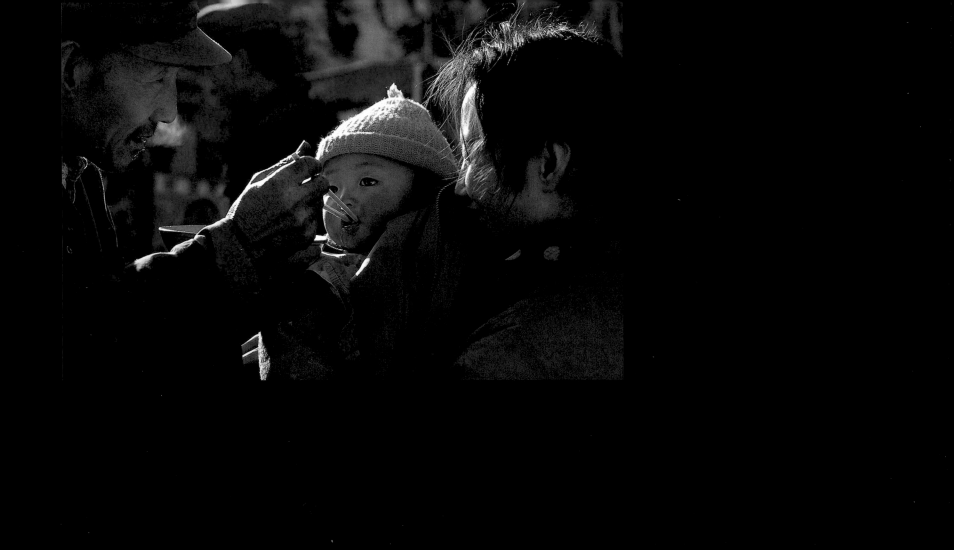

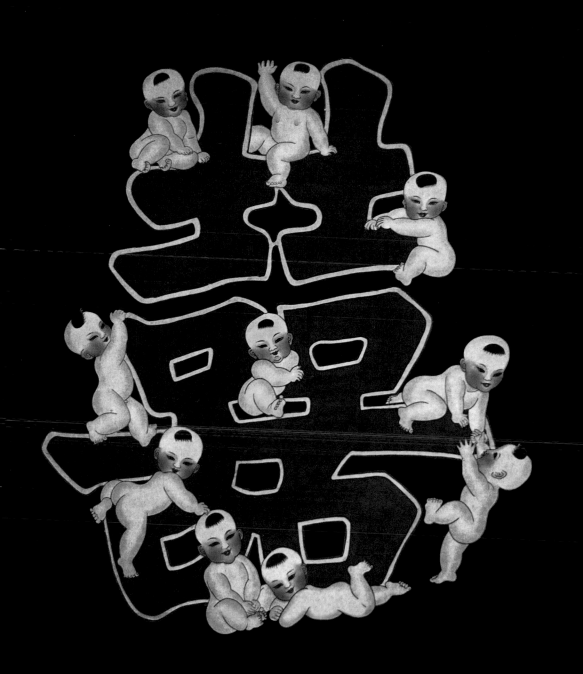

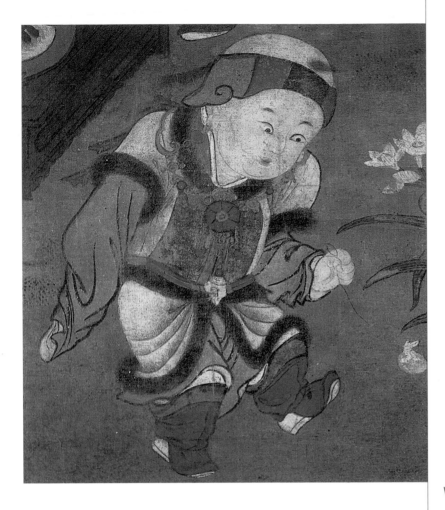

Whoever seeks a friend without faults
remains friendless.

Proverb

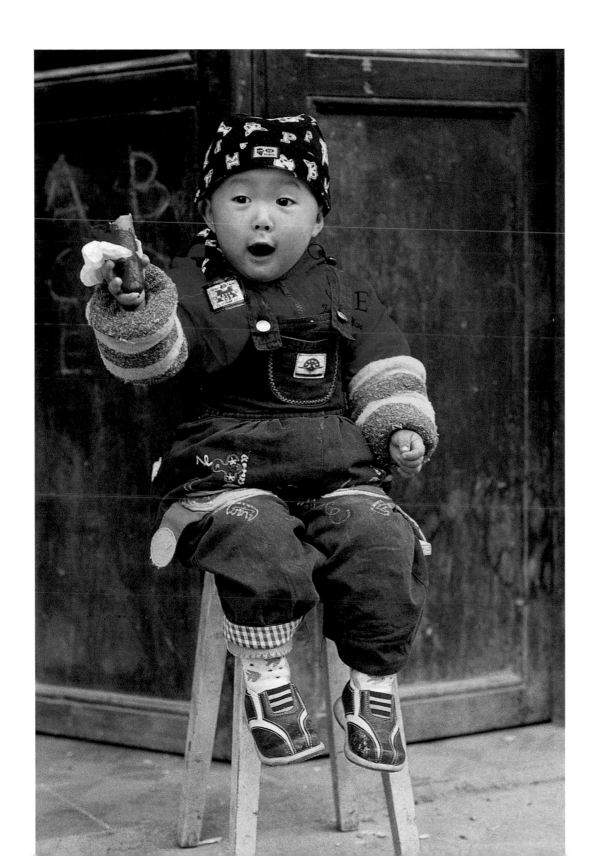

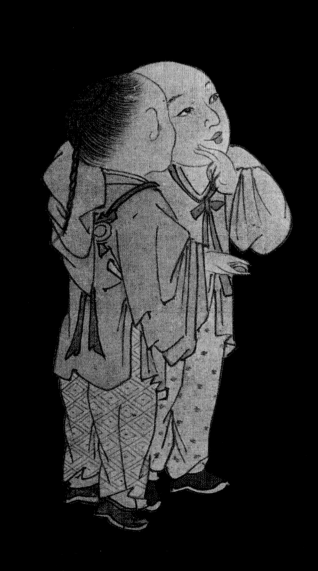

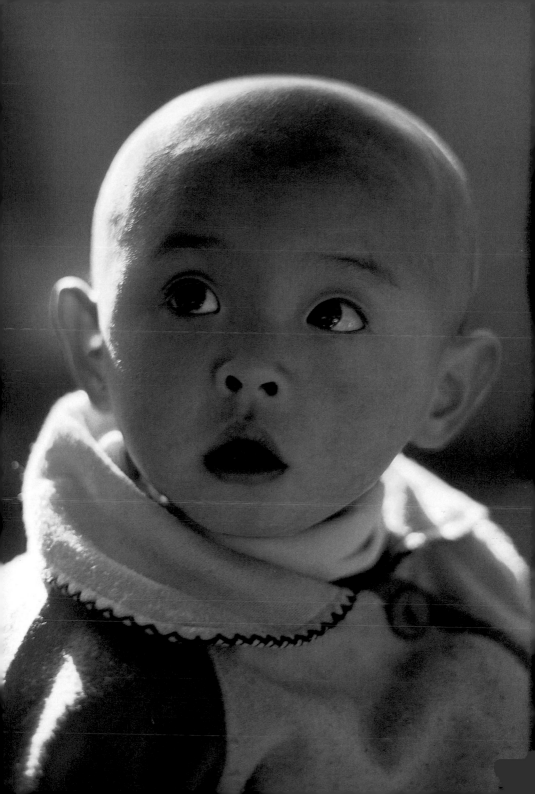

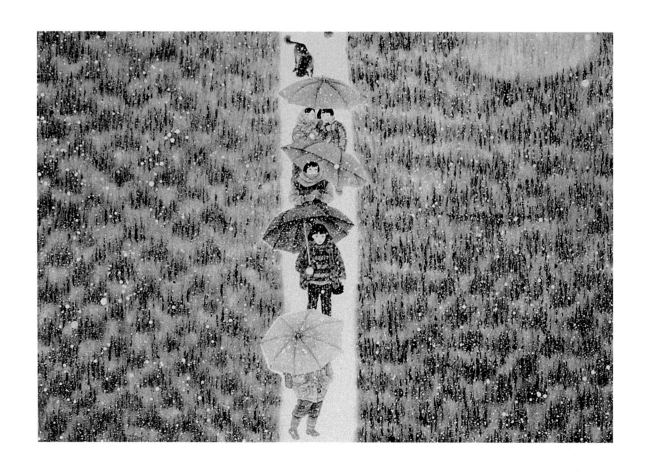

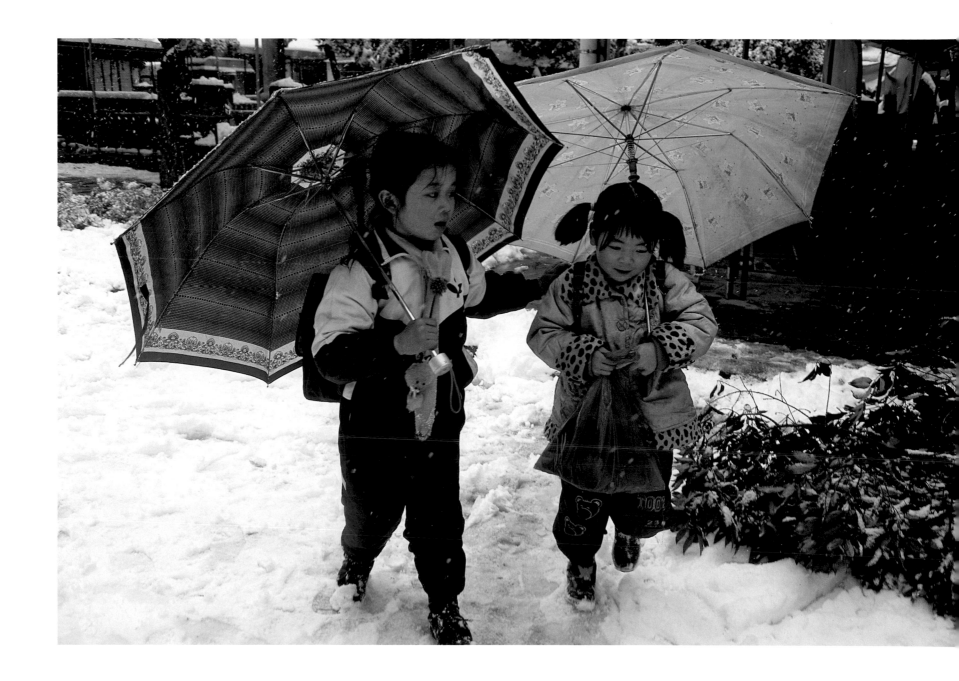

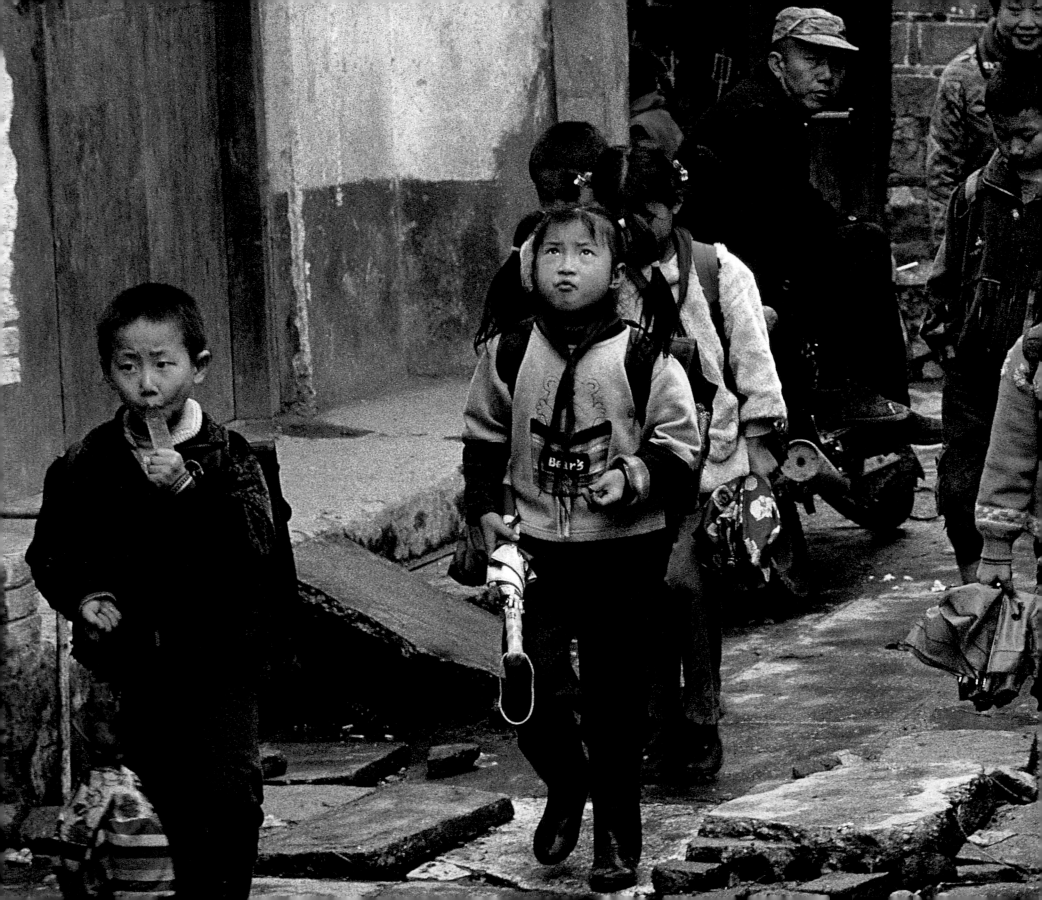

童心

Tung tung tung goes the red drum,
Hu hoa hu goes the green dragon.

Little white chicken, Second Little Brother,
Don't make a fuss and eat up your gruel.

The little black cat is wearing white gloves,
They call him "Coal-Dipped-in-Snow."

Little blue duck, Second Little Brother
Swallow your noodles every one.

The little white cat has huge green eyes,
They call him "Jade-Incrusted-with-Pure-Gold."

Little pot of tea, Second Little Brother
Eat the good rice if you want me to like you.

Tung tung tung goes the red drum,
Hu hoa hu goes the green dragon.

Lullaby from Henan

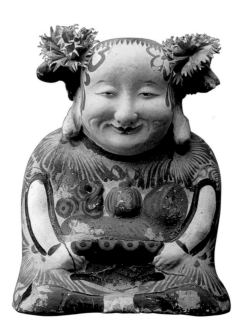

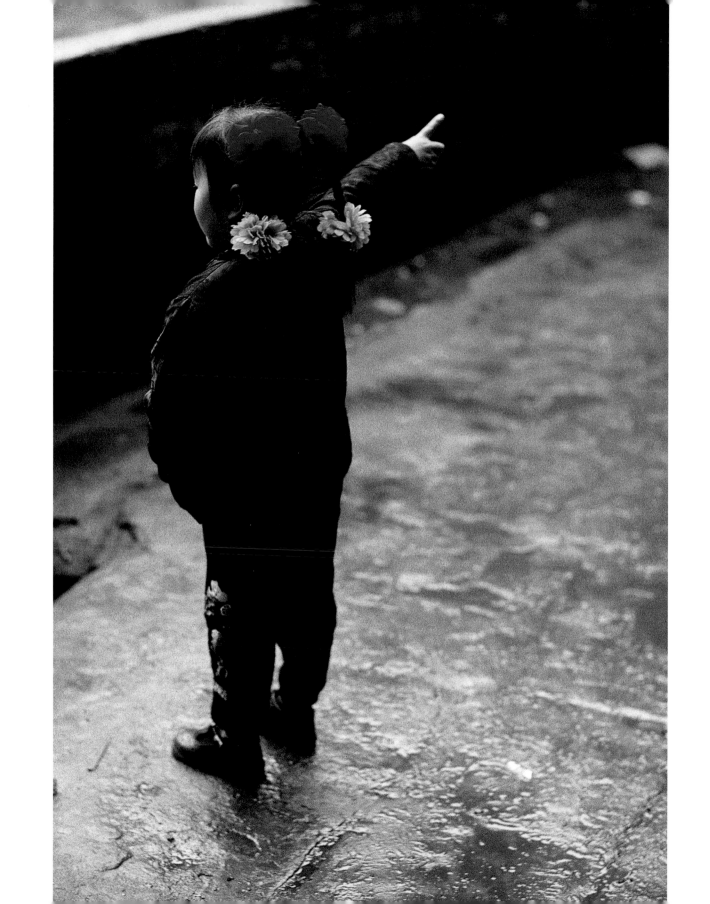

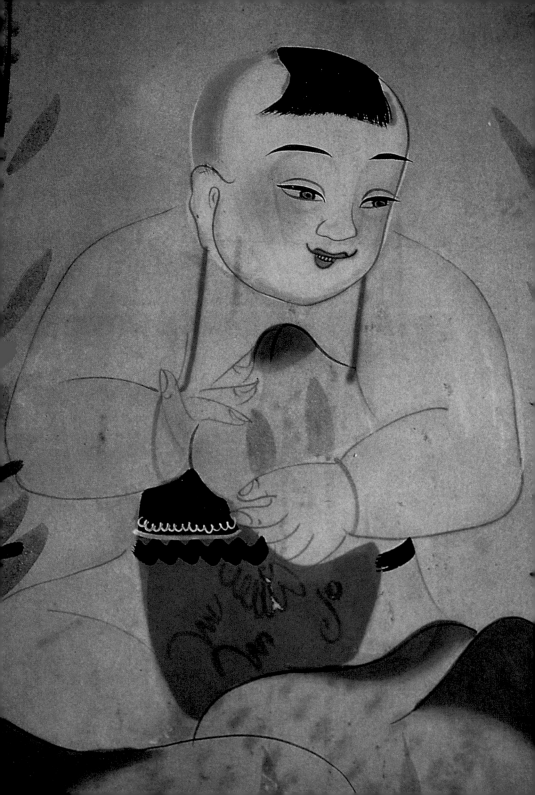

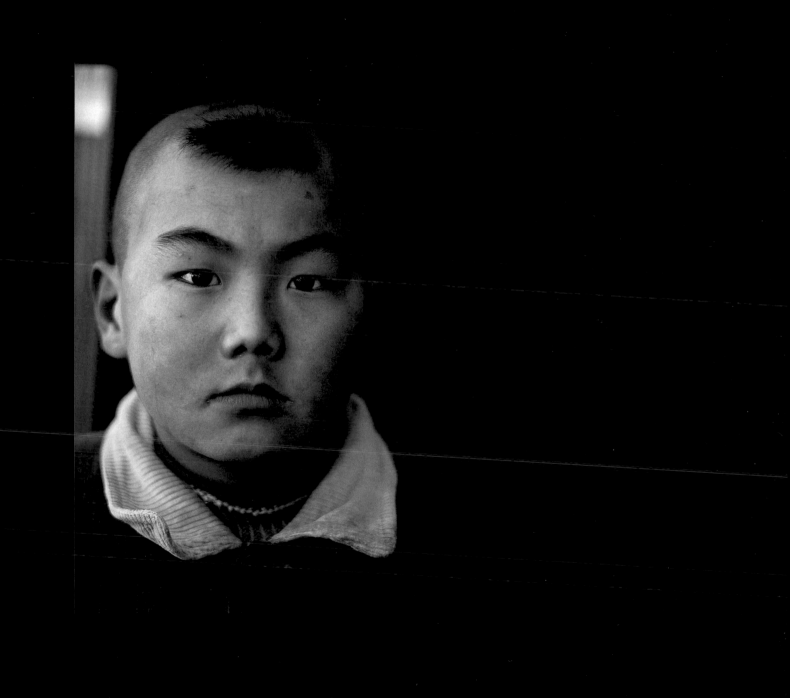

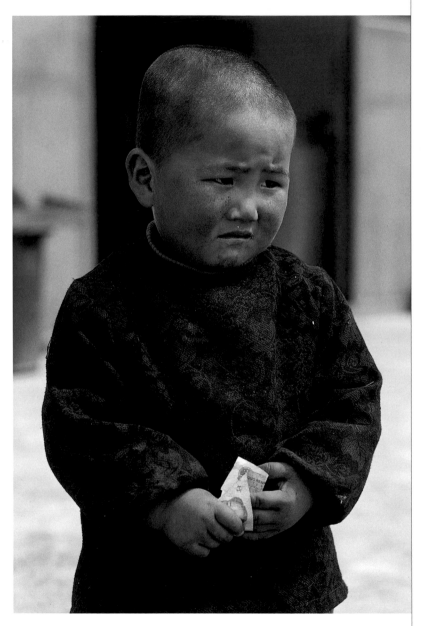

Parents can give their children but two things:
Roots and wings.

Proverb

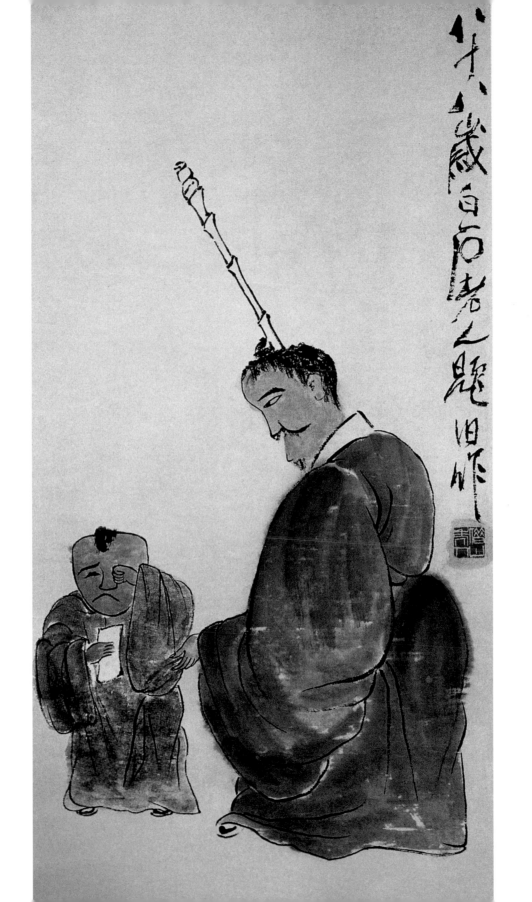

八十六歲白石老人題舊作

FLOWERS AND BIRDS

Once Zhuangzi dreamt he was a butterfly,
a butterfly flitting and fluttering around,
happy with himself and doing as he pleased.
He didn't know he was Zhuangzi.
Suddenly he woke up and there he was,
the solid and unmistakable Zhuangzi.
But he didn't know if he was Zhuangzi
who had dreamt he was a butterfly,
or a butterfly dreaming he was Zhuangzi.

Zhuangzi (Fourth century)

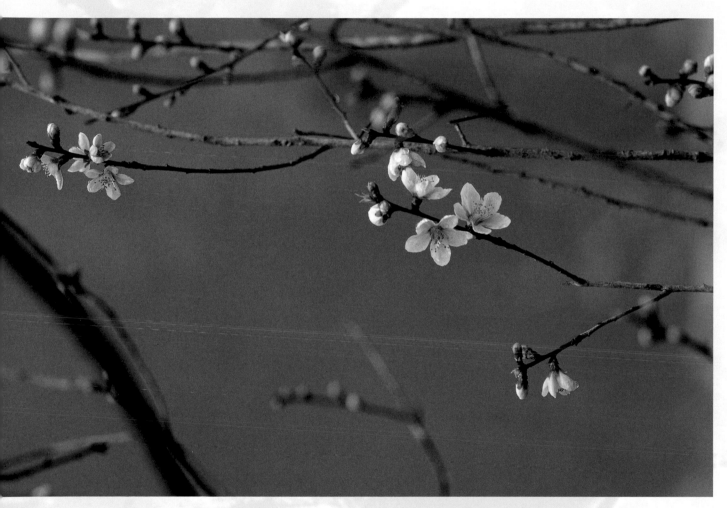

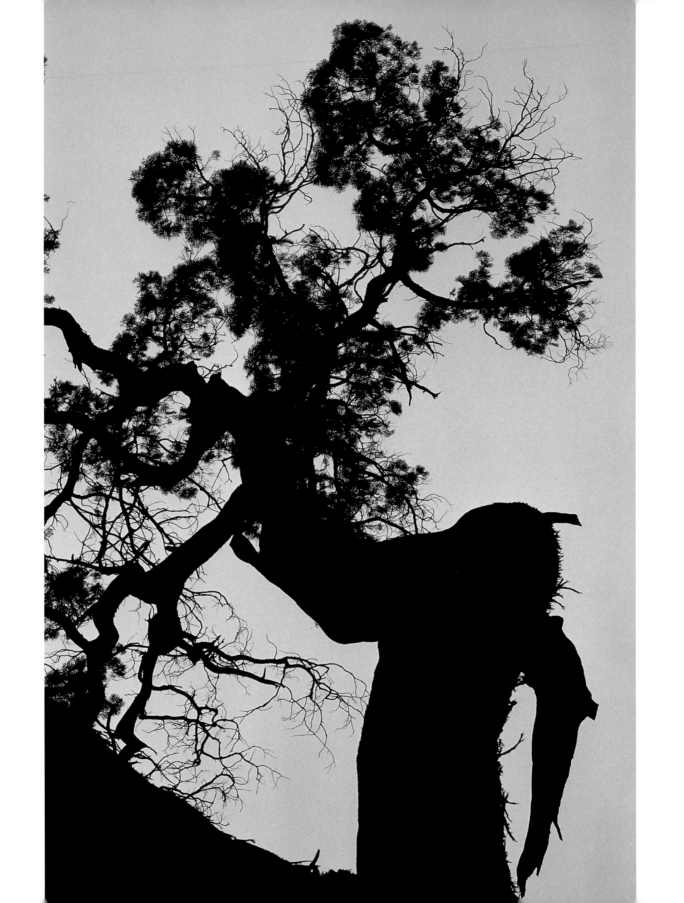

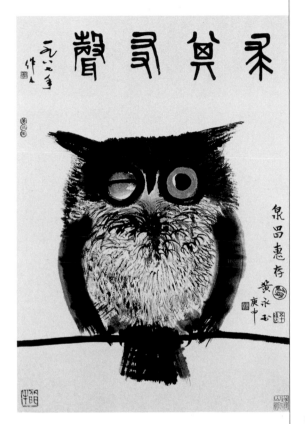

Whatever one plots in the dark
The divine eye sees as if in broad daylight.

Ancient saying

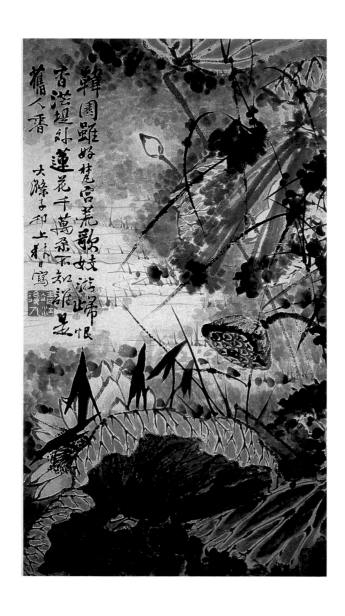

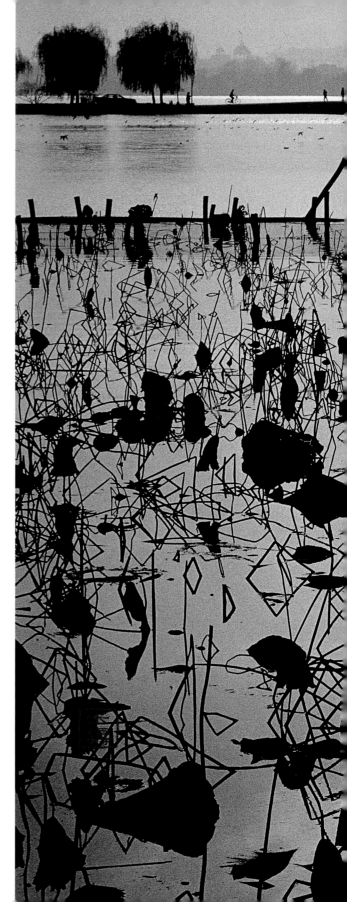

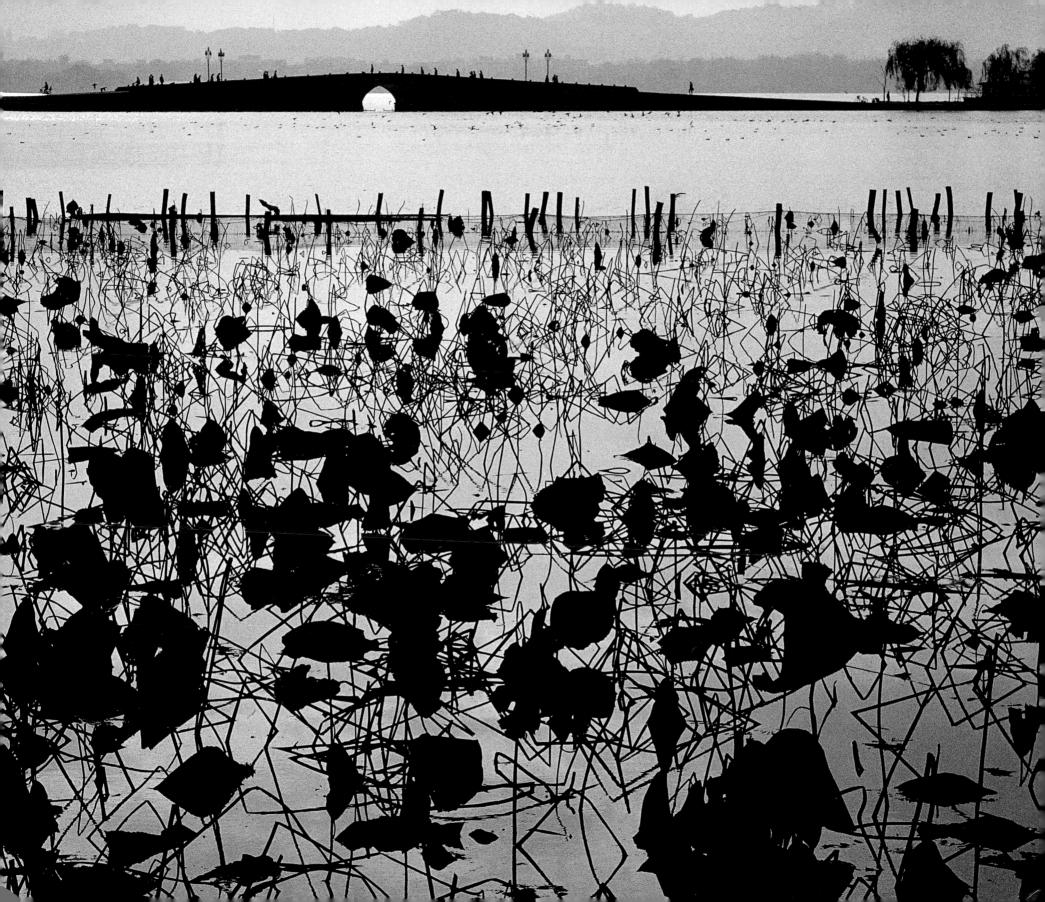

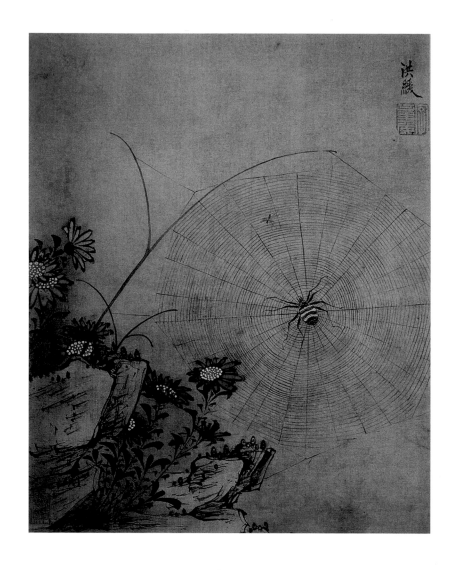

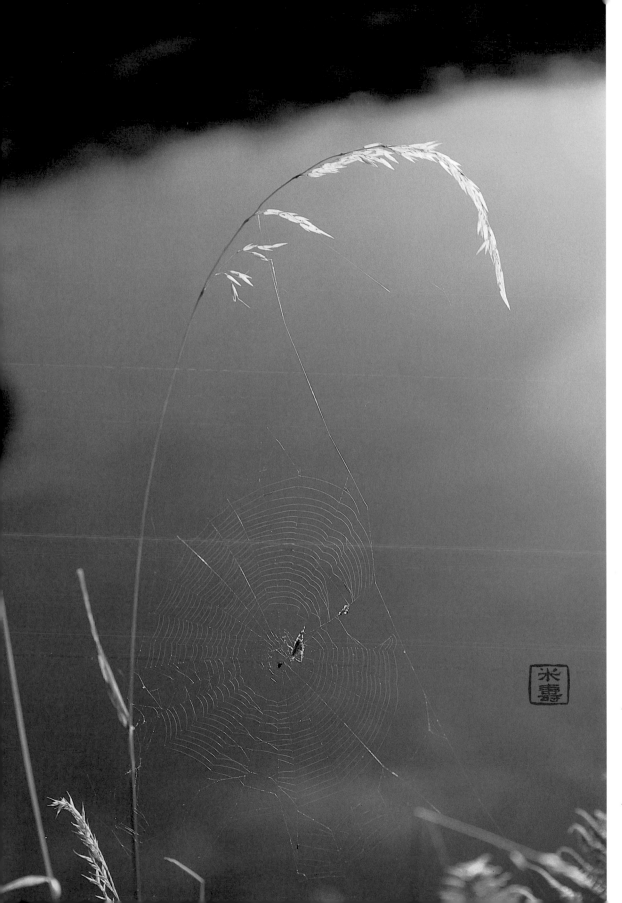

The falling moon
Catches onto the willows
Like a hanging spider.

Su Dongpo (1037–1101)

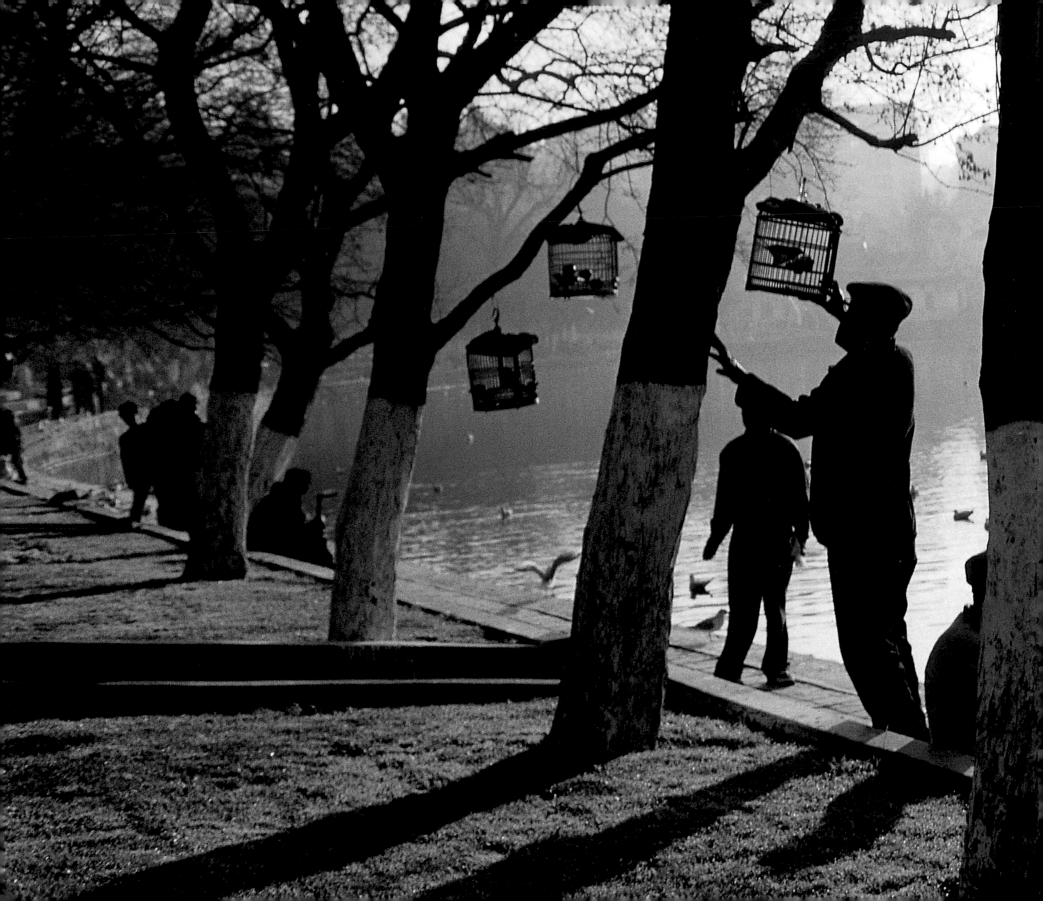

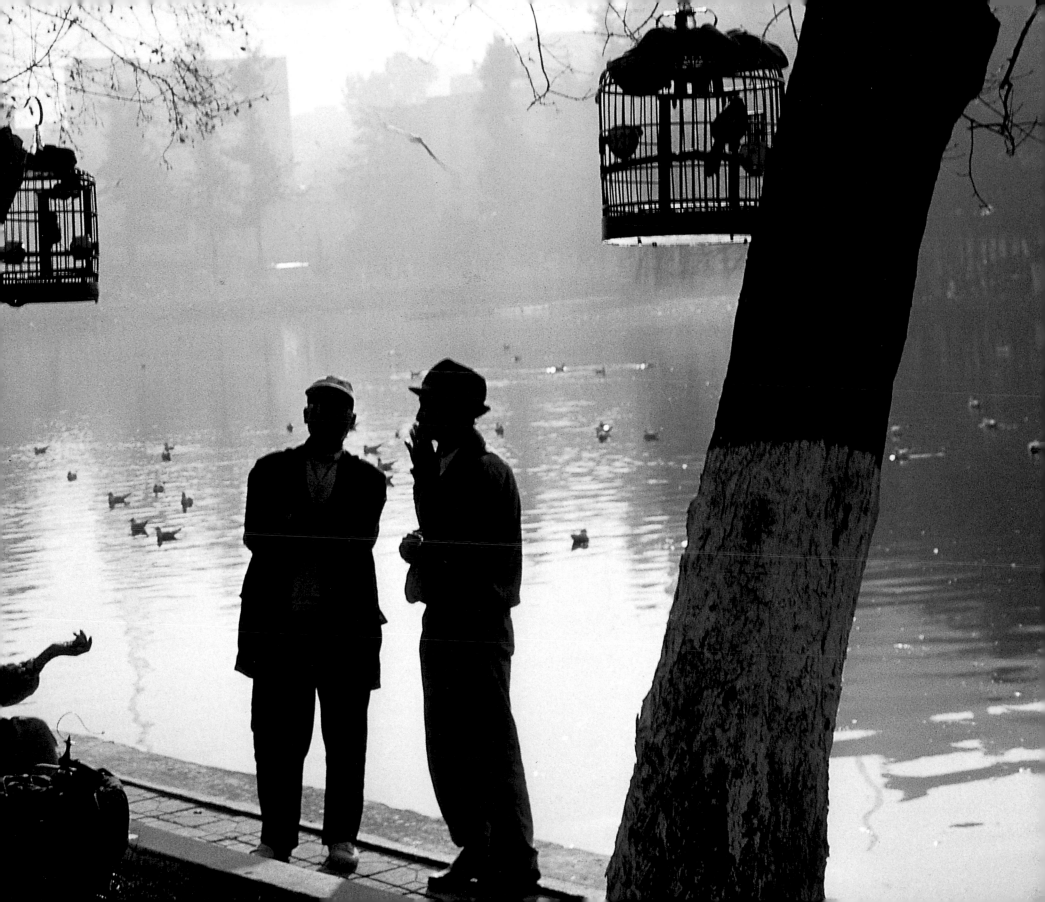

The branch snaps.
The bird opens its wings.

Proverb

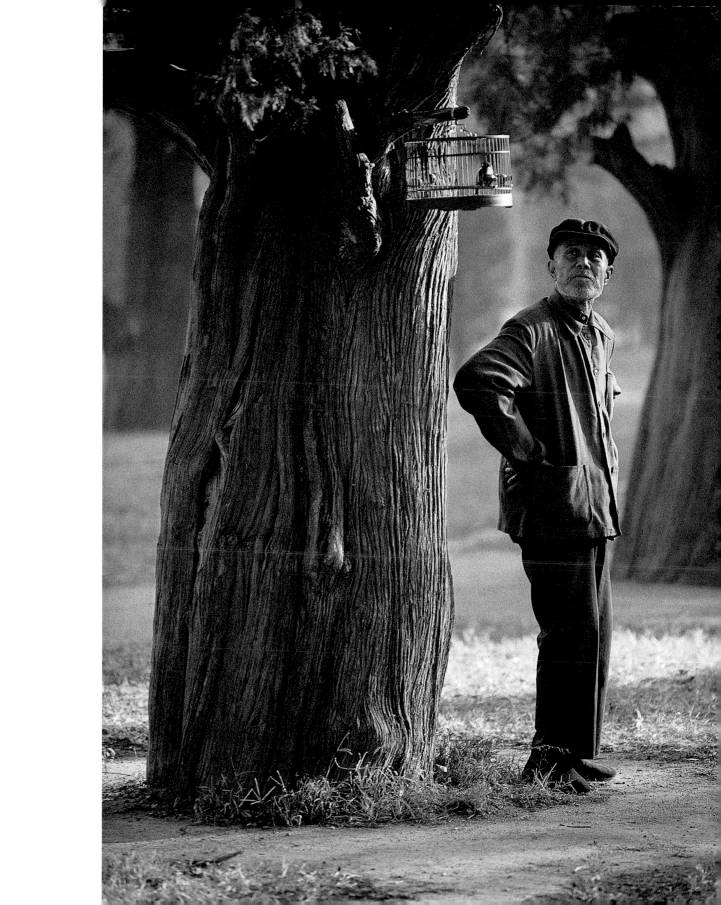

Knotty trunk, upstanding branches
worn smooth by the years.
A heart of emptiness
harks back to ancestral beginnings.

Shitao (1642–1707)

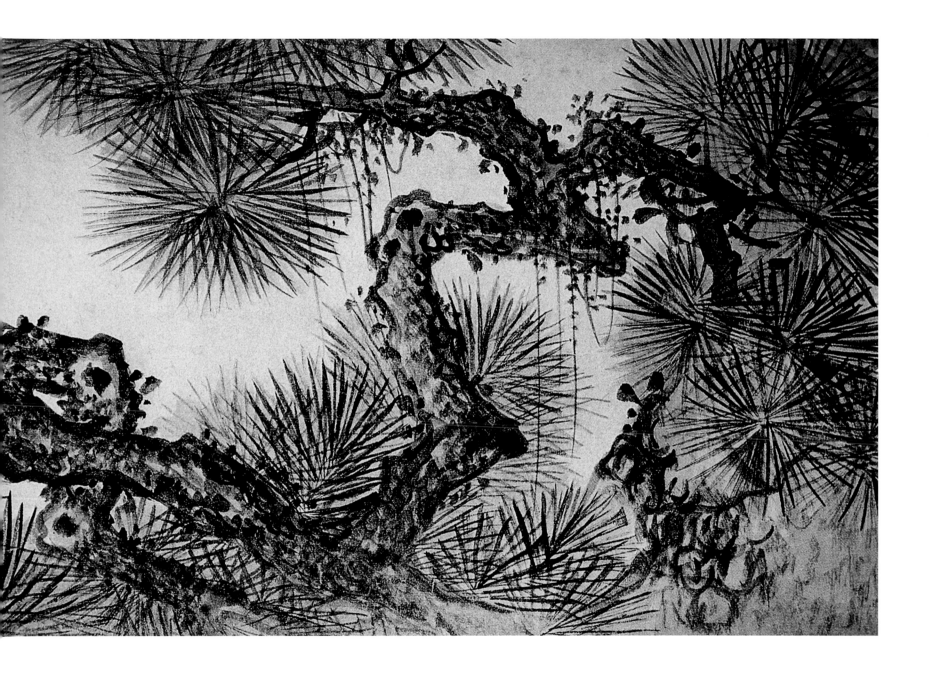

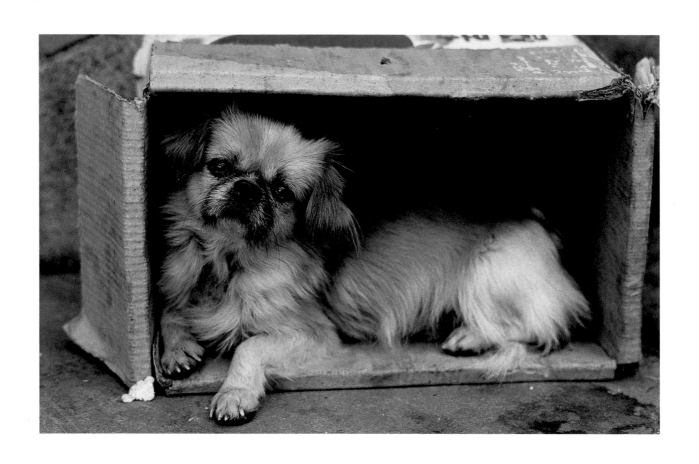

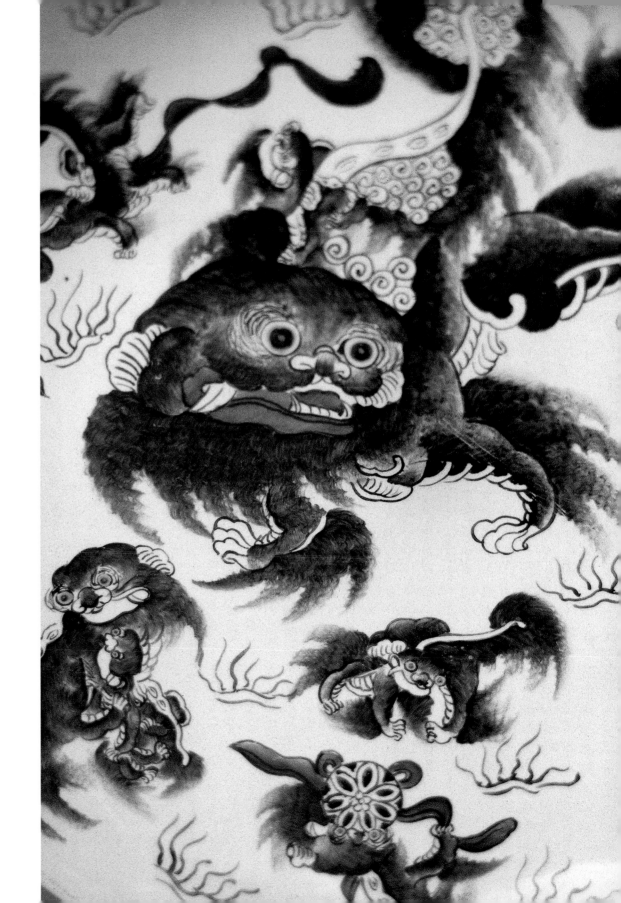

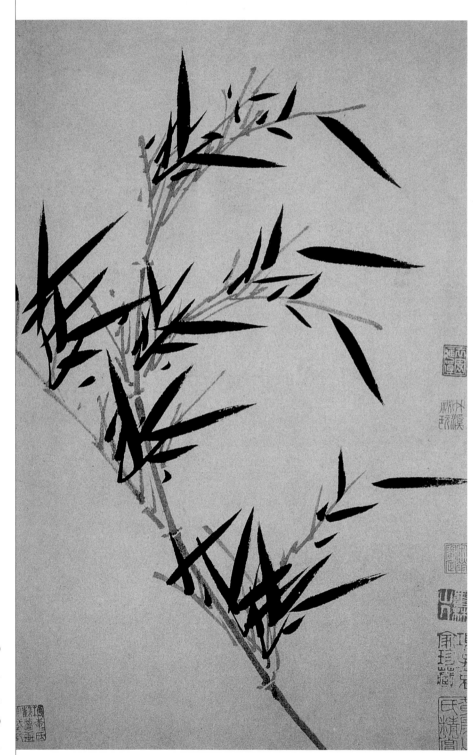

When Yu-k'o painted bamboo
he saw the bamboo but no longer saw himself.
As if possessed, he left off his body,
which turned into bamboo
and sprung without stint into ever fresher shoots.

Su Dongpo (1037–1101)

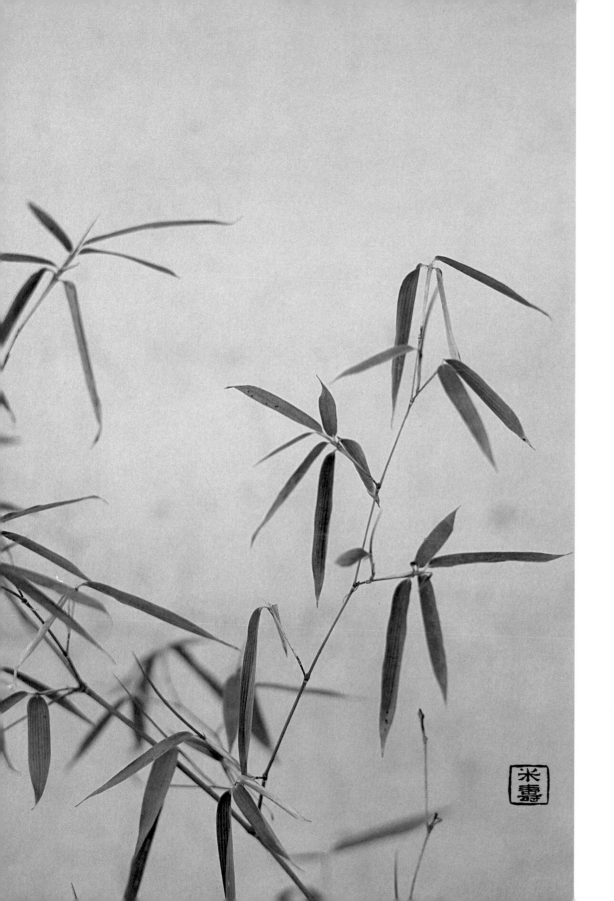

Wild geese
In the bullrushes
Enjoying a chat.

Sa Tou-la (Fourteenth century)

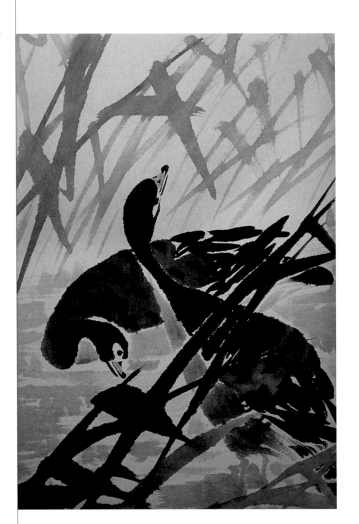

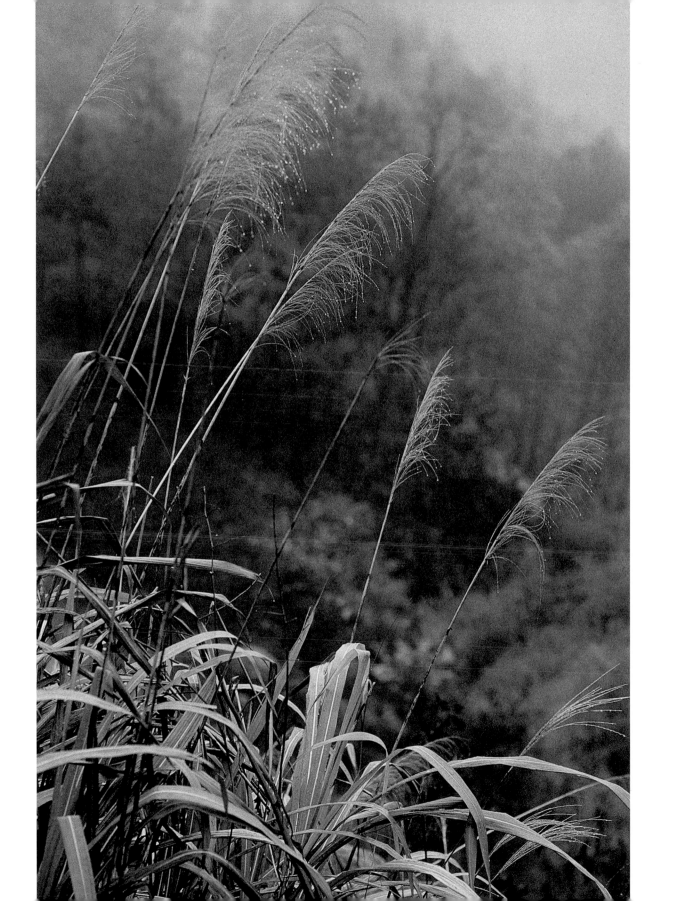

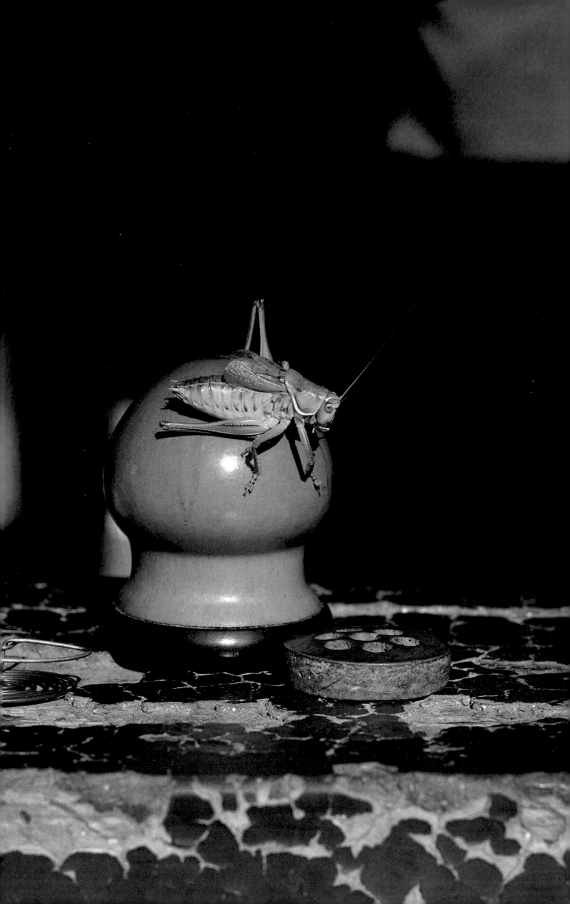

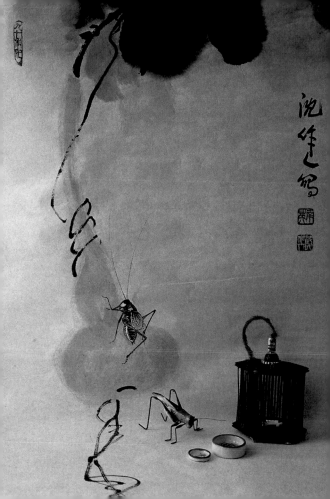

PASTORAL SCENES

Sun-up,
we get to work.
Sundown,
we get our rest.

Dig wells,
and drink,
plow fields to eat.

What has some "emperor"
to do with us.

Anonymous (c. 2300 BCE)

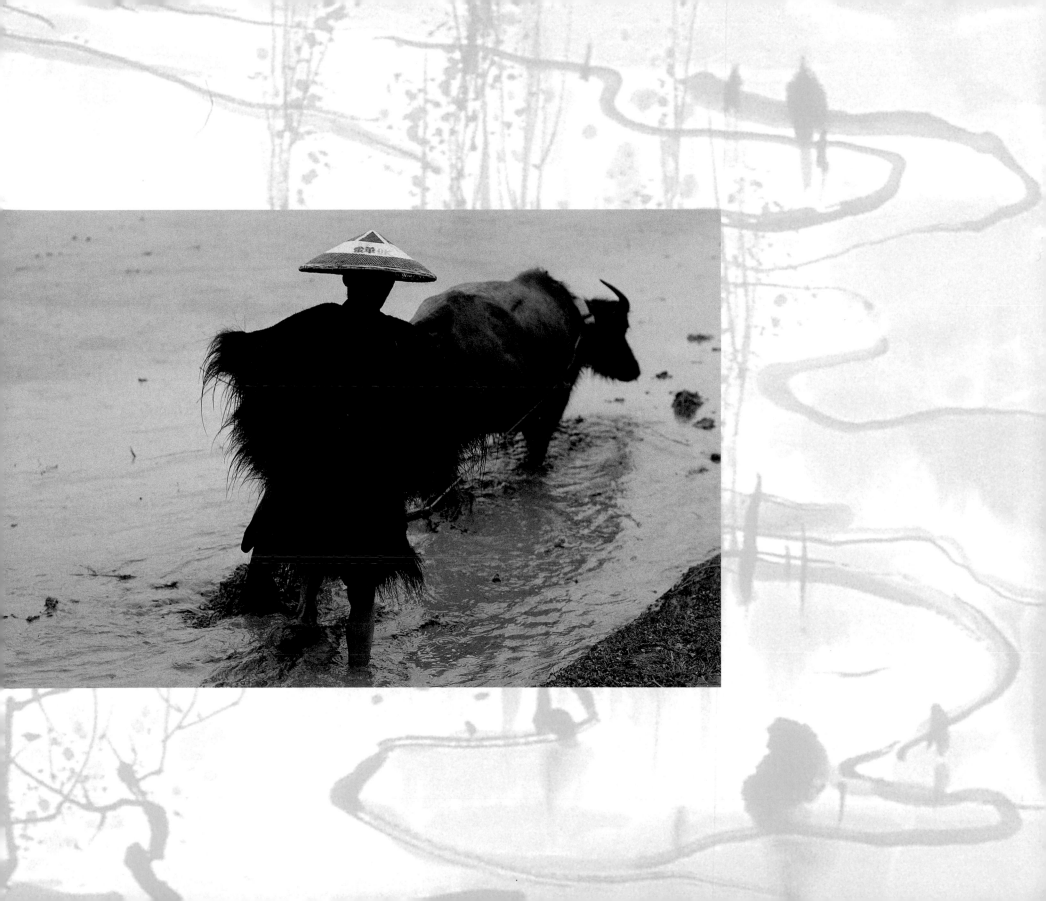

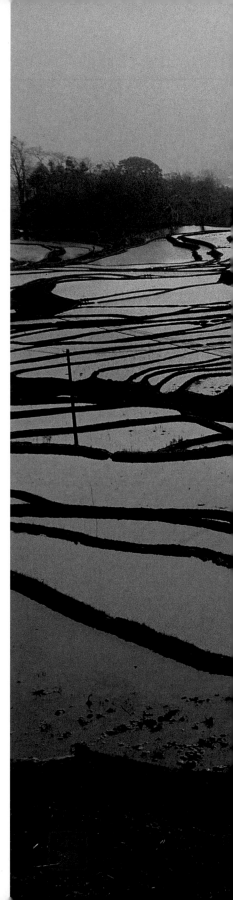

Paddy-fields ringed by levees
mirrors of many shapes.
And above a few stars
linger.

Tang Chi (Twentieth century)

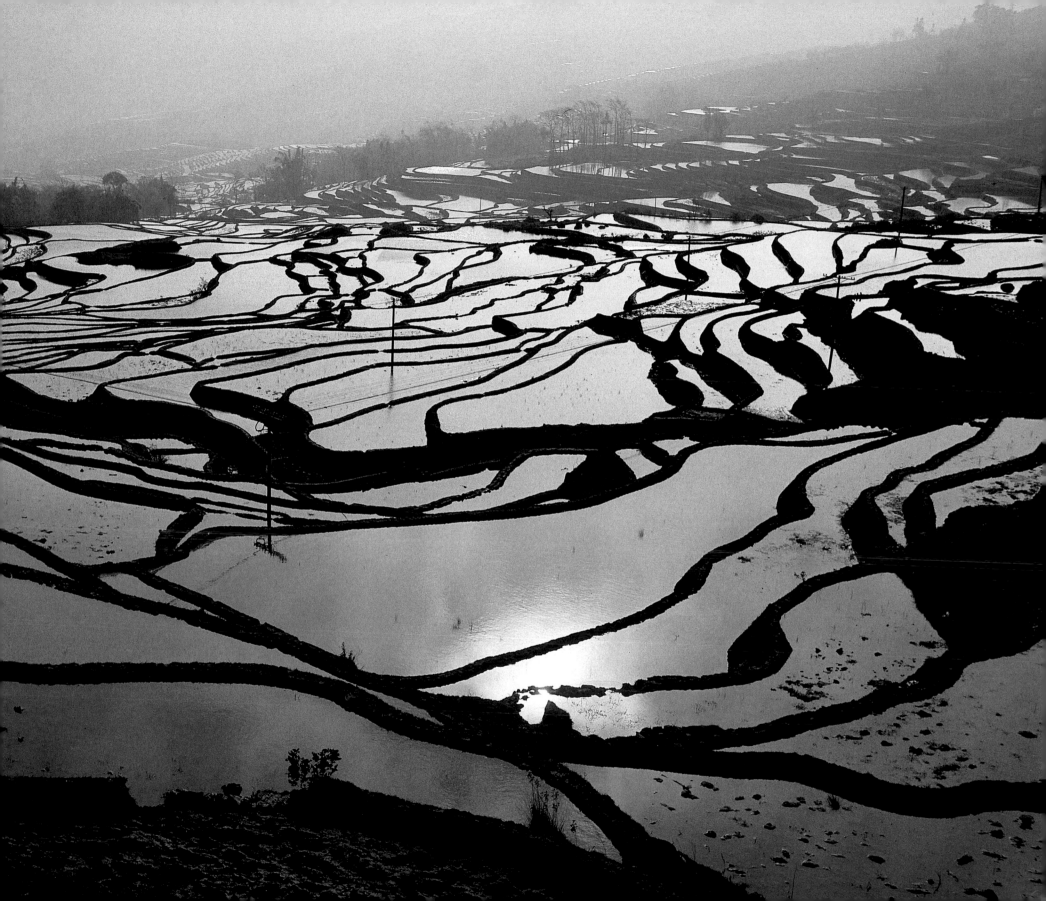

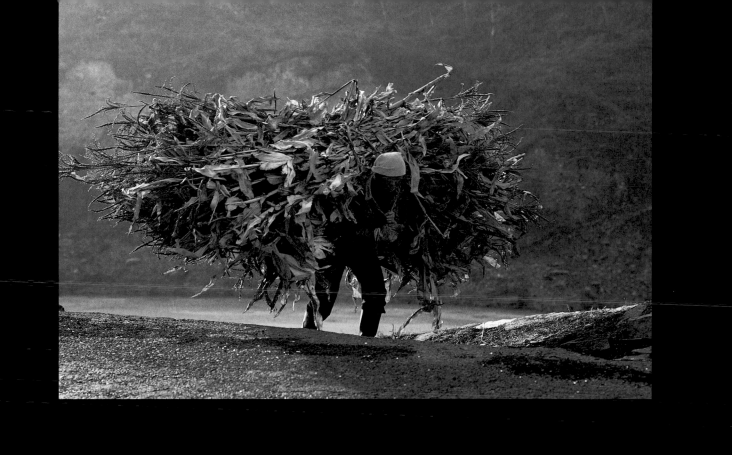

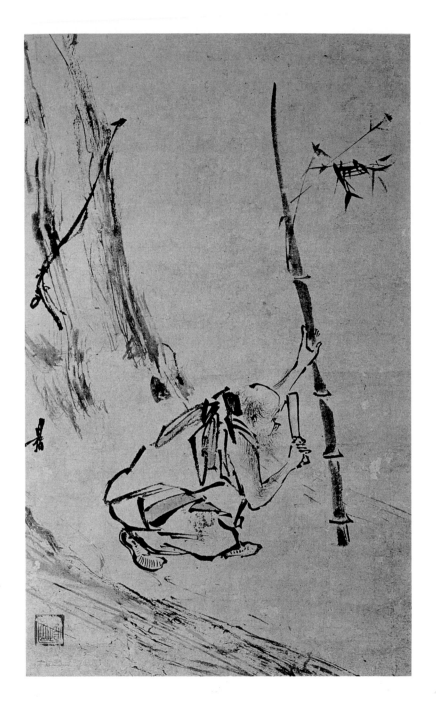

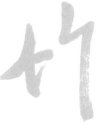

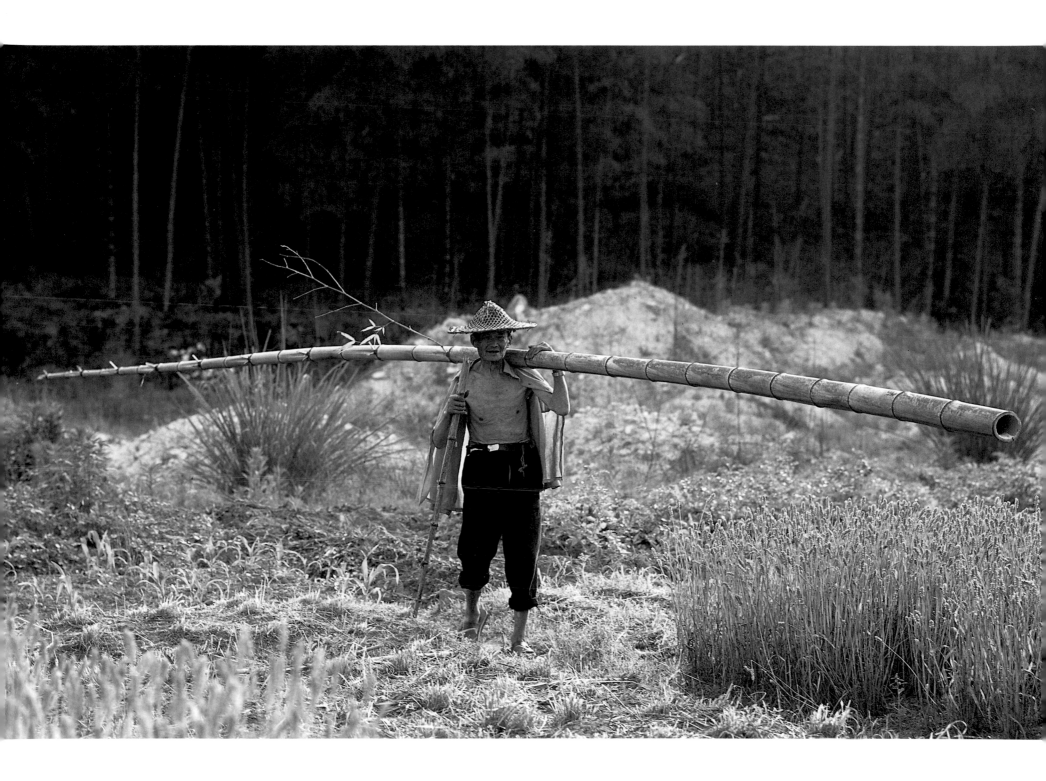

Without hair without a hat
nowhere could I find refuge and hide.
All that's left for me to do
is to turn into that man in the picture
carrying his fishing-rod,
lost among the waterlogged rushes,
where, boundless, the earth and sky
are as one.

Shitao (1642–1707)

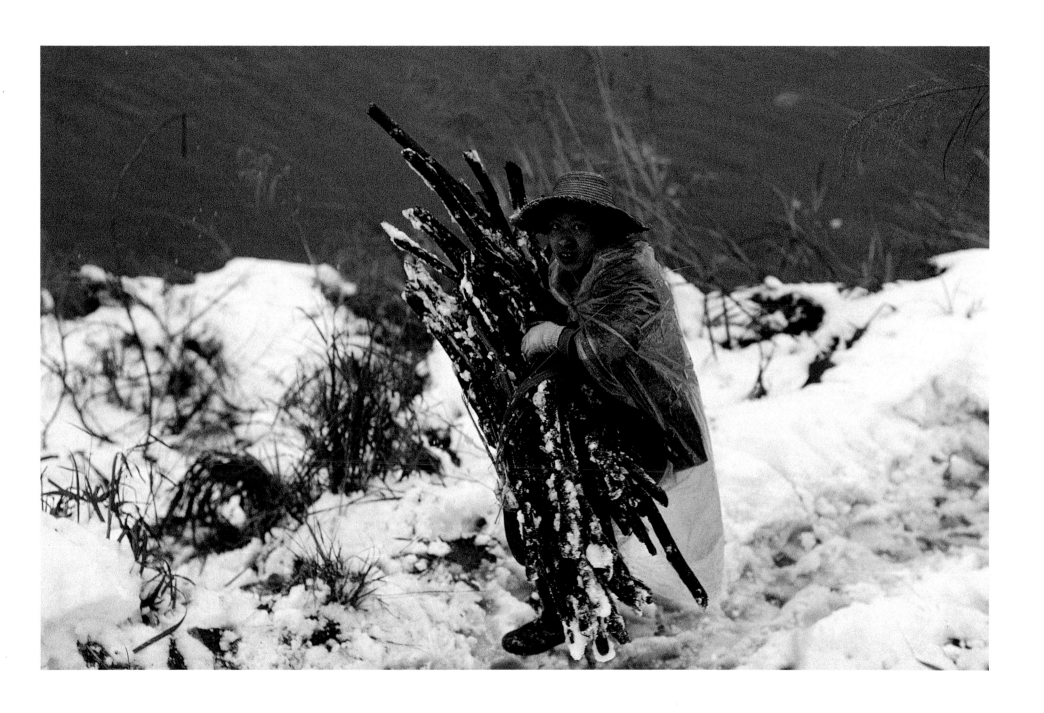

If you want to be happy for a day
get drunk.
If you want to be happy for a month
get married.
If you want to be happy for a year
kill the pig.
If you want to be happy your whole life long
become a gardener.

Proverb

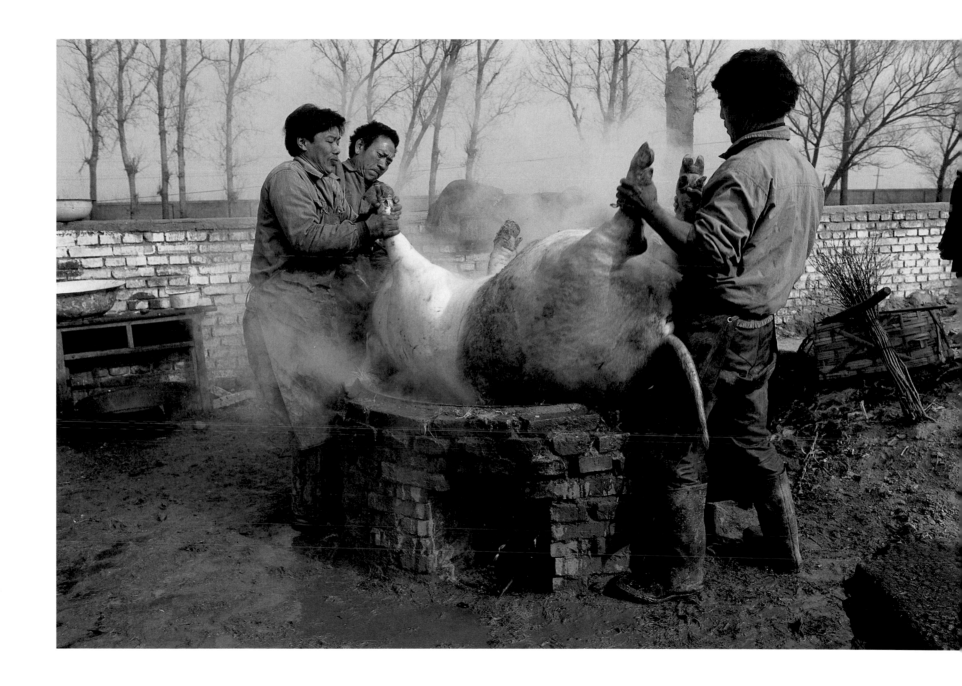

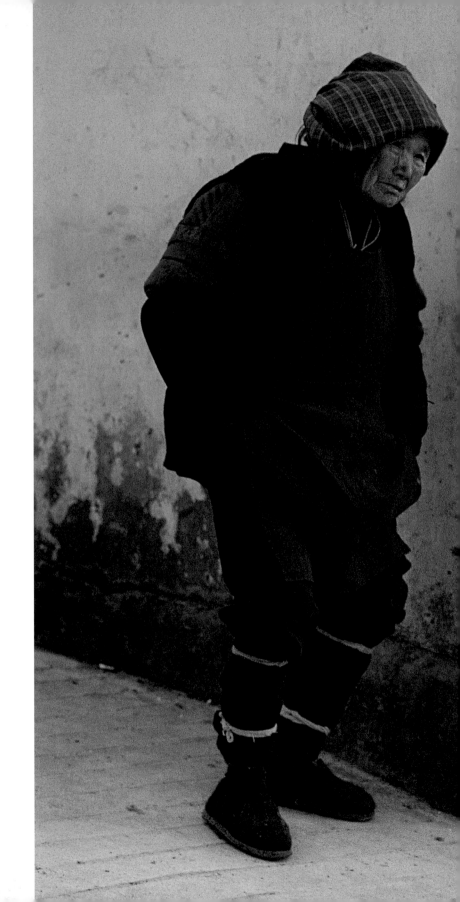

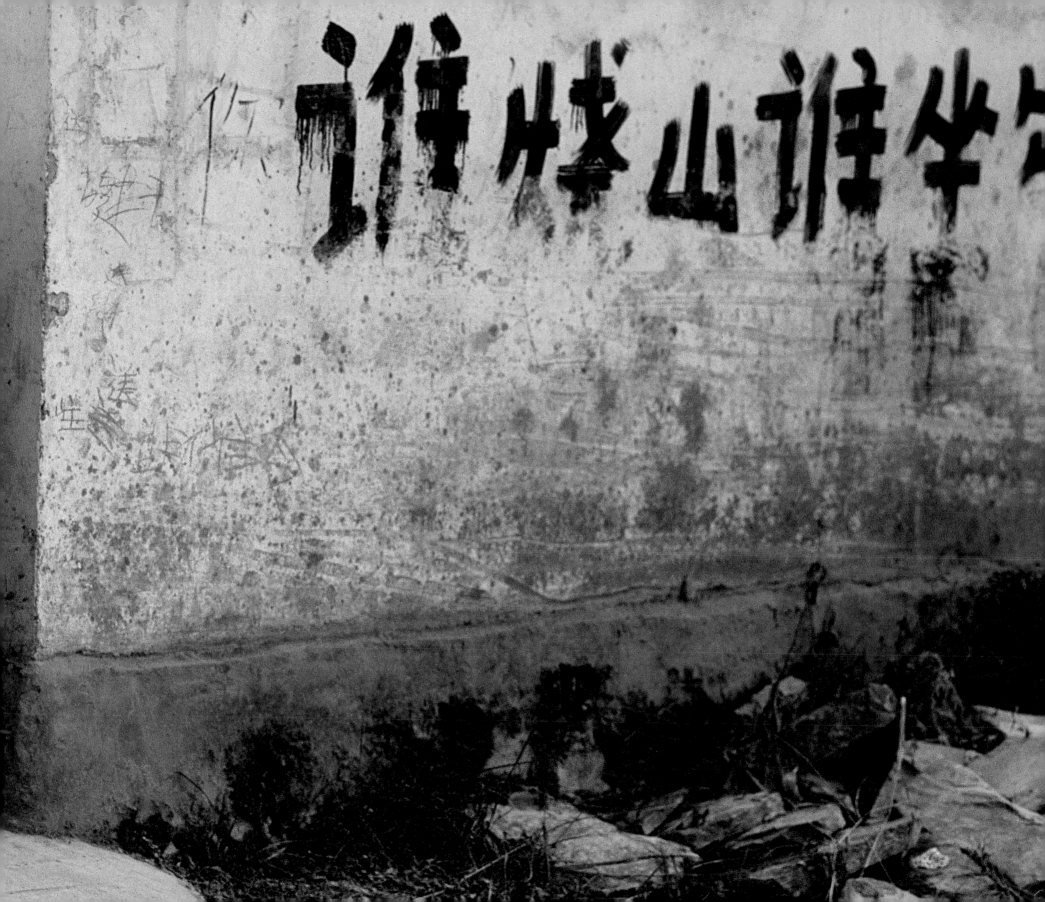

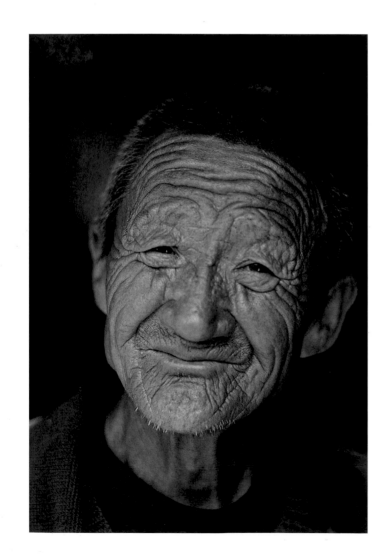

黄土地

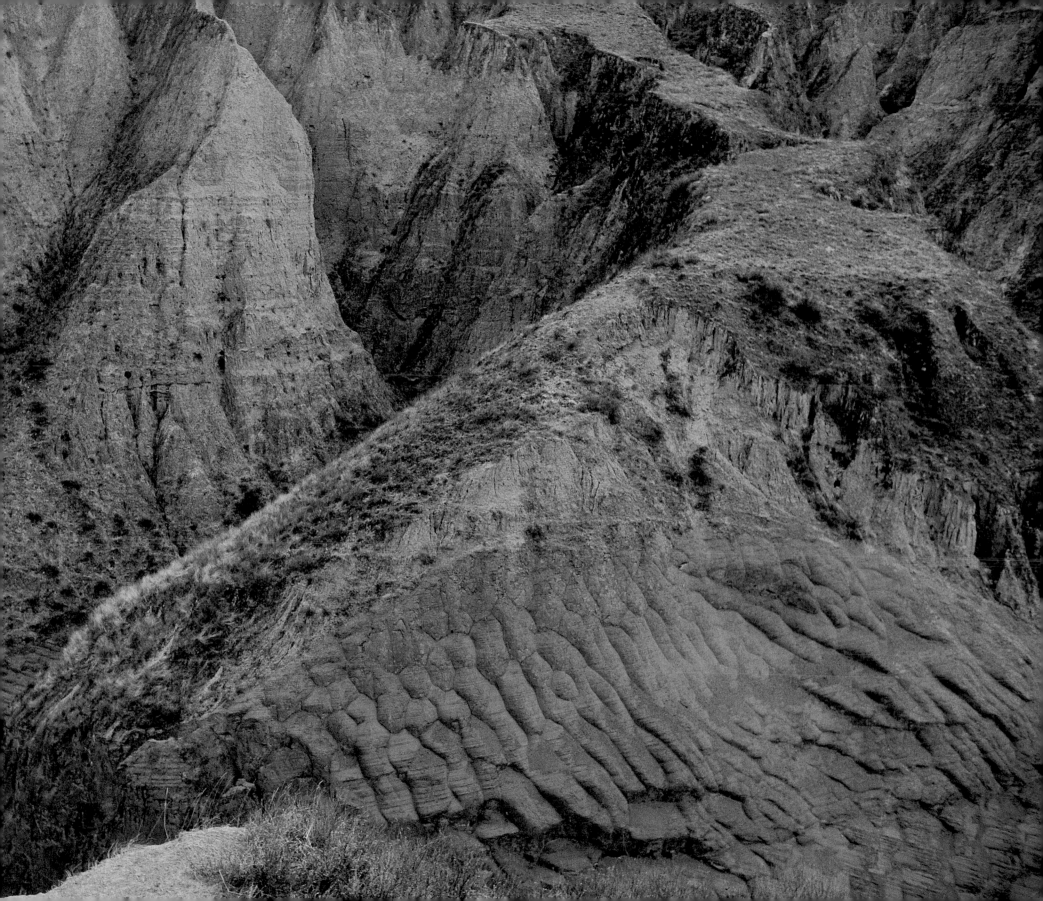

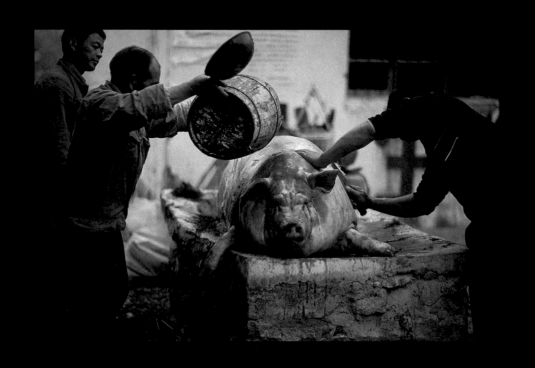

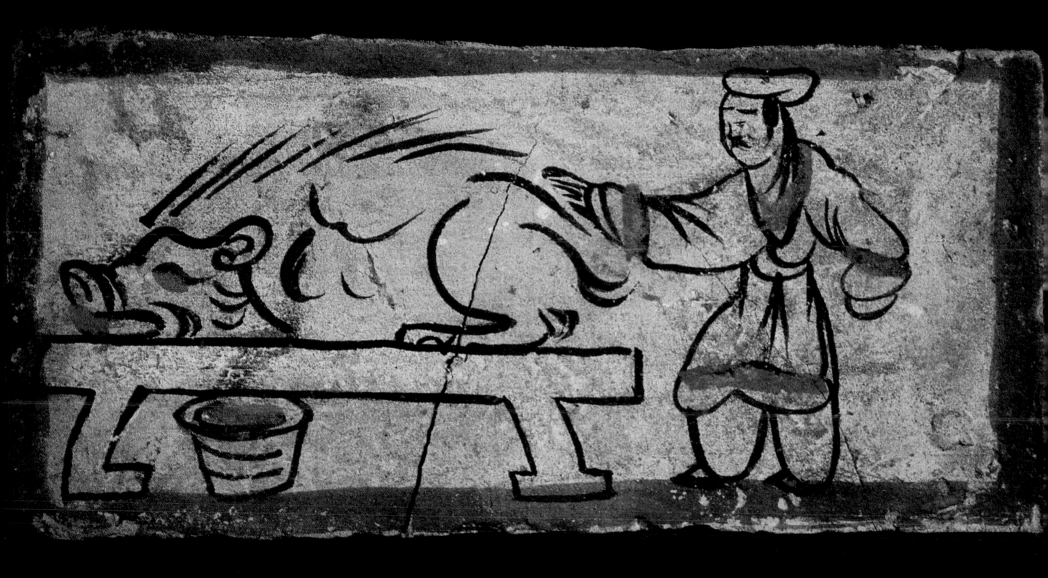

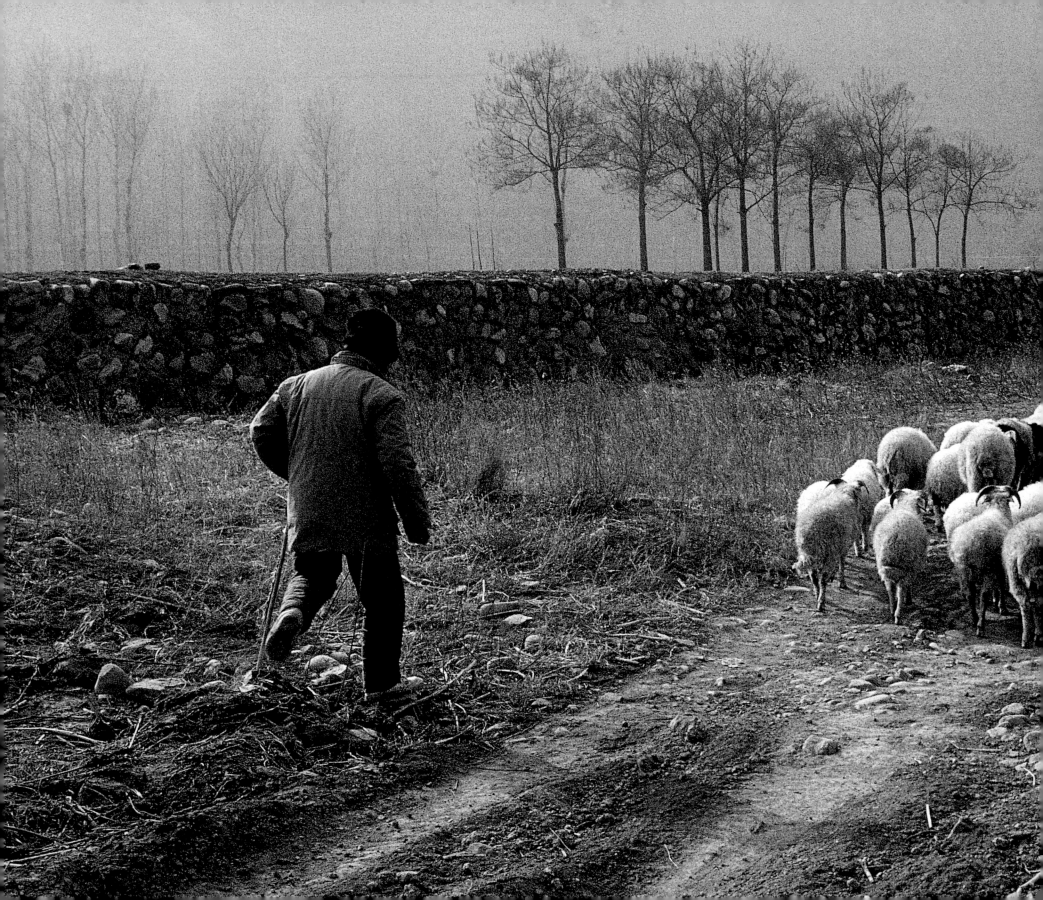

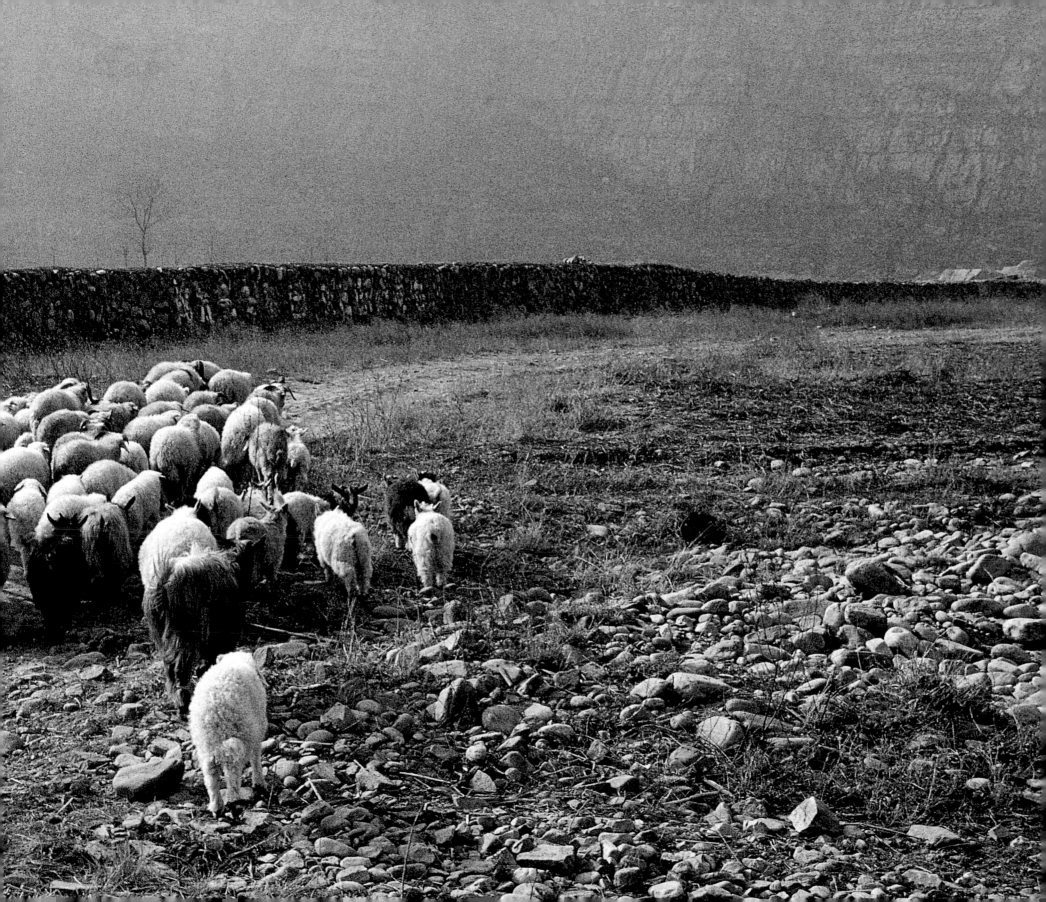

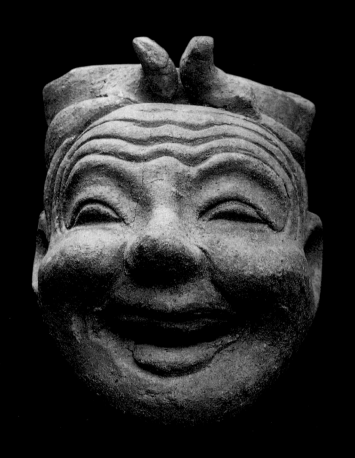

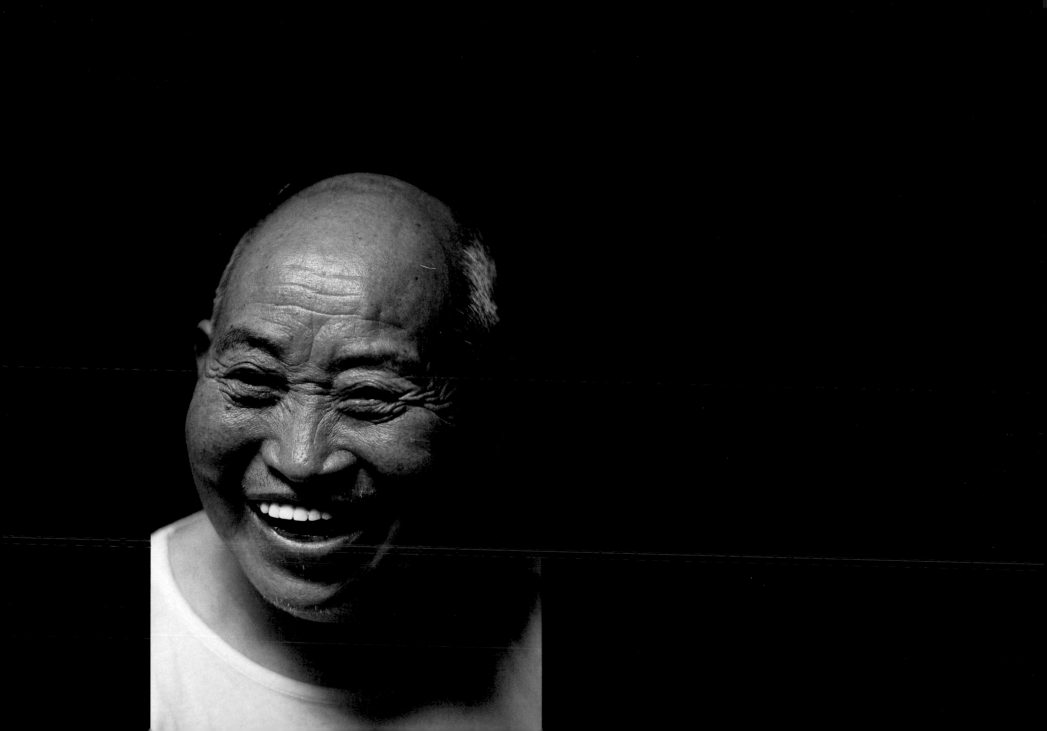

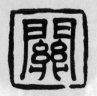

WALLS AND DRAGONS

Snow

Landscape of the North.
One hundred leagues locked in ice,
ten thousand leagues of swirling snow
and to both sides of the Great Wall,
a single white immensity.

Mao Zedong (1893–1976)

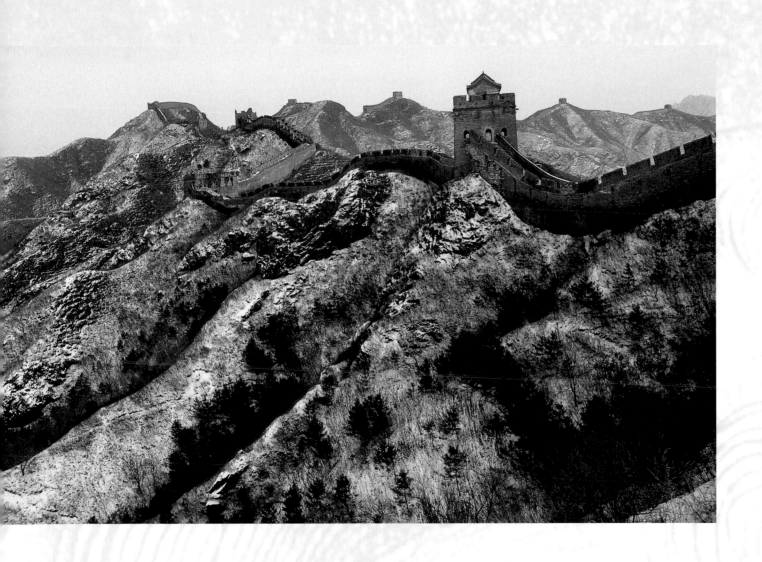

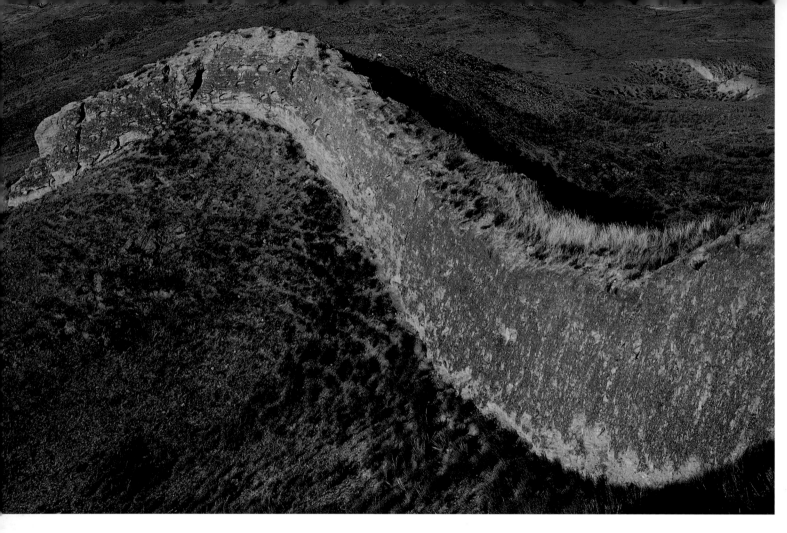

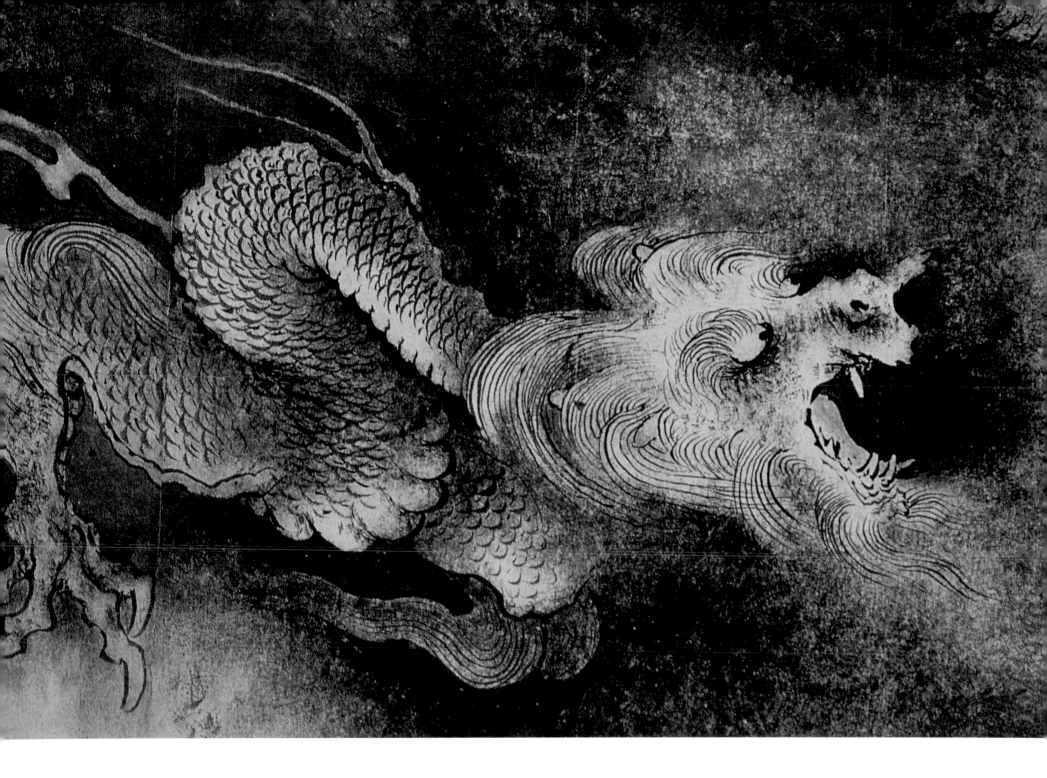

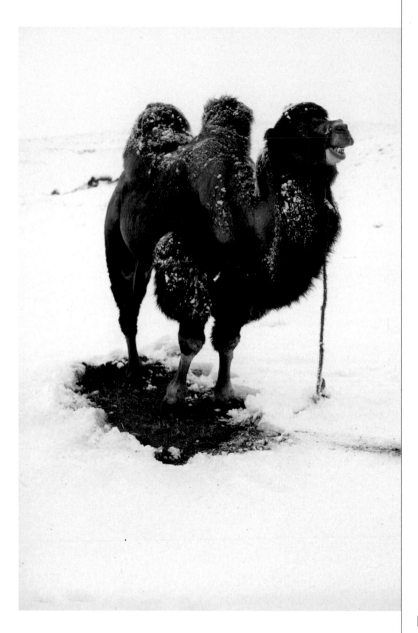

For the cold sands of the desert
I left the high passes.
Camels whinny in the night
aging in the yellow mist.

Chen Fu (1240–1303)

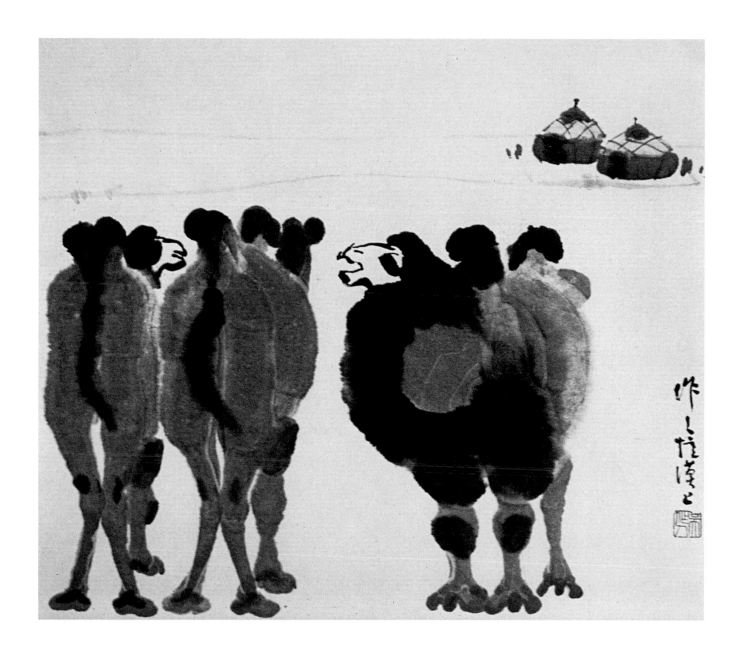

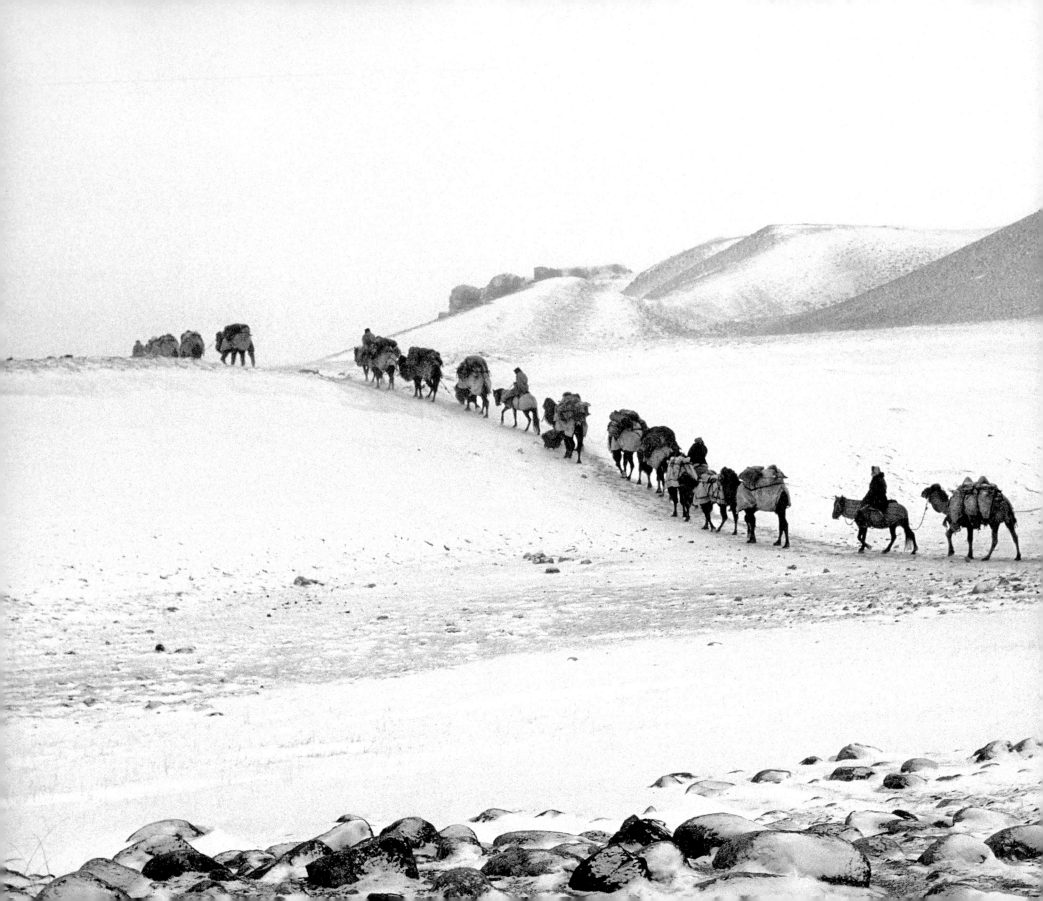

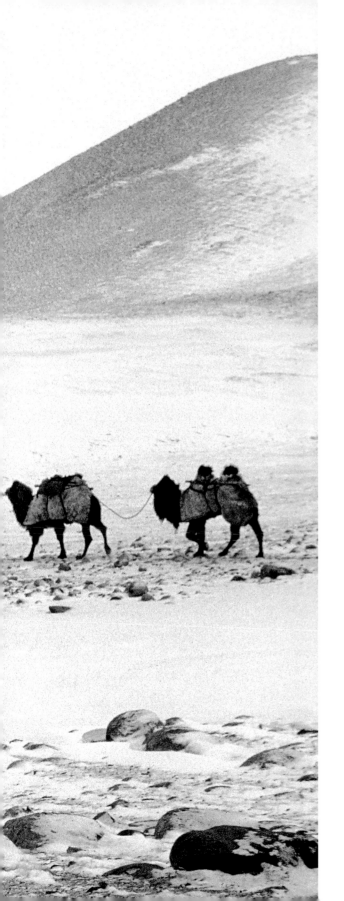

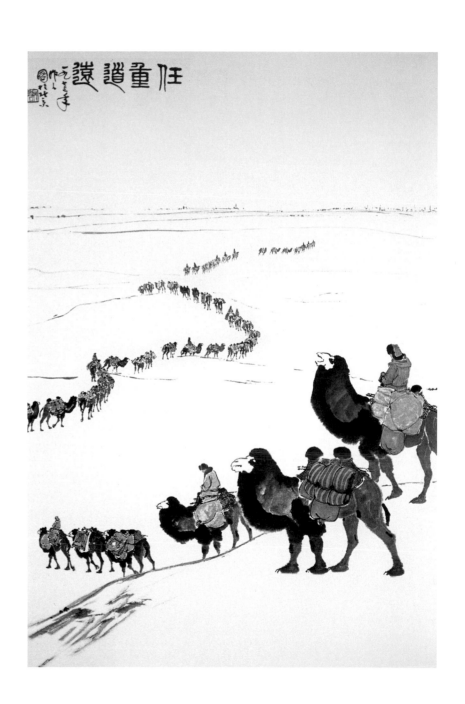

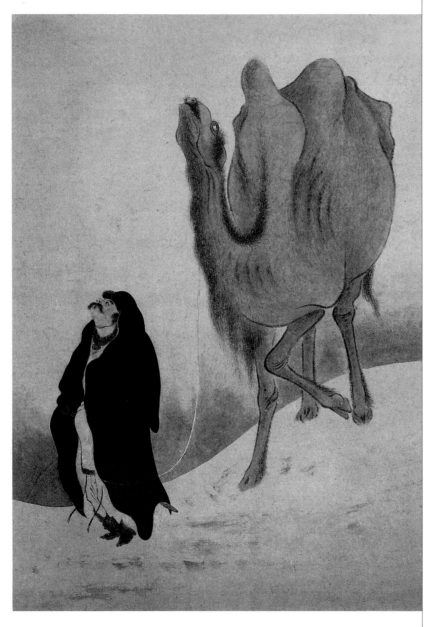

Camel, my friend,
Kneel down
A yellow tortoise
Is your elder sister.

Camel, my friend,
Greet her nicely:
A black tortoise
Is your goodly wife.

Camel, my friend,
Snuffle thrice:
A blue tortoise
Is your sister-in-law.

Nursery rhyme from Hebei

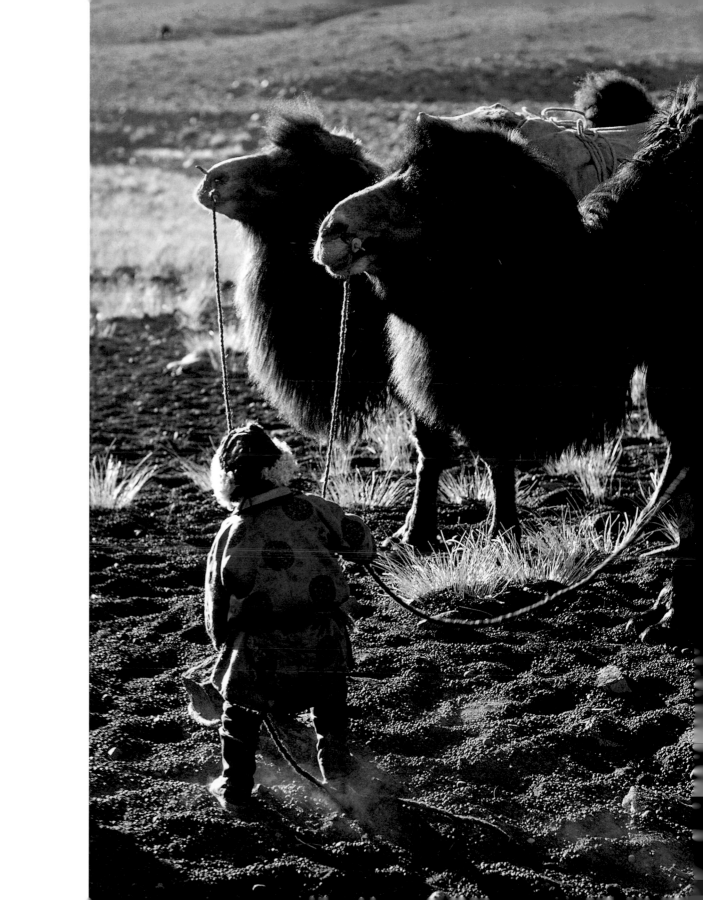

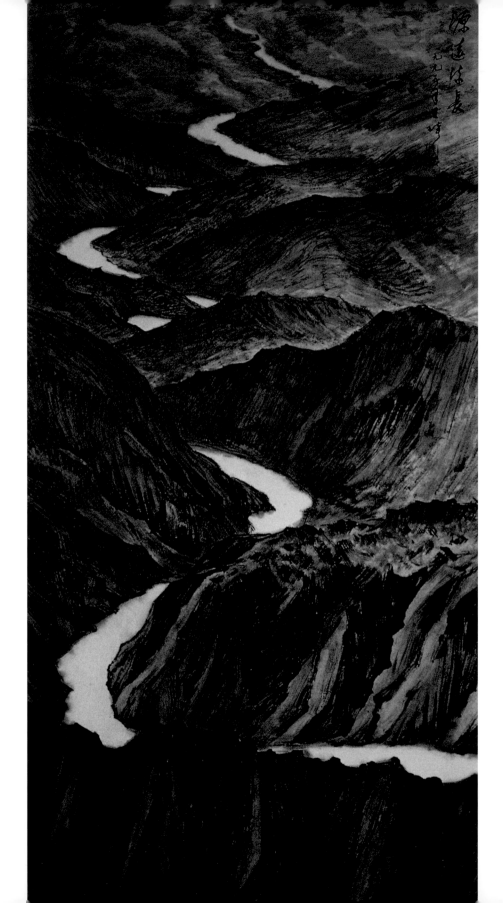

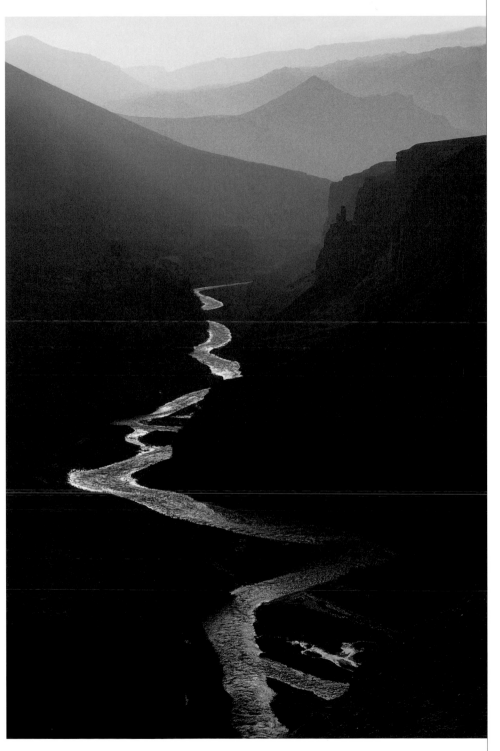

I see nothing else but the Great River
that flows on until it meets the sky.

Li Bo (701–62)

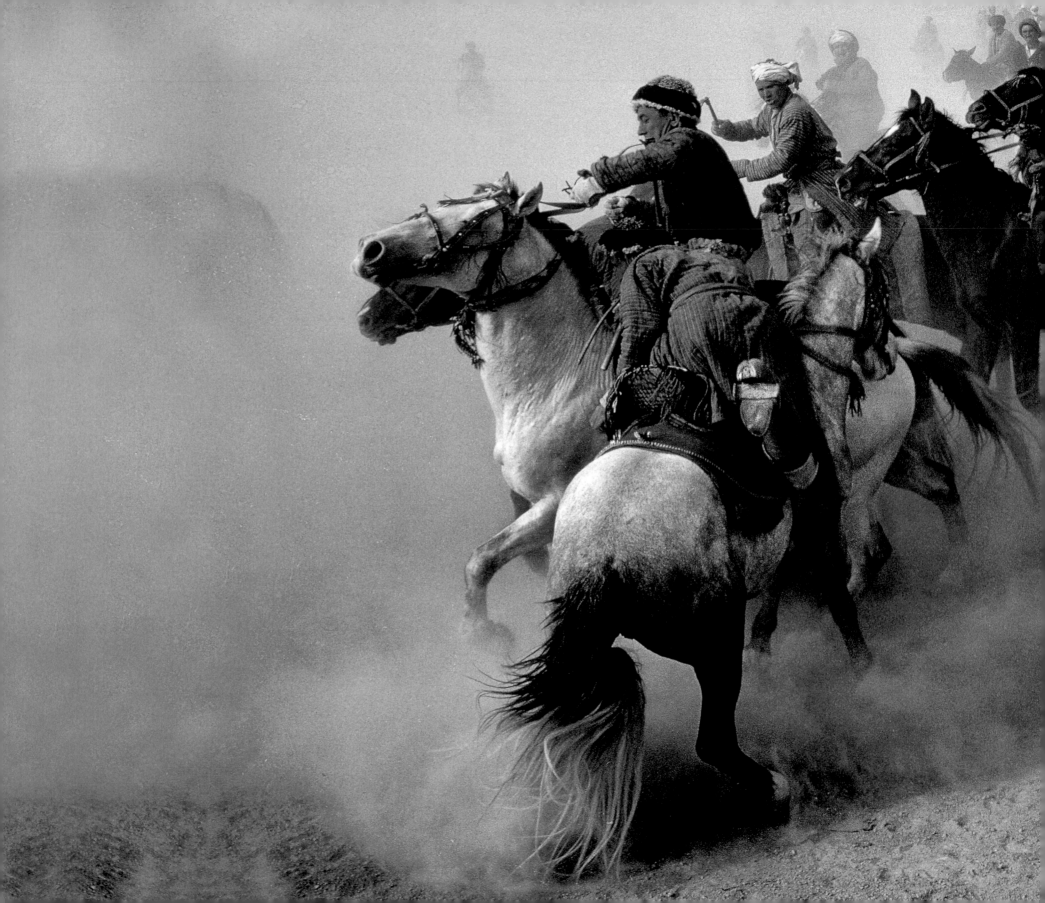

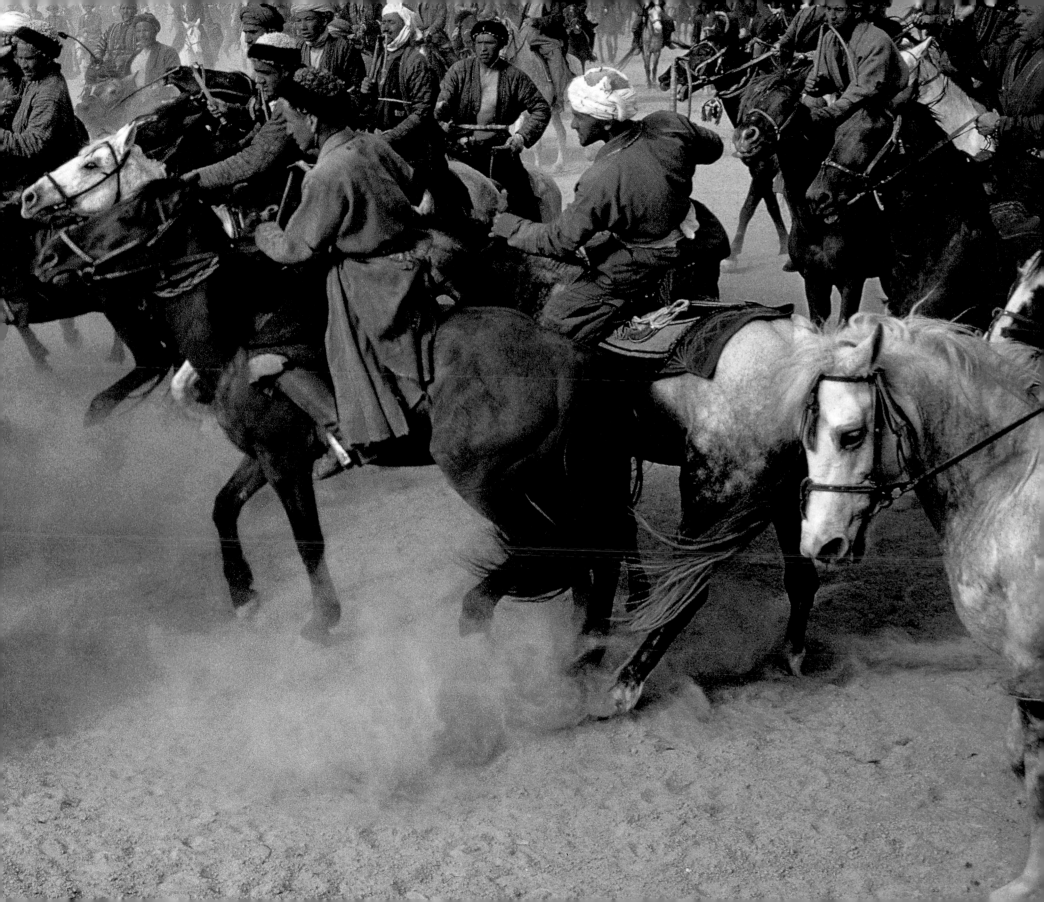

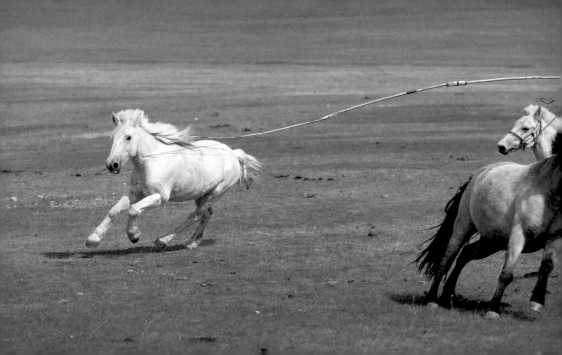

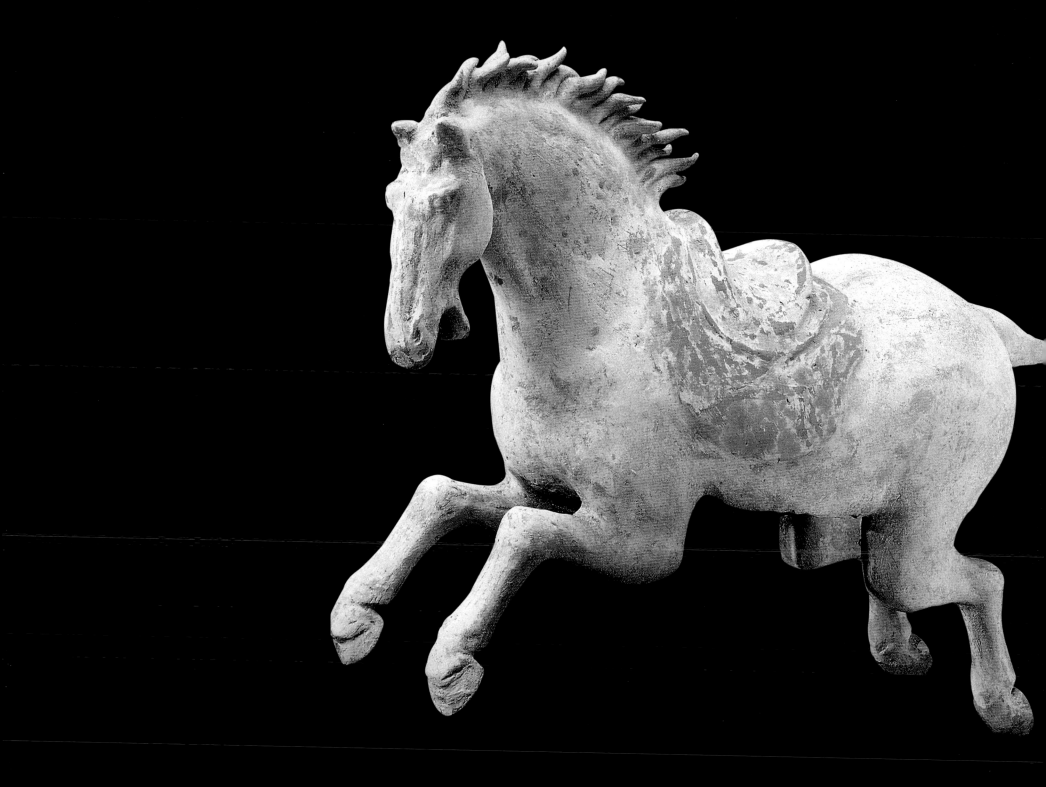

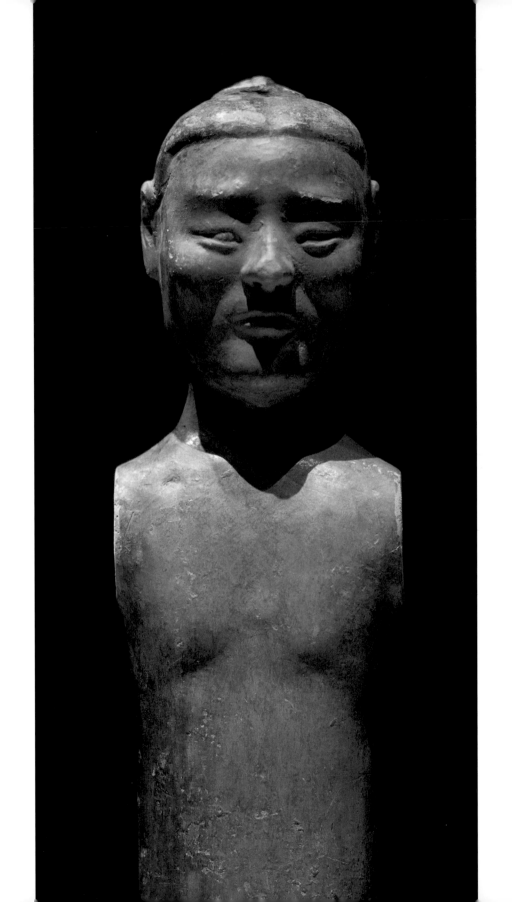

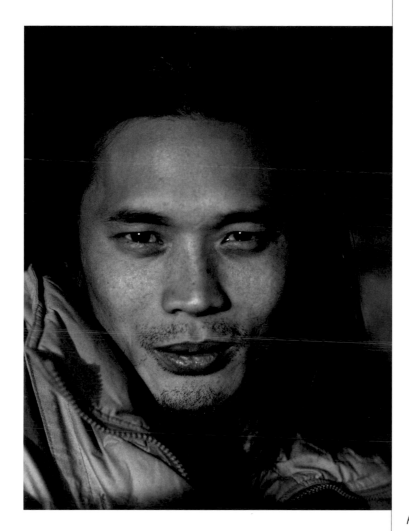

A faithful friend is an elixir of long life.

Proverb

Ten thousand horsemen
came down from the sky.
The frontiersmen look on
rubbing their eyes.
In the endless ditches of
the Great Wall
they let their horses drink
until they run dry.

Xu Lan (Eighteeth century)

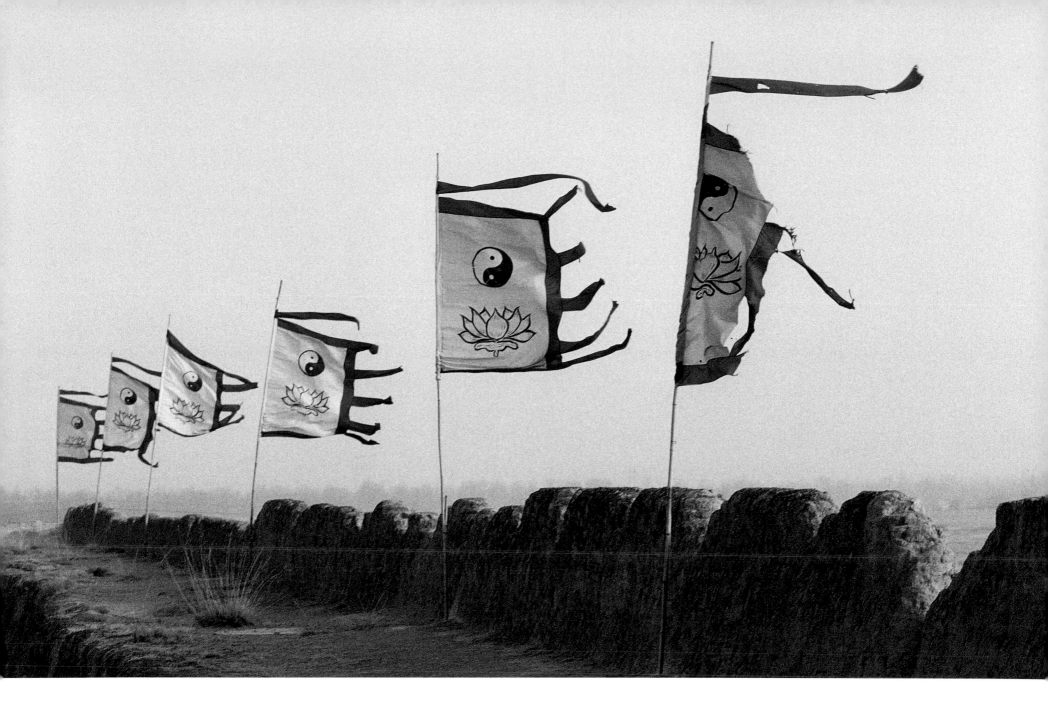

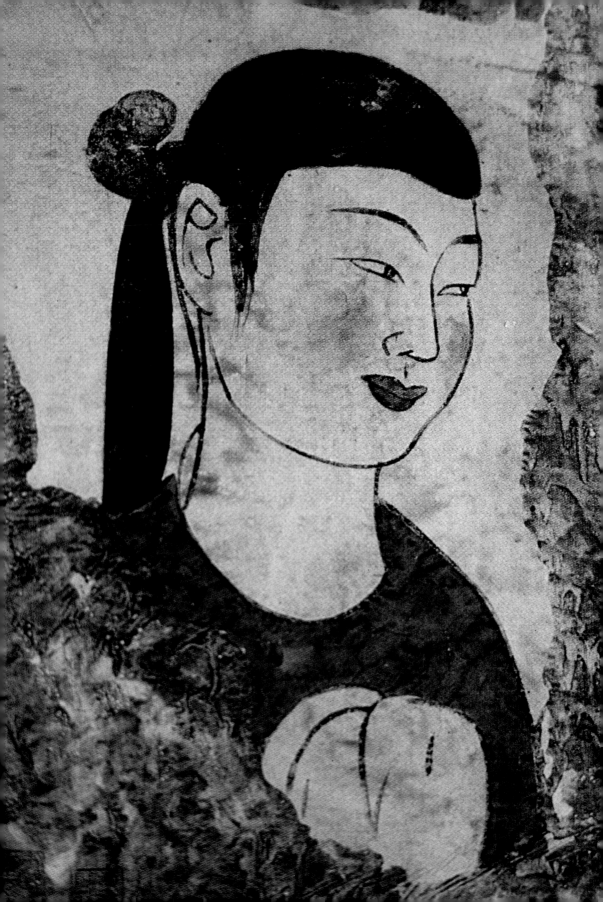

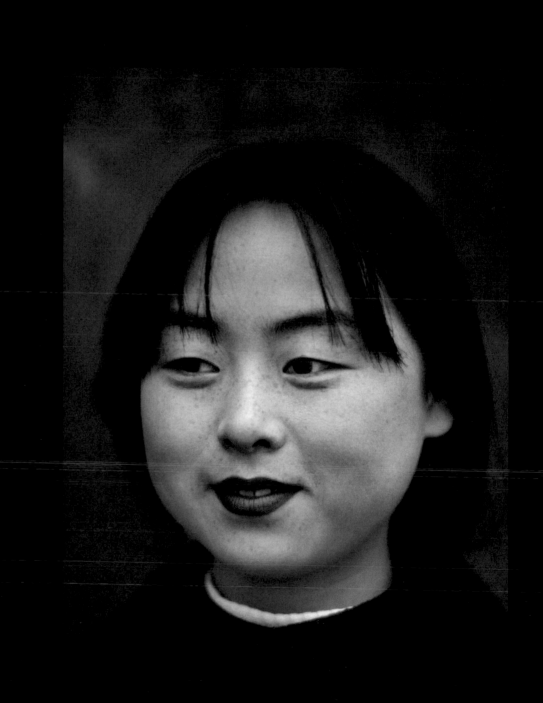

PATHWAYS TO HEAVEN

The Dao—

Self-creating, acting through non-action,

Born before the Earth, before the Sky,
Silently embracing the totality of Time,

It is the ancestor of every doctrine
And the mystery that exceeds all mysteries.

Taken from a cave inscription of 1556

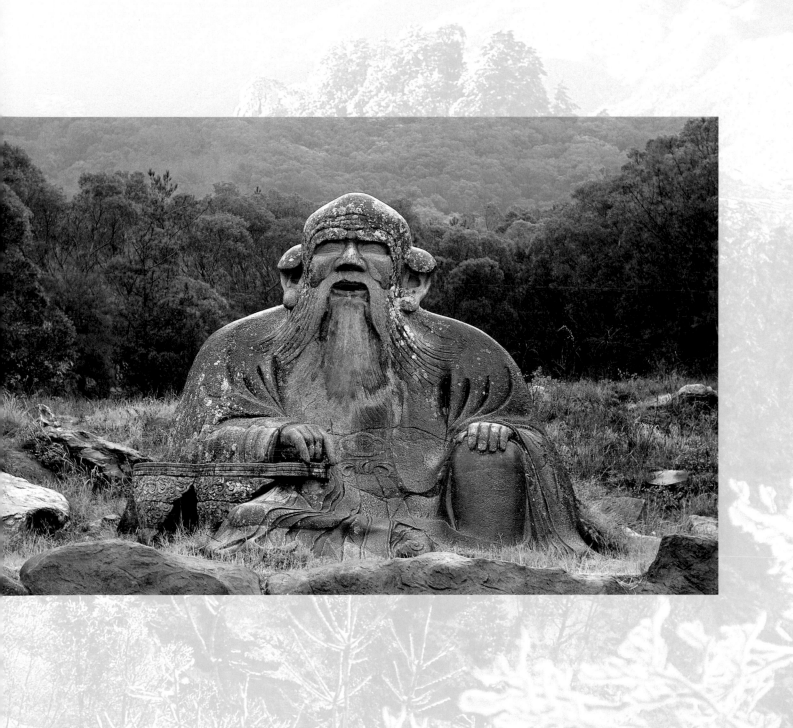

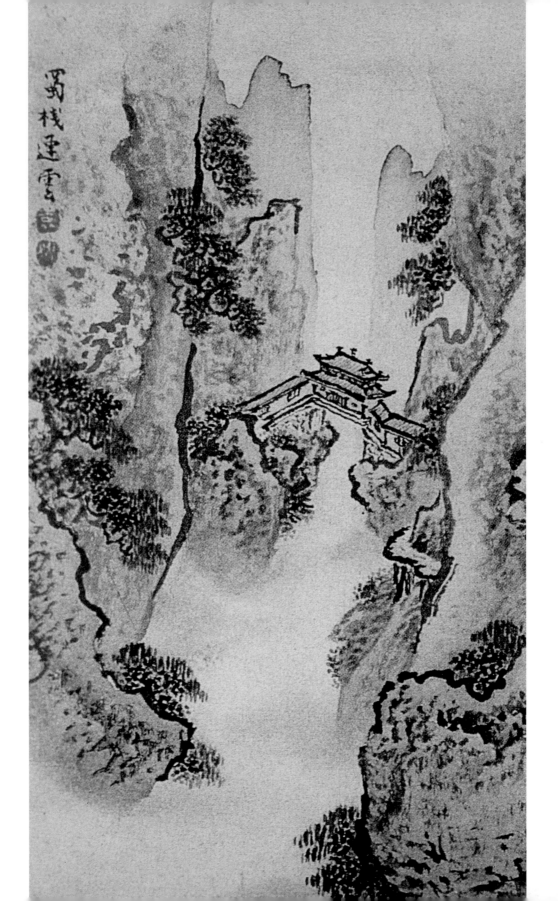

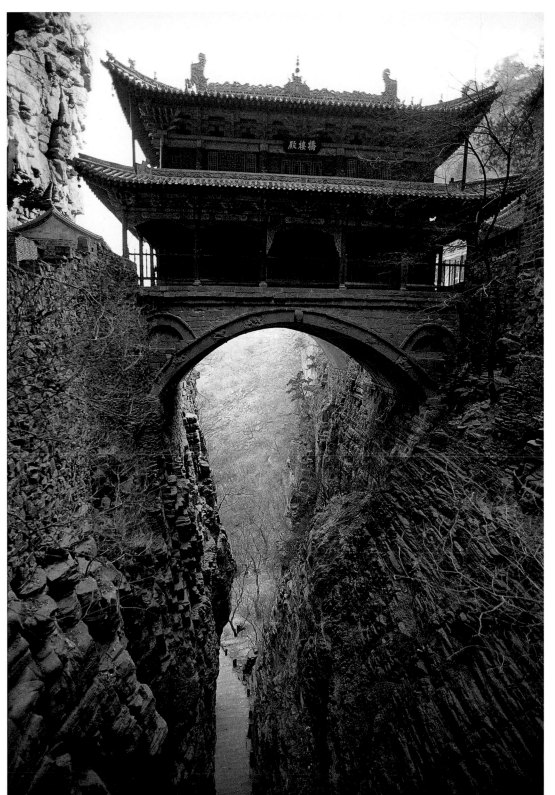

Tough is the road to Shu
harder than climbing up to the azure sky
. . .
Between those peaks and heaven
a single foothold is not enough!
From the cliffs withering pines
hang head down!

Li Bo (701–62)

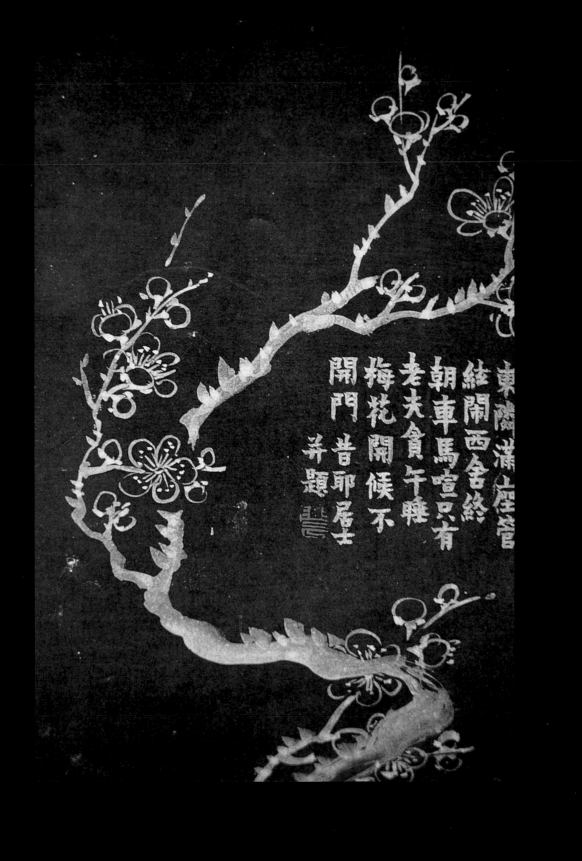

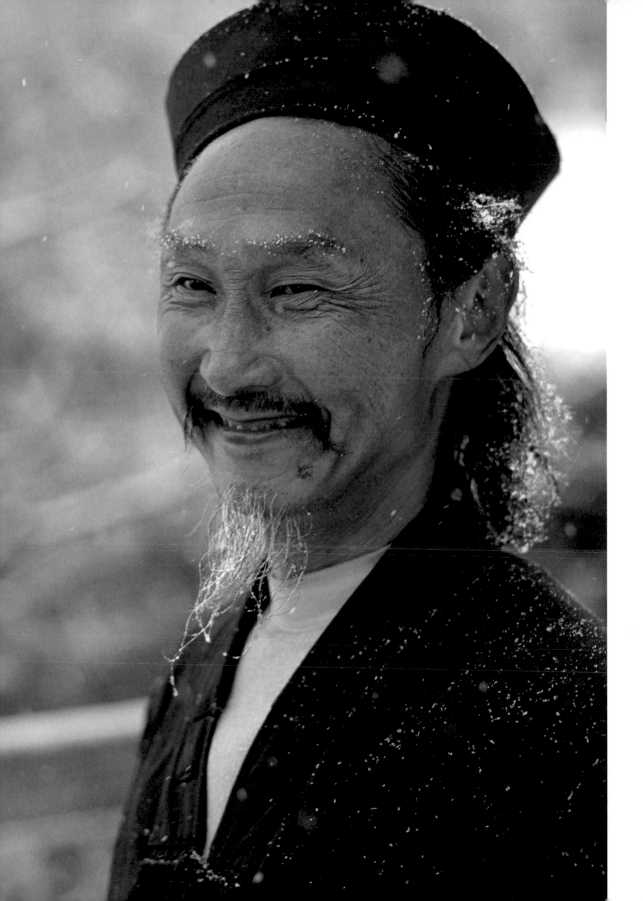

道生一一生二二生三三生萬物

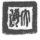

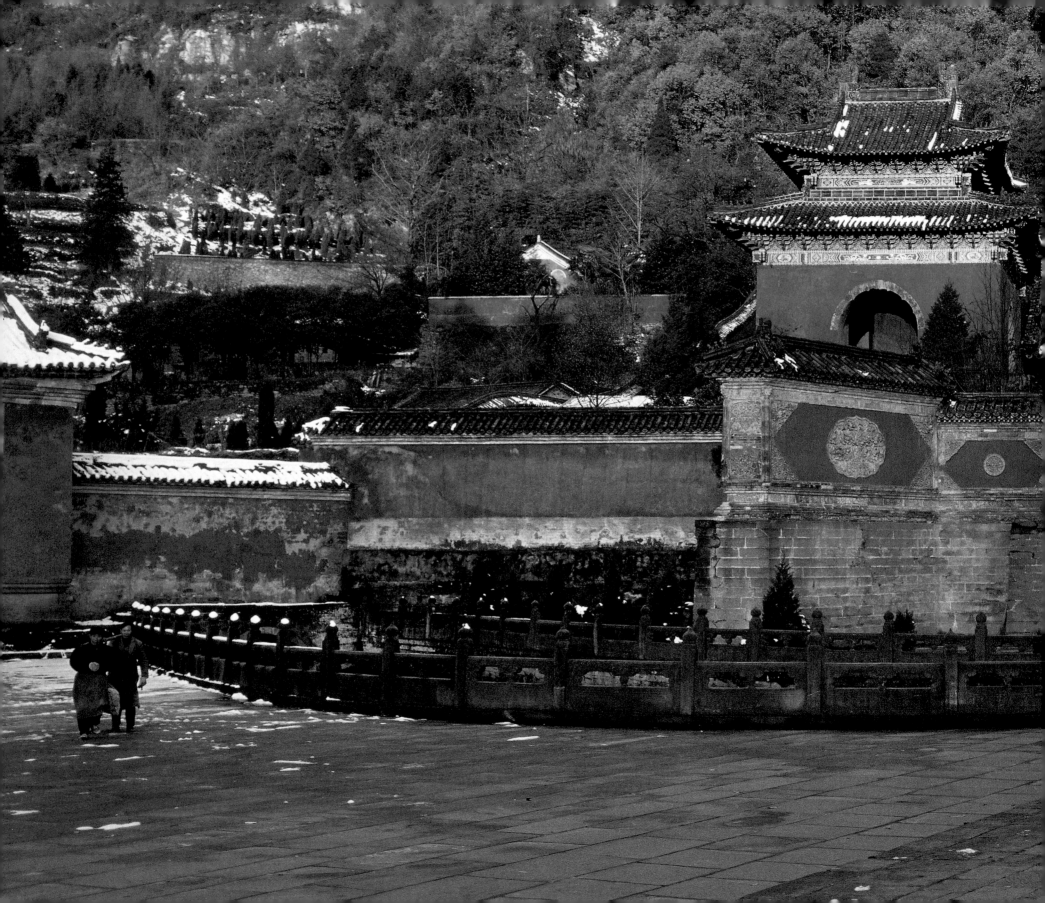

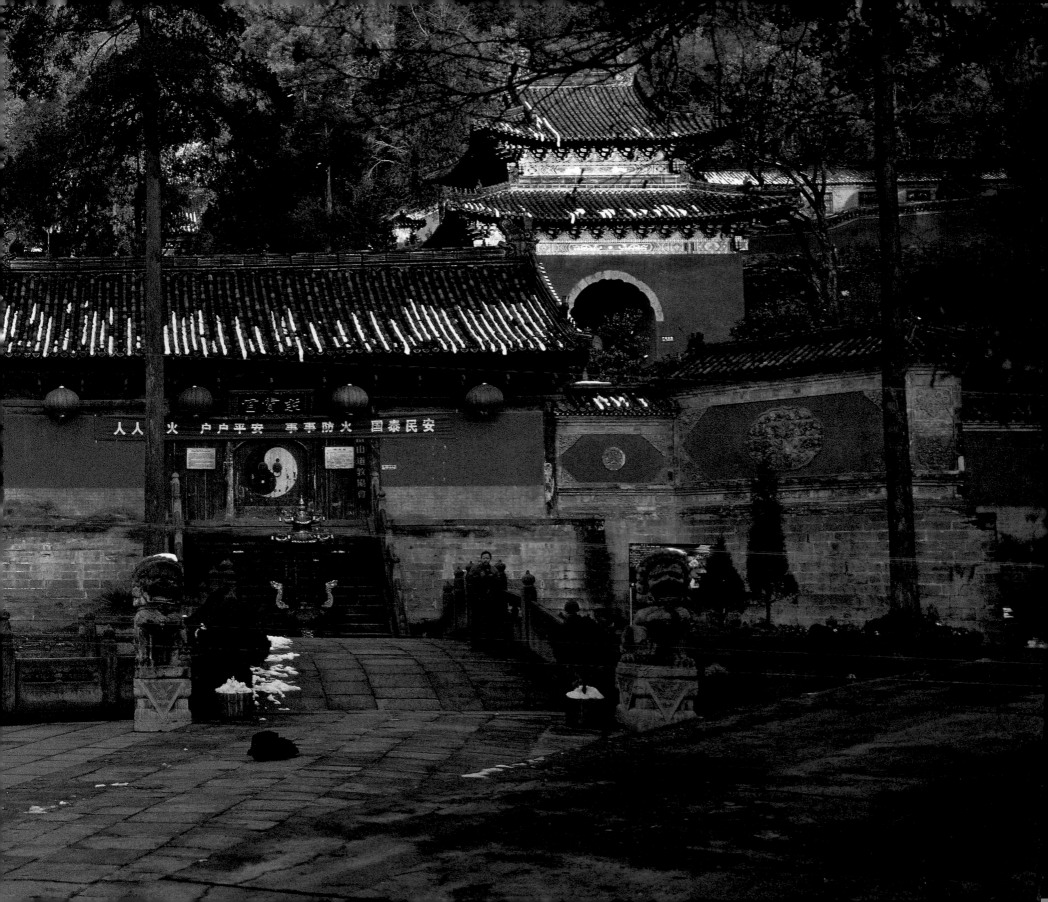

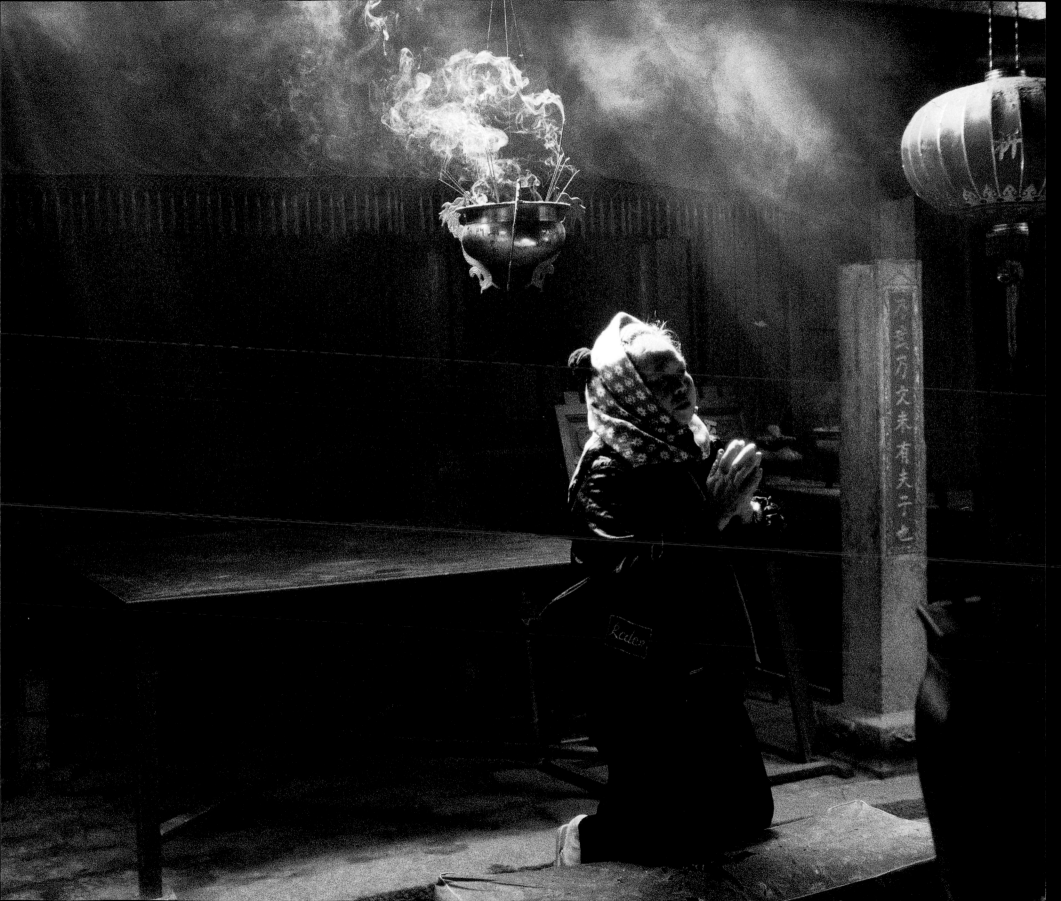

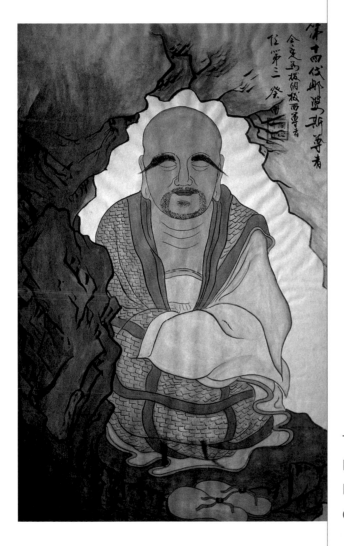

The temple of the summit at night.
Raise your hand and stroke the stars.
But quiet! Keep your voices down
don't wake the denizens of heaven.

Li Bo (701–62)

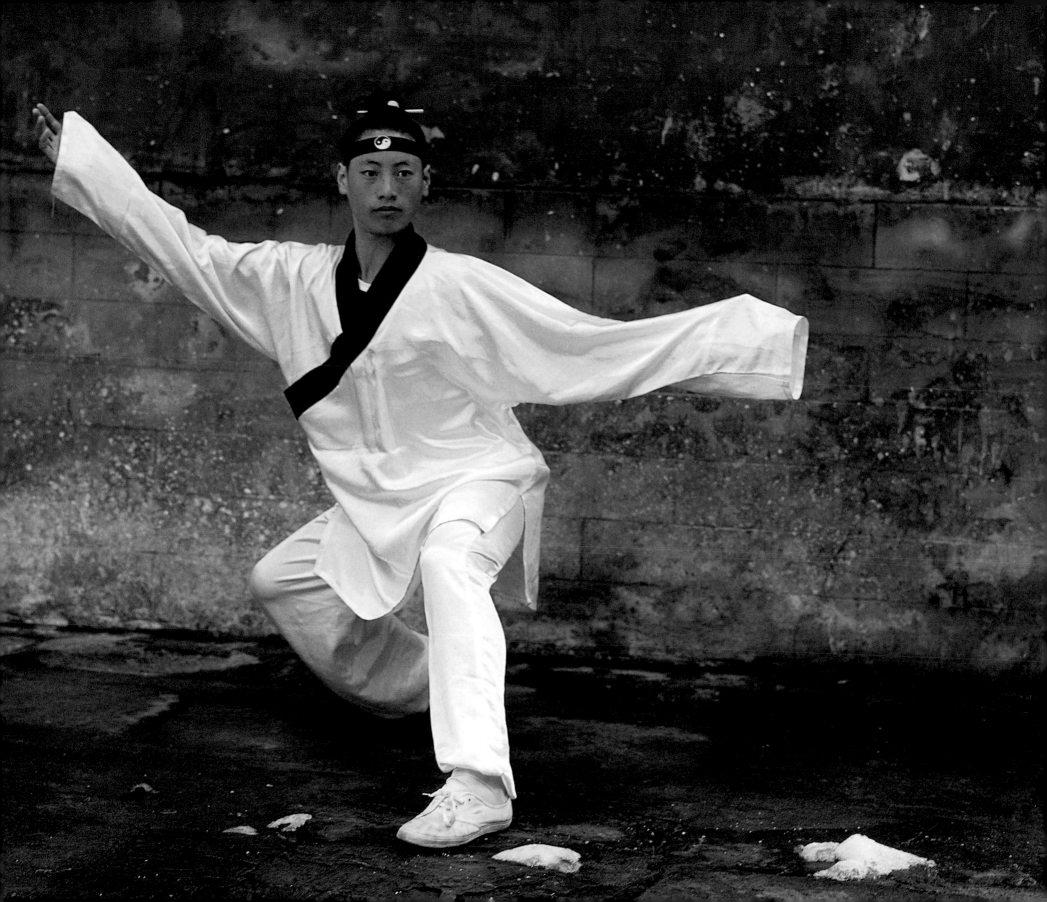

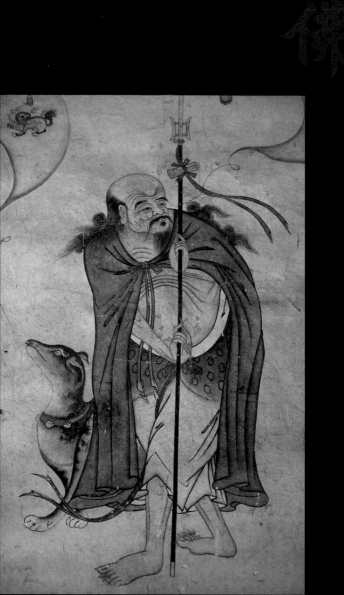

佛

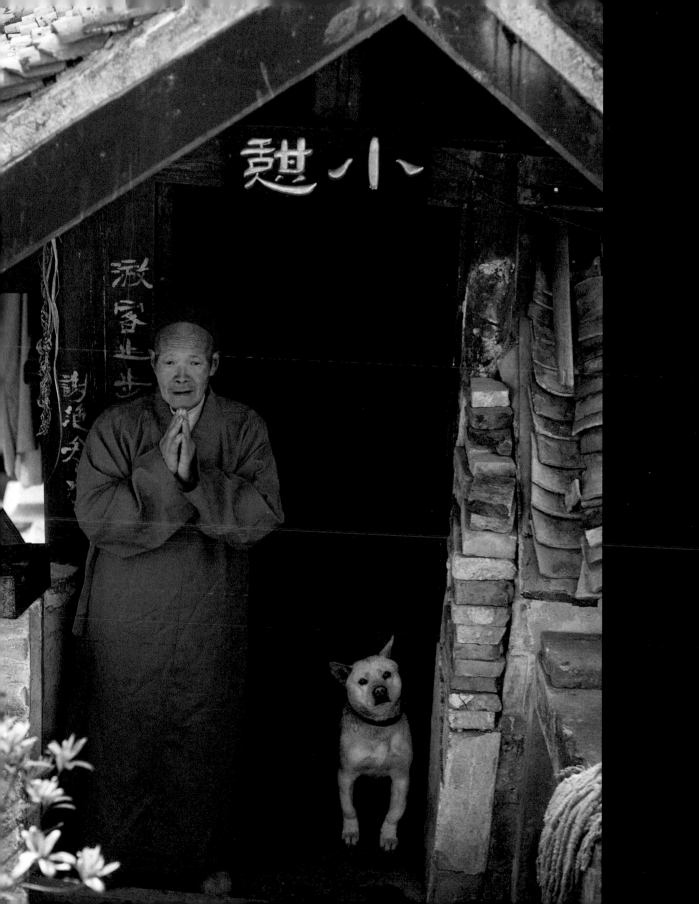

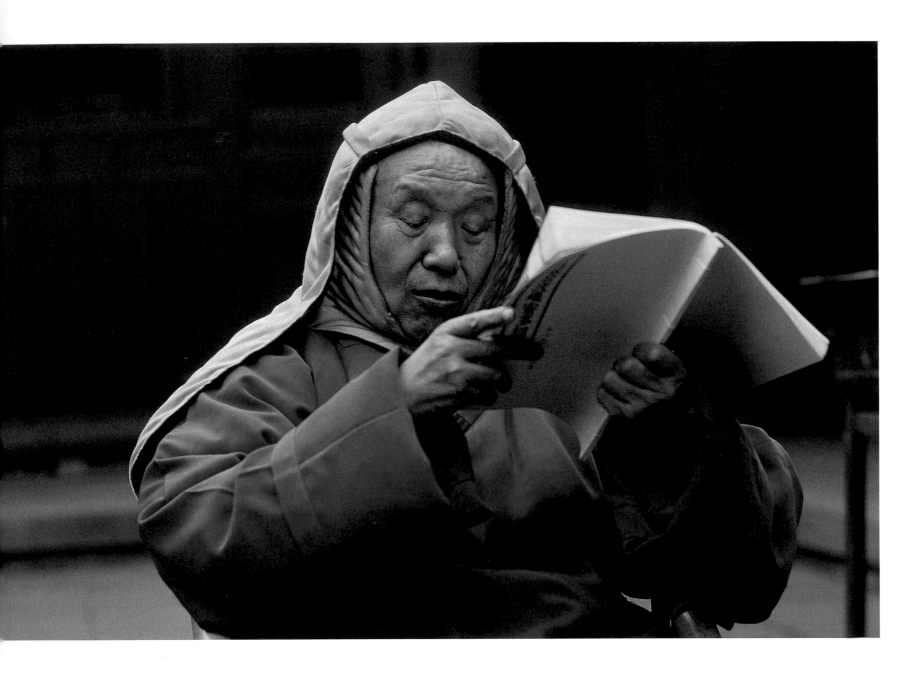

吽 唥 叭 呢 嘛 唵

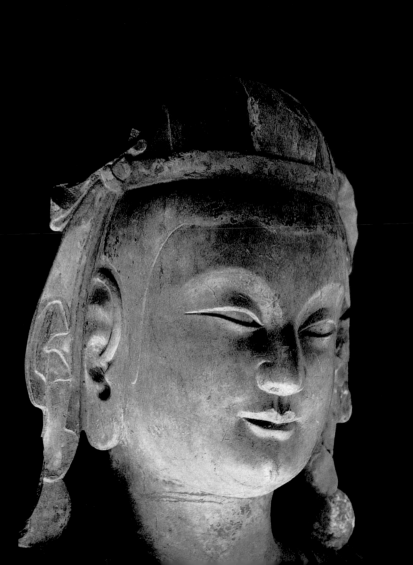

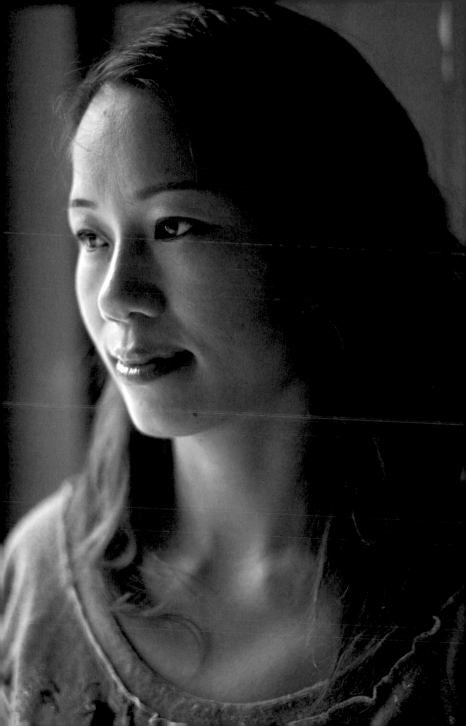

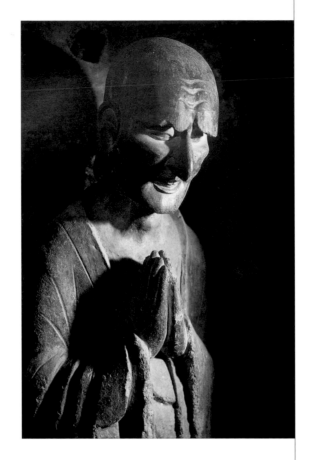

Be your own light, your own refuge.
Believe only what you try out yourself.
Don't accept authority simply because
it comes from some great man
or is written in a sacred book,
for truth is different for each of us.

The Buddha (Fifth century BCE)

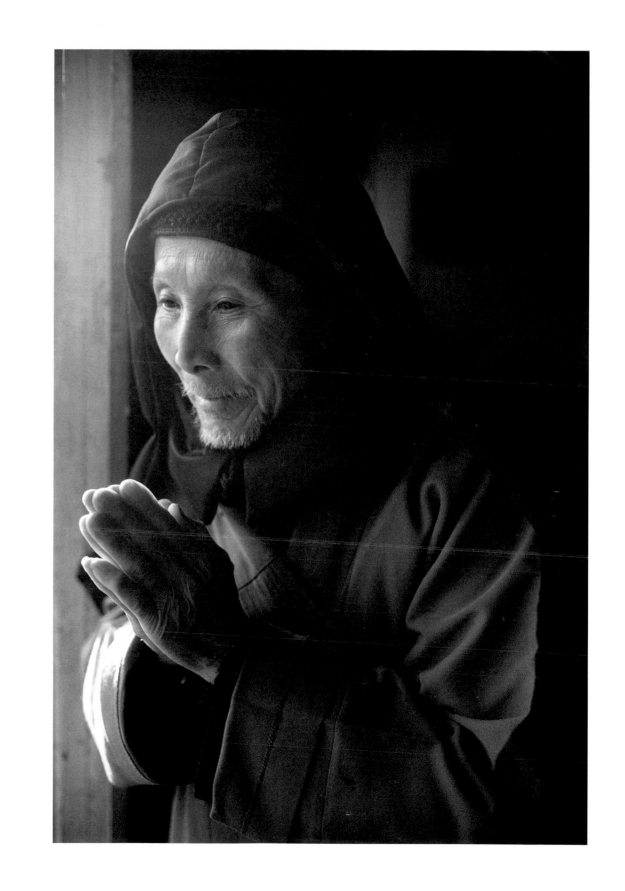

MOUNTAINS AND WATERS

The virtuous takes delight in mountains
The wise enjoys water.
For one: rest
For the other: movement.
The virtuous lives for a long time
The wise lives happily.

Confucius VI

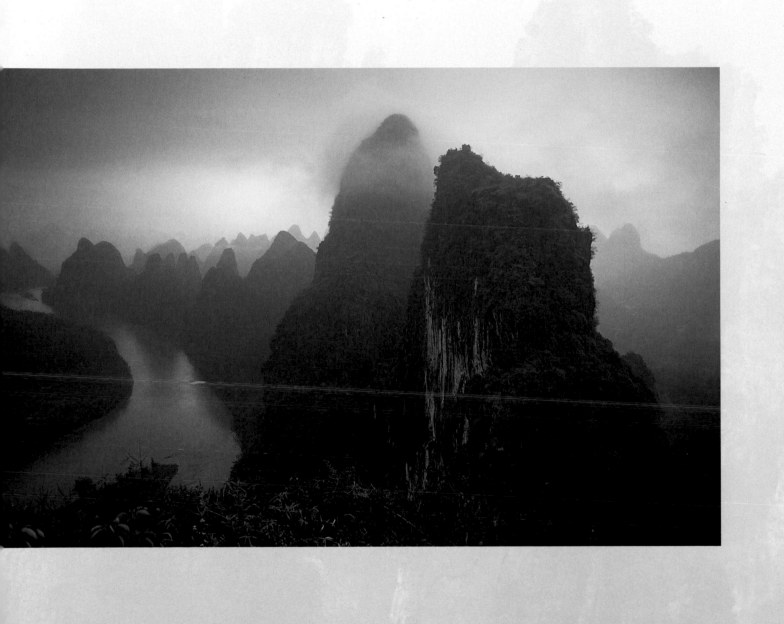

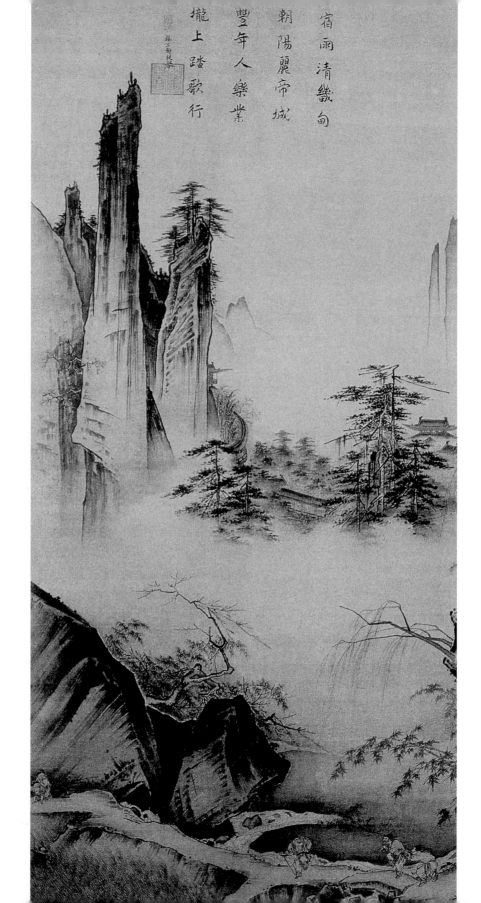

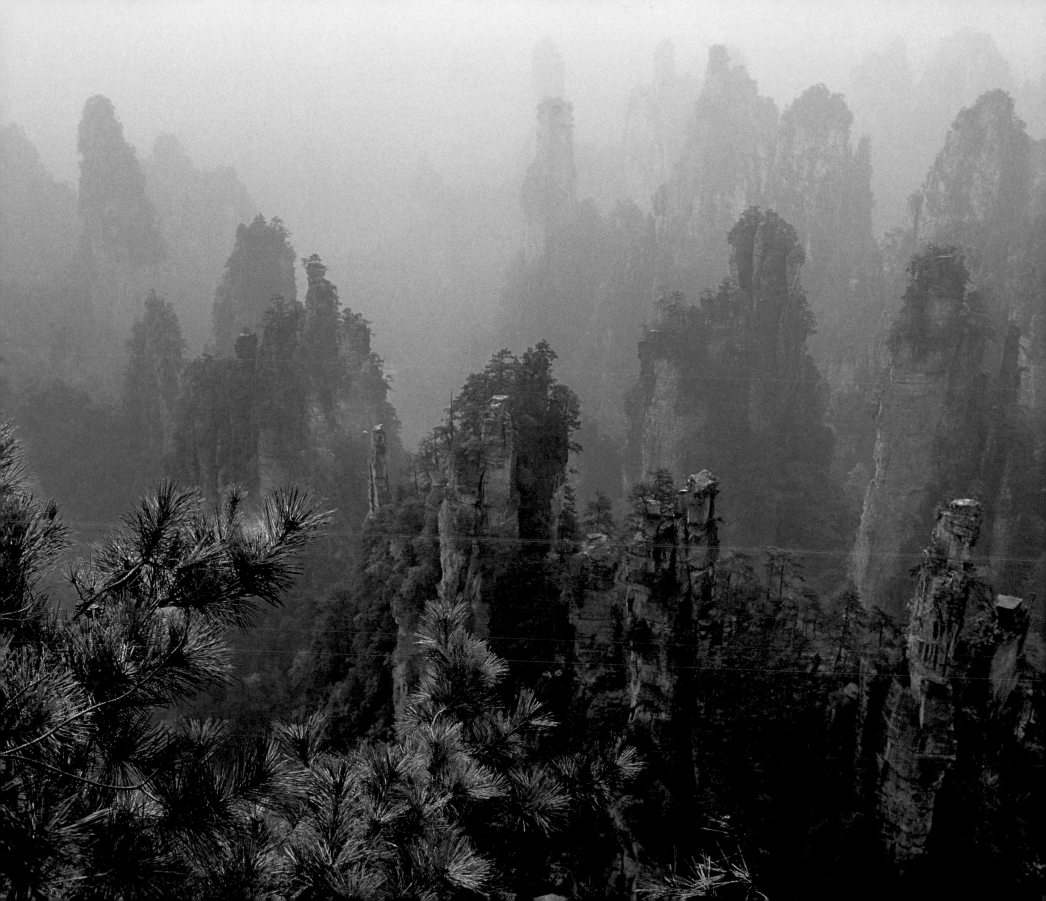

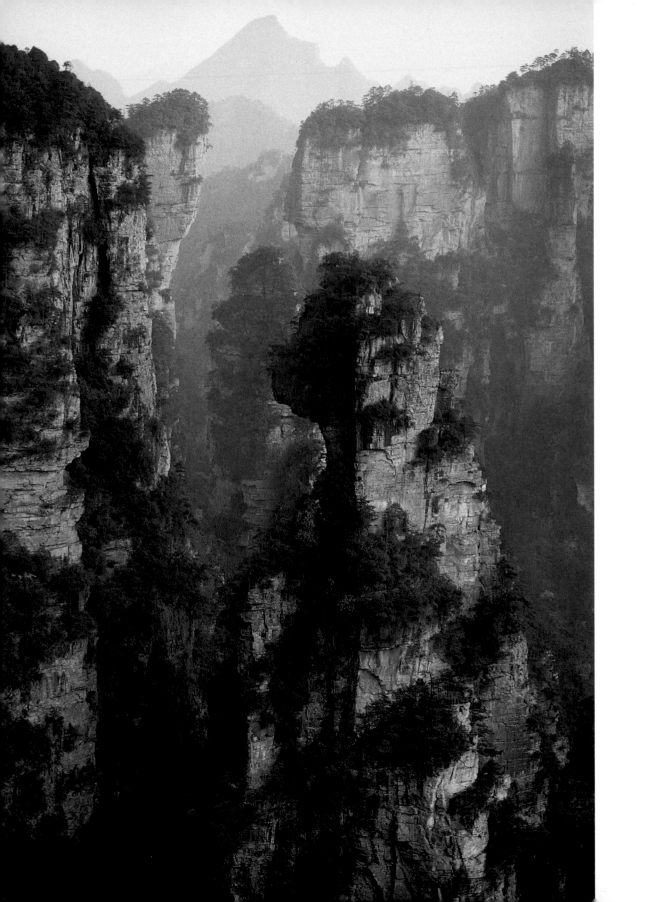

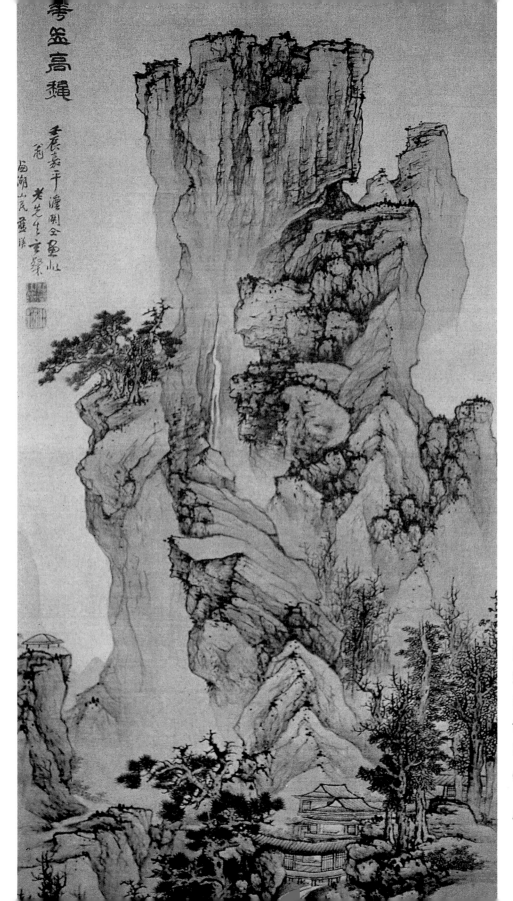

Dizzying rocks rip the sky asunder.
Snaking trees rend a way for the sun.
In shaded ravines
the glory of spring comes to naught.
Upon ice-clad summits the snows
of summer persist.

Kong Zhigui (447–501)

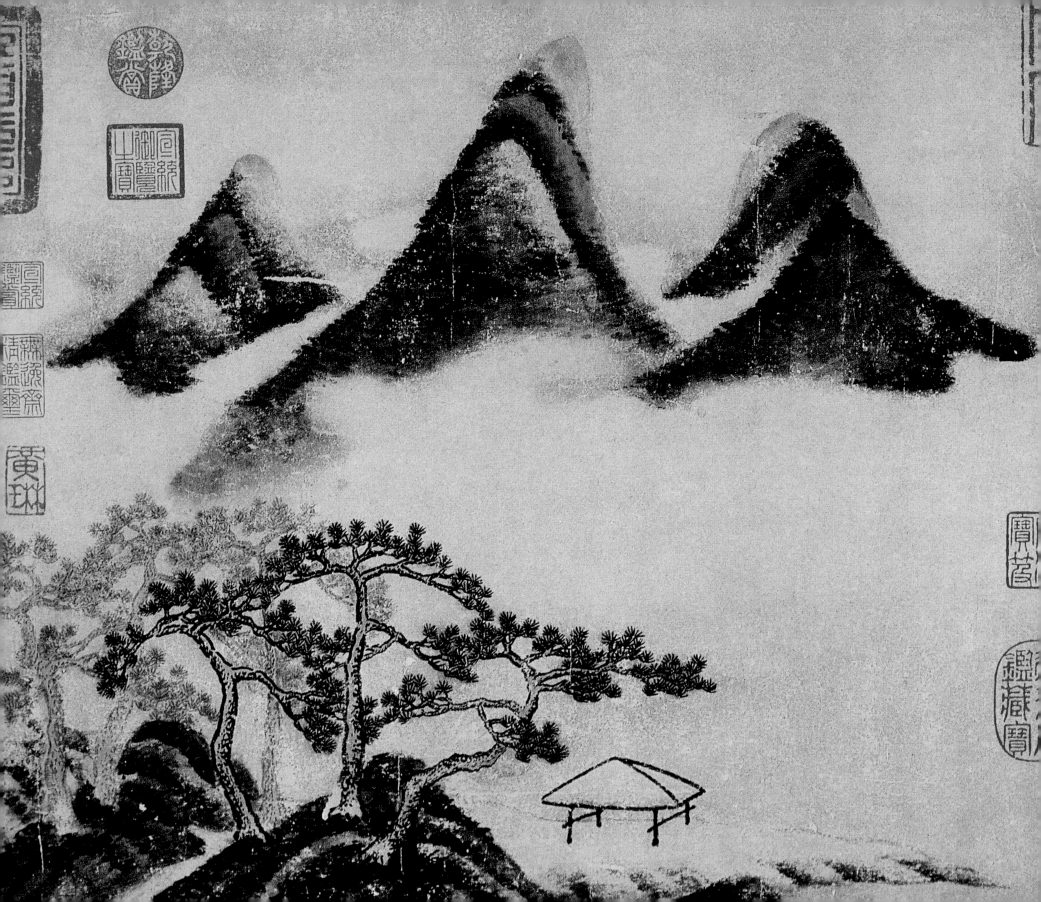

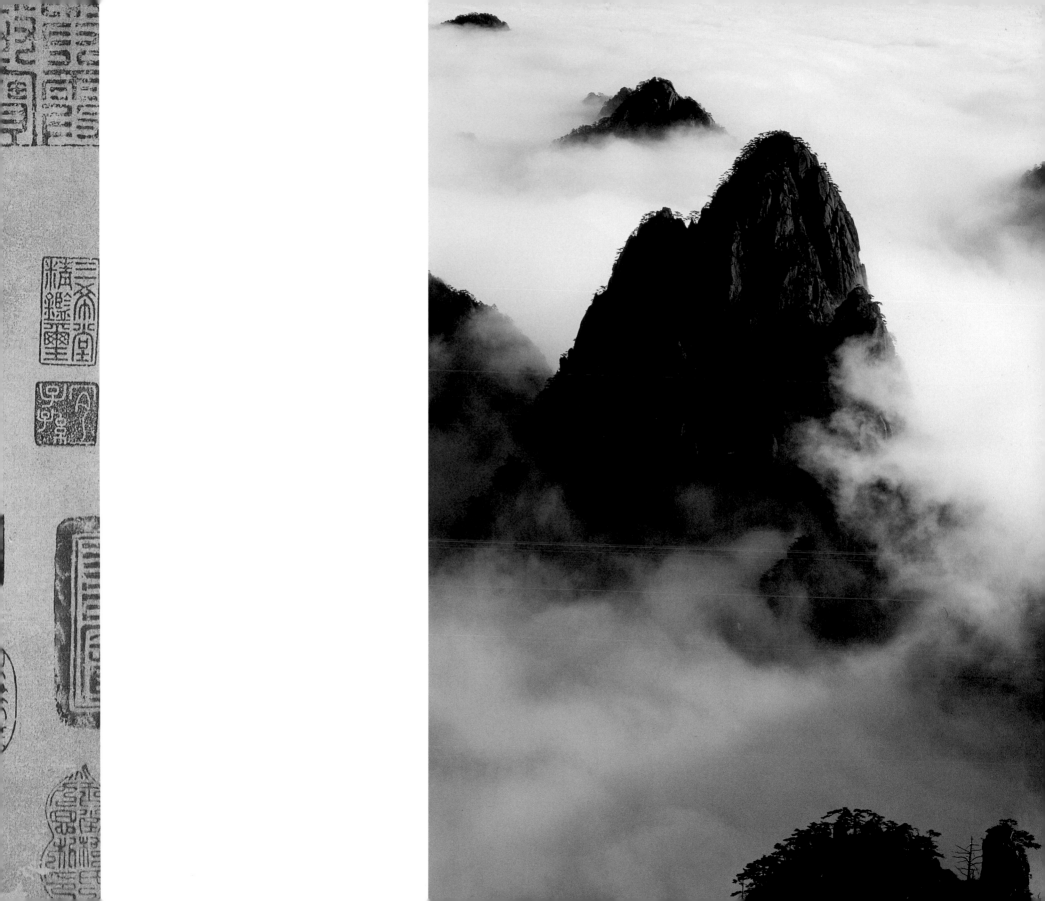

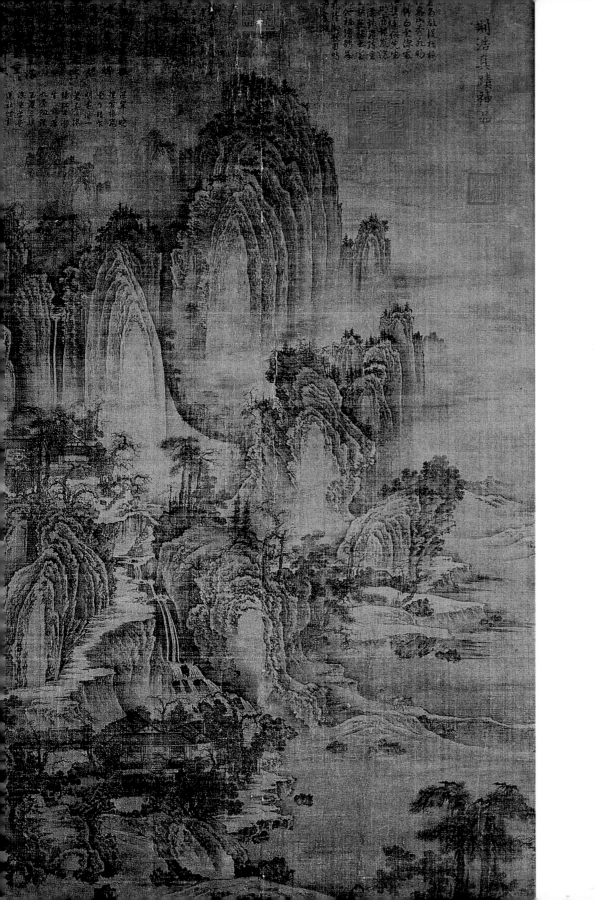

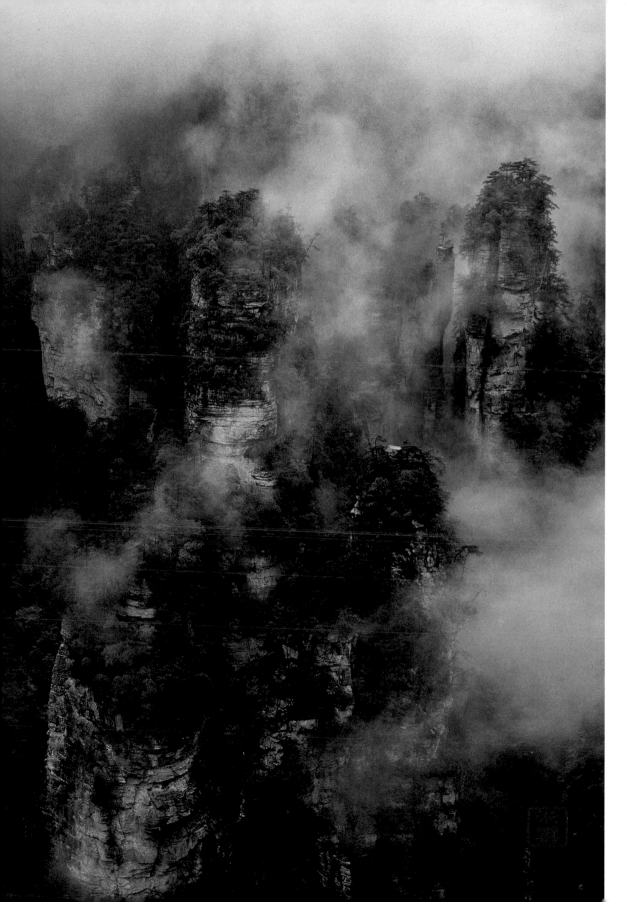

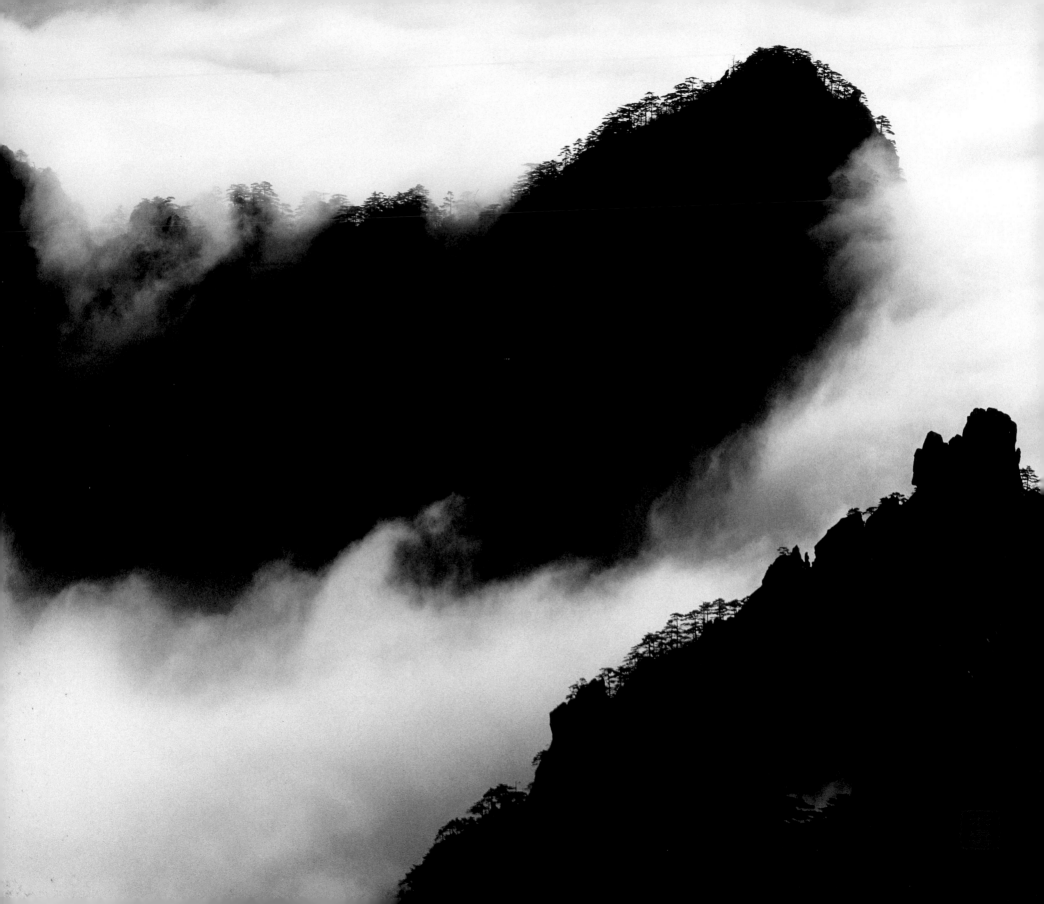

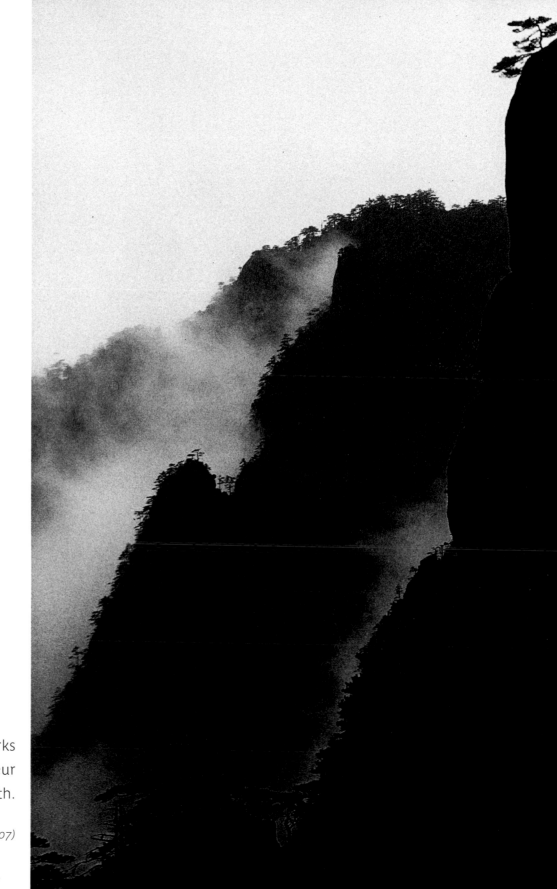

Ink leaves black marks
that proclaim the grandeur
of heaven and earth.

Shitao (1642–1707)

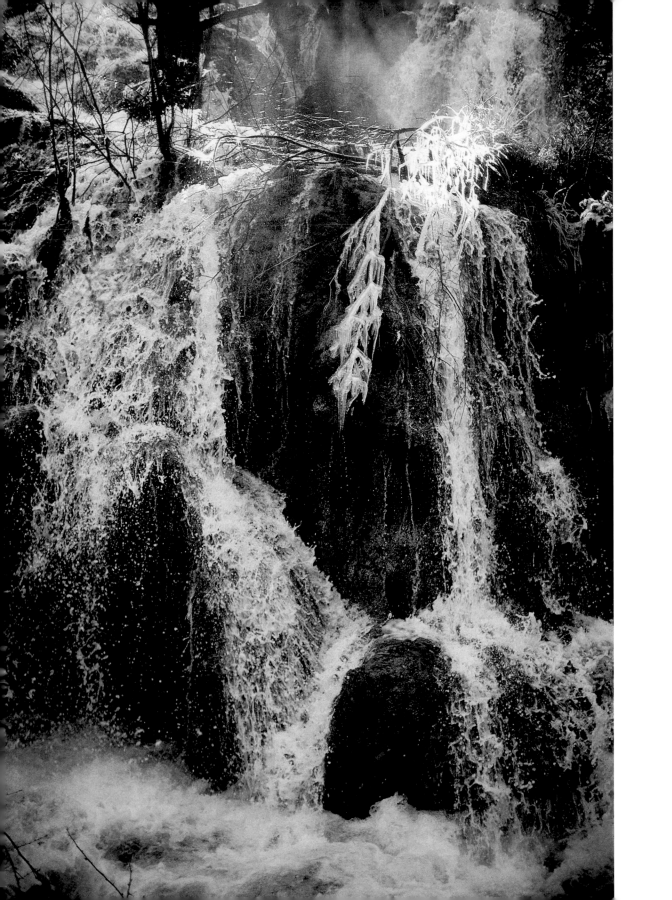

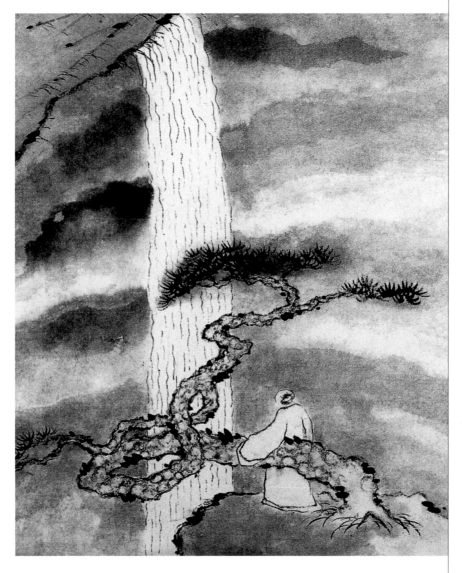

In ten thousand valleys
the high-crowned trees press forward.
Between a thousand mountains
lingers the cuckoo's hoot.
One night it rains in the highlands
and by morning a hundred
swift-flowing streams
babble at the foot of the trees.

Wang Wei (701–61)

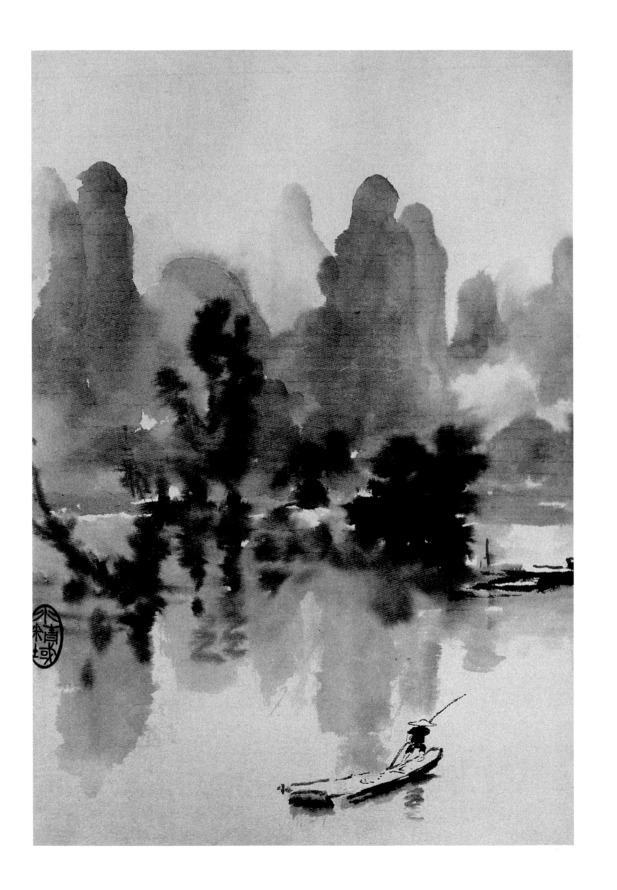

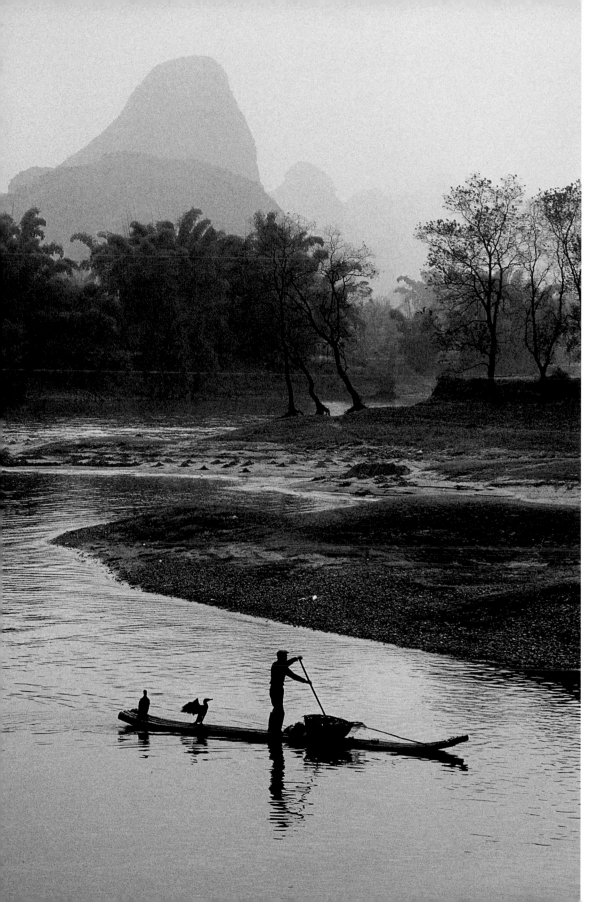

日暮蒼山遠愛是
煙波江上人愁

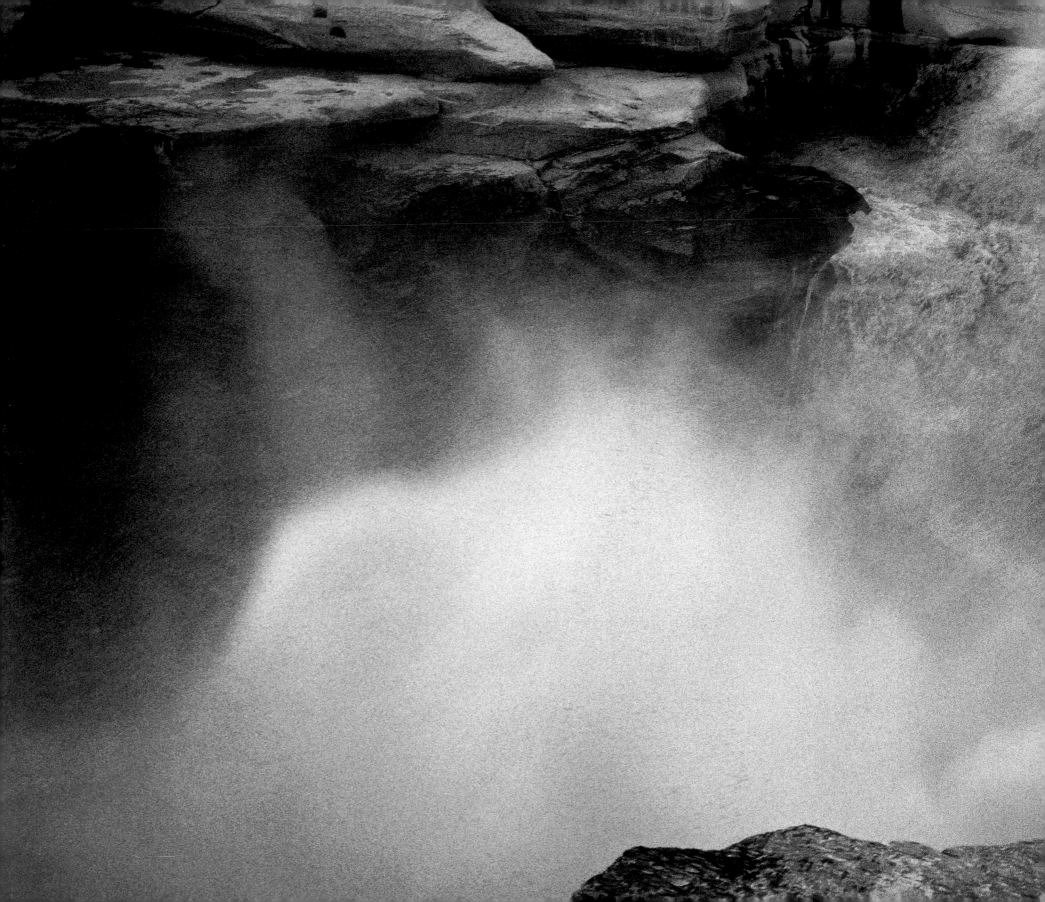

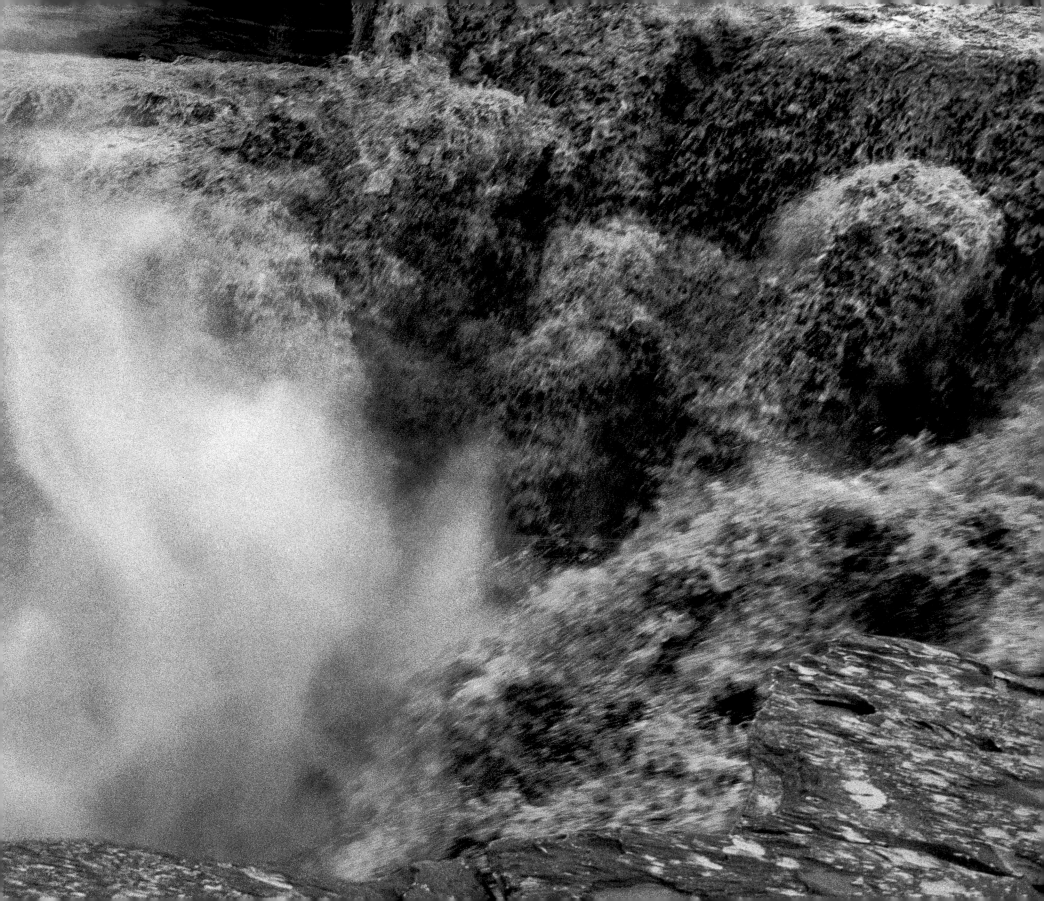

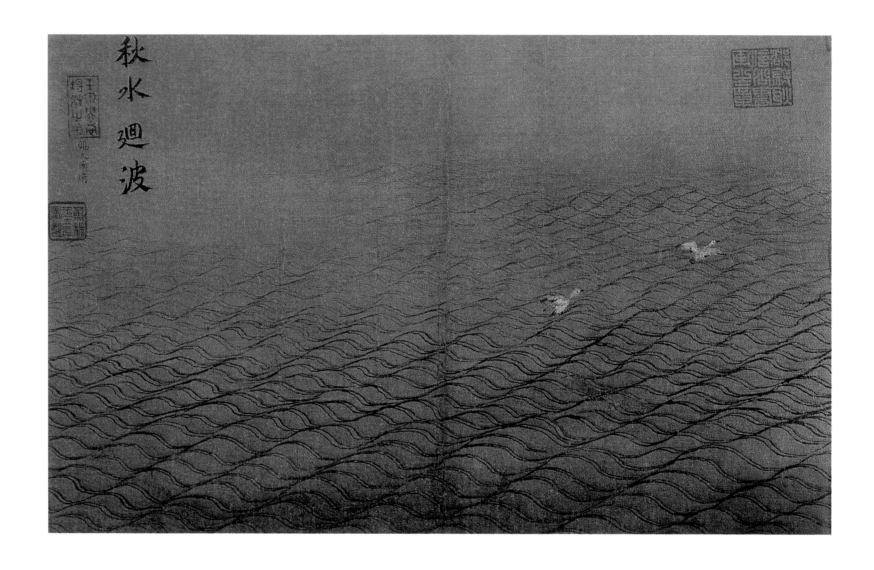

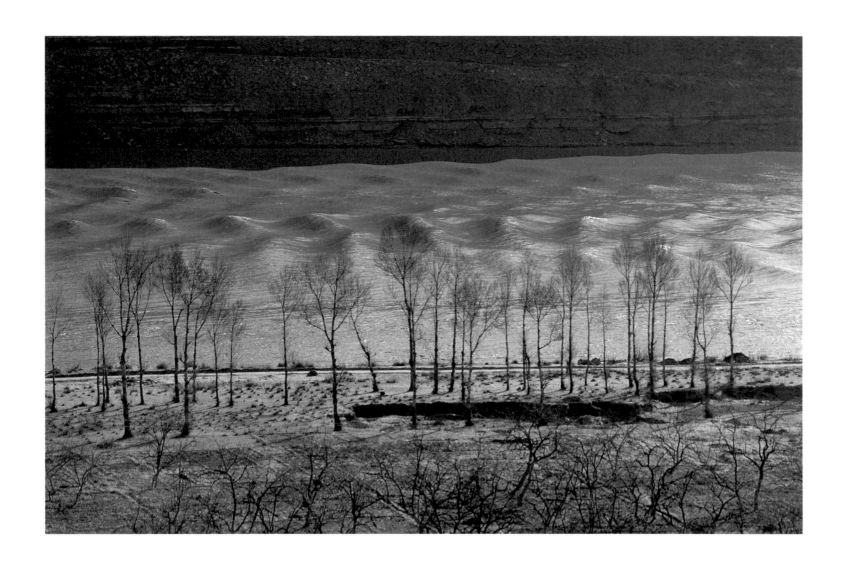

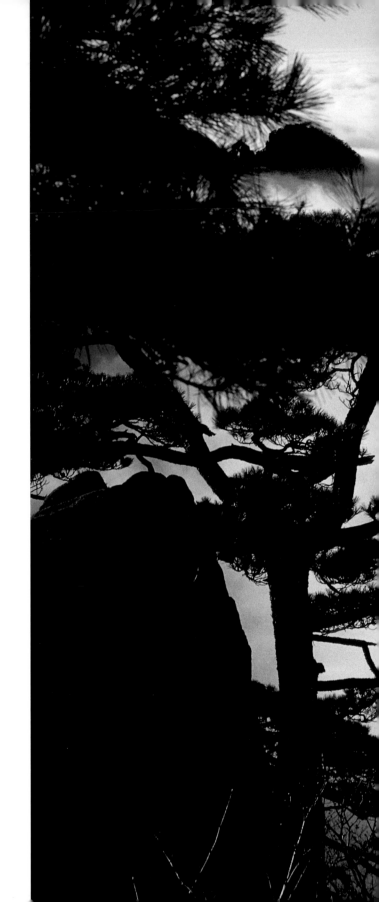

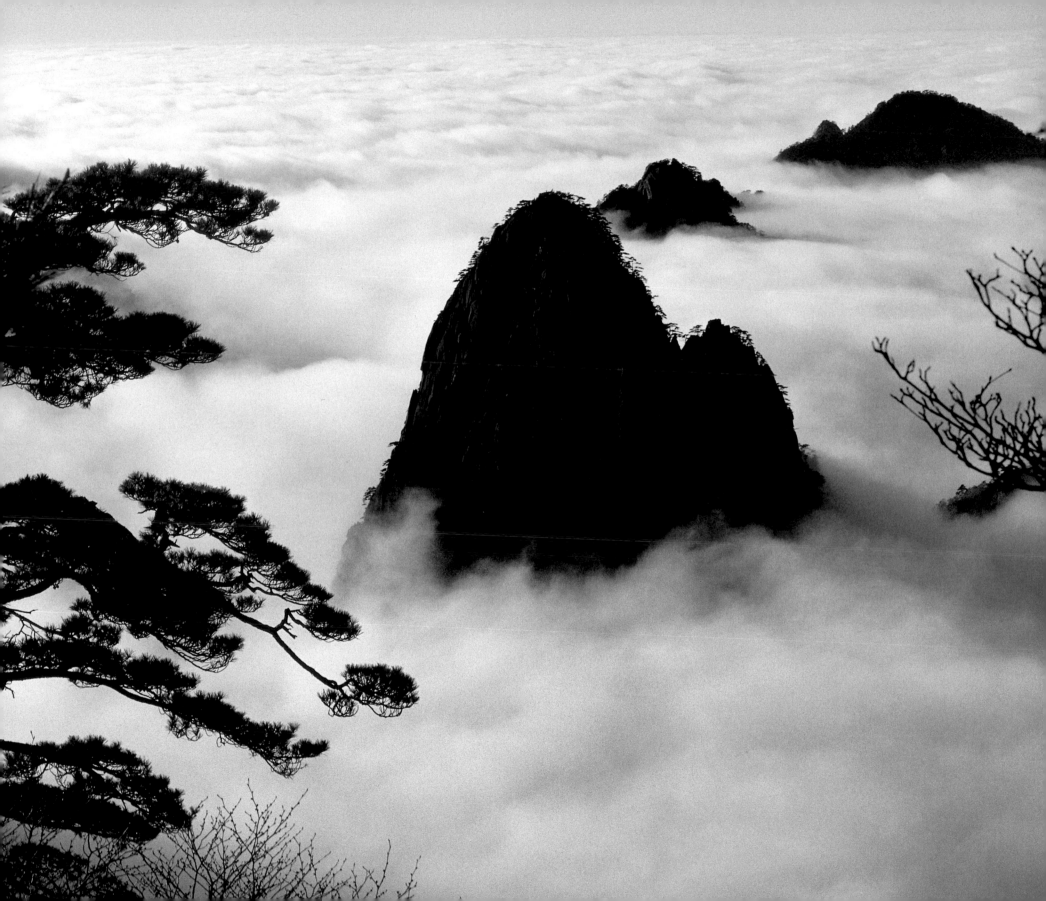

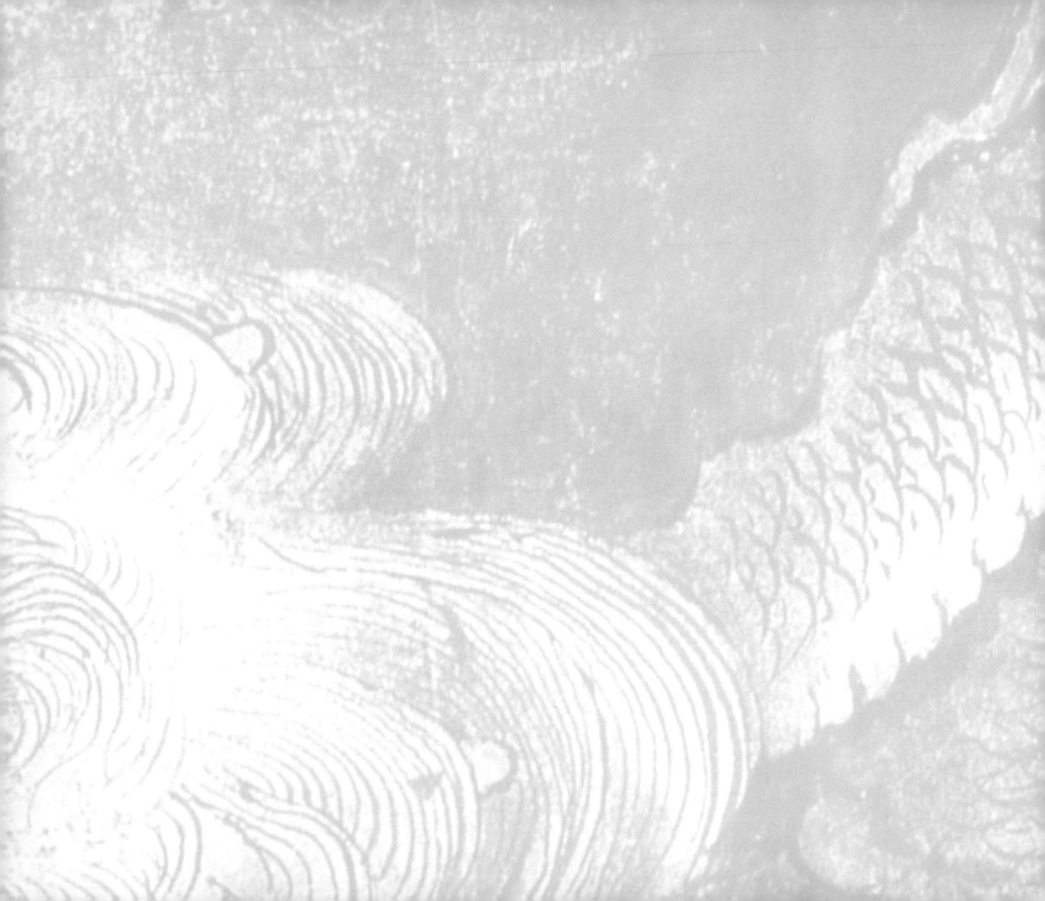

33 Lotus flower
Dal Lake, Srinagar, Kashmir, July 1982.
Symbolizing purity, the lotus is regarded as the preeminent flowering plant from India to the Far East. It takes root in muddy water before rising up on gracious stems and blossoming in the sunshine. An image of the Buddha—in China, this "princess of flowers" is the plant most frequently represented in art and religion.

34 *Stags and Hinds beneath the Red Maples of Autumn*
Detail of an anonymous painted vertical scroll, Yuan period (1279–1368). National Palace Museum, Taipei.

35 The countryside in fall
Yanduhe region, Hubei province, November 2002.

36 Chrysanthemums
Painting by Zhou Yigu (1686–1773). Private collection.

37 Chrysanthemum
Flower show in Beihai Park, Beijing, November 1995. The chrysanthemum has been grown in China for more than two thousand years. It is the flower of long life, joy, and serenity that blooms in the ninth month of the year, September, and is especially celebrated on the ninth day of the ninth month. "Nine" (*jiǔ*) sounds like *jiu*, meaning "a long time" and "forever" but the two are written differently.

38 *Two Twisted Dragon Pines in the Unsullied Dawn of the Mountains of Dream*
Painting in the so-called "manner of the old masters" (Mi Fu, eleventh century) by Yang Huich'i (early eighteenth century). Private collection.

39 "Taoist" temple beneath the snow
Hubei province, November 2004.
Photograph by Mi Shou (Michaud) in tribute to Mi Fu (1051–1107), the great Song painter. Dreamscape shot in the first rays of the rising sun as it lights the Pillar of Heaven (Wudang Shan). Over a gap of almost one thousand years, China and the West meet. Everything changes; only beauty, harmony, and truth endure.

40–41 A fall landscape
Hunan province, November 2003.
Once the rice harvest has been taken in, nothing remains but some woebegone stretches of stubble with the occasional man armed with a long pole guarding his ducks.

42 Calligraphy *tiān zhī jìng* meaning "mirror of the sky"

42–43 Landscape with paddy fields
Yuan Yang region, Yunnan province, February 2001. These magnificent rice plantations are known as "mirrors of the sky."

44 *Terraced Paddy Fields*
Contemporary painting by Wang Qi. Private collection.
Ideogram *jìng* meaning "mirror"

45 Terraces under the snow
Guangxi province at a place known as Longji, "the dragon's backbone," January 2003.

II AS THE DAYS GO BY

46 The seal character *hui* meaning "meeting"
This seal is designed to communicate the idea of human relationships as fundamental to Chinese culture.

47 The village elders of Zhangguying
At a wedding, Hunan province, November 2003.

48 *The Ancestor*
Nineteenth-century woodcut, Zhejiang province. Private collection.
Seal meaning "Know your ignorance at the age of seventy"
Seal painted by Li Keran (1907–1969).

49 The village scholar
Xiao Qi, Xiangi province, December 2004.
A descendent of the ancestor depicted on the woodcut.

50 *Preparing Noodles*
Paper cut-out, Shaanxi province. Private collection.

51 A villager in her kitchen
Fujian province, February 1996.

52 *Blind Drunk*
Contemporary painting by Wangjianan. Private collection.

53 The village drunk
Zhuge, Zhejiang province, November 2003.

54 *Go Players*
Painting by Chen Hongshou (1599–1652). Private collection.

55 Card players in the village of Tianjagang
Shanxi province, October 1995.
As the inventors of paper, it is only logical that the Chinese were also the first to make playing cards, reputedly in the ninth century. Printed using engraved wooden blocks, the backs are decorated with famous characters, including some from the long novel *The Water Margin (Shuihu Zhuan).* The Chinese are inveterate gamblers, betting enormous sums.

56–57 Village called Luncun
Anhui province, April 1999.

58 *Preparing Tea*
Painting by Chen Hongshou (1599–1652). Private collection.
Ideogram *Chá* meaning "tea"

59 Tea ceremony in the tea room of Madam Pangyi
Hangzhou, Zhejiang province, June 2007.

60 *Child with a Lantern*
Paper cutout. Private collection.
Ideogram *fēng huáng* meaning "Phoenix"
This is the name of the town in the Hunan province shown here.

60–61 Historic timber houses in the town of Fenghuang ("Phoenix")
March 2007.

62 *Ancestral Couple*
Nineteenth-century woodcut. Private collection.

63 Elderly couple
Zhejiang province, October 2003.

64 *Kite Festival*
Extract from the *Chinese Empire Illustrated* by T. Aliom and G. N. Wright (1859), nineteenth-century English print. Private collection.

65 Kite seller
Weifang, Shandong province, April 1998.
Ideogram *fēng* meaning "wind"

66 *Actress at Beijing Opera*
Unidentified contemporary woodcut. Private collection.

67 Portrait of a student in a role from the Beijing opera
Dramatic Arts Academy Fu Hsing, Taipei, Taiwan, October 1997.

III SKILL AND INGENUITY

68 The seal character *shù* meaning "skill"
This seal highlights the technical ingenuity of the Chinese people.

69 Grandmother making paper cutouts for her grandson
Village in Fujian province, February 1996.

70 *The Water Chore*
Print from the Yuan era (1269–1368). Private collection.
In spite of the invention of the wheelbarrow by the Chinese by the first century BCE, the most widespread system of carrying things remains a simple plank. In the West, however, the wheelbarrow did not make an appearance until the eleventh century—that is, one thousand years later.

71 Water chore in winter
Hebei province, January 2004.

72–73 Noria and farmer with a shoulder piece in the morning fog
Hunan province, November 2003. The noria wheel used for irrigation is said to have been invented in the third century (at the time of the Three Kingdoms) by a certain Ma Jun.

74 Stucco head of an *arhat* (or *luohan* in Chinese)
Song period (960–1279). Private collection.

75 Portrait of an inhabitant of the village of Zhuge
Zhejiang province, November 2003.

76 *Fisherman with a Dip Net*
Detail of a painting on silk by Ni Zan (1301–1374). Private collection.

77 Fishing with traditional nets on the Yangzi
Jiangsu province, August 1965.
The Yangzi is called the "Blue River" by Westerners.

Calligraphy from a poem by Liu Zongyuan (773–819), *Snow on the River*:
"In his solitary boat, beneath his cape of straw, an old man fishes for snow in the frozen river."

78 Fishing for toad with rod and reel
Zhejiang province, May 2007.

79 Anonymous painting of the Song period (960–1279)
Private collection.
Note the fishing reel, a Chinese invention dating back to the third century.

80 *Crane*
Rubbing from a brick from a tomb of Eastern Han period (third century), Xinye, Henan province.
Ideogram *qì* meaning "vital breath"

81 Taoist *gōng fù* master executing the crane move
Temple of Zixiao in the Wudang Shan, Hubei province, November 2004.

82 *Gathering Water Chestnuts*
Unidentified painting. Private collection.

82–83 Gathering water chestnuts on a lake at Hangzhou
Zhejiang province, August 1965. This aquatic plant with white blooms produces spiky, edible fruit that resemble chestnuts.

84 *A musician playing the flute*
Earthenware brick with pigment, dating from the Five Dynasties period (907–60). Museum of Bingxian, Shaanxi province.

85 Taoist monk playing the flute
Temple of the Celestial Masters, Shangqing, Jiangxi province, December 2004.

86 *The Calligrapher*
Detail of a painting on a screen. Private collection.

87 Master of the Nine Mountains writing the name of the Buddha (Fo) in calligraphy
Monastery, known as the Vast Pines, South Korea, October 1973.

88 Junks in the Bay of Macau
August 1965.

89 *Junks*
1945 painting by Gao Jianfu (1878–1961). Gift of R.H. Ellsworth, Metropolitan Museum of Art, New York. Photo © Metropolitan Museum of Art.
Ideogram *zhōu* meaning "boat"

IV CHILD KINGS

90 The seal characters *bǎo bèi* meaning "treasure" and "darling"
Indeed, what could be more valuable than a child?

91 The silhouette of a young boy from Beijing reflected in a mirror-like red lacquer door
Temple of Heaven, Beijing, June 2007.

92 Cricket Fighting
Macau Museum, April 1998.
The "ring" is usually a piece of clay pottery.

93 *Child with his Cricket*
Detail of a contemporary painting on glass. Private collection.

94 A country scene of a family in an orchard
Detail of a painting by Yuan Jiang (1671–1746). Nanjing Museum.

95 A family returning after gathering *muzi* flowers
Hebei province, December 2002.
The white seeds are used to make soap.

96 A grandfather feeds his grandson using chopsticks
Gansu province, January 1997.

97 Ideogram *xǐ* meaning "double happiness"
Twentieth-century woodcut depicting ten babies. This kind of print is a traditional wedding gift and signifies, "I wish you many children." Private collection.

98 *Children Cooking* Baozi
Detail of an anonymous painting on silk. Yuan period (1279–1368). National Palace Museum, Taipei. A *baozi* is a steamed bun stuffed with ground pork or mutton.

99 Boy who, to his astonishment, has just seen a "foreign devil"
Sichuan province, November 2002.

100 *Two Children Admiring the Treasures Brought by a Traveling Entertainer*
Detail of a painting on a square silk fan dating from 1210 attributed to the Song era painter Su Hanchen. National Palace Museum, Taipei.

101 A young boy is surprised to see a "long nose" in a village
Province of Hebei, December 2003.
"Long nose" is the Chinese expression for Westerner.

102 *Children Carrying Umbrellas in the Snow*
Twentieth-century woodcut. Private collection.

103 Two schoolgirls taking shelter under umbrellas one snowy day
Guangxi province, January 2003.

104–105 School outing
Dachang, Sichuan province, November 2002.

106 Porcelain china doll from the contemporary period
Private collection.
Seal characters *tóng xīn* meaning "child's heart"

107 Young girl whose hair is adorned with paper flowers
Chongqing, Sichuan province, April 1996.

108 Boy with a traditional hairstyle holding a peach, a symbol of immortality
New Year woodcut, Qing period (1644–1911). Private collection.

109 Schoolboy with traditional hairstyle coming out of school
Shaanxi province, February 2004.

110 Portrait of a child who is upset or just acting up
Autonomous province of Ningxia, April 2007.

111 *A School Teacher Gives a Pupil a Dressing-Down*
Contemporary painting by Qi Baishi (1863–1957). Private collection.

V FLOWERS AND BIRDS

112 The seal character *huà* meaning "change" or "transformation"
This seal character was chosen for its references to change in nature.

113 Peach branch in flower
Fenghuang region, Hunan province, March 2007.
Butterfly stamp
Qing period (1644–1911). Private collection.

114 Silhouette of an unidentified tree
Court of the temple of Guang Sheng, Shanxi province, January 2004.

115 *Owl*
Contemporary painting by Huang Yongyu. Private collection.

116 *Lotus*
Painting by Shitao (1642–1707). Museum of the Forbidden City, Beijing.

116–117 Lotuses wilting on a lake in west Hangzhou
Zhejiang province, November 1997.

118 Cobweb
Painting by Chen Hongshou (1598–1652). Private collection.
The spider augurs happiness because its name is pronounced the same as the word for happiness. It is known as the "happy insect" and a spider hanging from the middle of its web is seen as happiness descending from heaven.

119 Cobweb
Pont-de-Saint-Agrève, Ardèche, France, July 1973.

120–121 Bird lovers
On the shores of the Green Lake (Cuihu Gongyuan) at Kunming, Yunnan province, February 2001.

122 *Bird lover gazing at his little pet in its cage*
Paper cutout by the artist Chen Zhinong. Private collection.

123 Bird lover
Temple of Heaven Park, Beijing, November 1995.
The Chinese passion for birds dates back to the distant past. The ancients wrote that they symbolize "higher states of being." The sight of grown men walking in parks with birds in cages is a common one. Certain teahouses,

where bird lovers appreciate and compare the respective merits of their cagelings and enjoy the company and friendship of like-minded people, are fitted with metal bars from which cages can be hung.

124 Pine tree in the snow
Mountain of the Three Pure Ones (Sanqingshan), Jiangxi province, December 2004.

125 *Ten-Thousand-Year-Old Pine Tree*
Painting by Emperor Xuanzong (1426–35). Liaoning Provincial Museum, Shenyang.
More than a hundred and twenty varieties of pine are said to grow in China, but the Chinese employ just one term for the bark: "brown skin of a dragon." It is the most frequently depicted tree in art as it is the symbol of vital energy and longevity—and even of immortality. It also represents the unwavering strength of a man who does not flinch before criticism and resists all temptation—just as a pine stands firm before the assaults of wind and storm.

126 "Lion dog" in his makeshift kennel
Anhui province, October 2003.

127 Drawing of a "lion dog" on a piece of contemporary porcelain
Beijing, private collection.
Ideogram *shī* meaning "lion"

128 Painting of bamboo by Wu Zhen taken from a bamboo album, 1350
Yuan period (1279–1368). National Palace Museum, Taipei. (See caption p. 141)

129 Bamboo
Village of Zhuge, Zhejiang, October 2003.

130 *Two Wild Geese in the Reeds*
Detail of a painting from the Qing period (1644–1911). Private collection.

131 Gorse
Hubei province, December 2002.

132 Grasshopper on the gourd that serves as his cage
Temple of Heaven Park, Beijing, November 1995.

133 Grasshopper with cage and crockery against an unidentified contemporary painting, *Grasshopper with its gourd*
Michel Culas's private collection.

VI PASTORAL SCENES

134 The seal character *fēng* meaning "abundant harvest"
This seal evokes the bounty of the earth.

135 Tending the paddy fields
Hunan province, April 1999.
In a field drenched by spring rains, a farmer sporting a traditional cone-shaped bamboo hat and cape made of braided palm fibers—now often replaced by a transparent plastic raincoat—plows through the mud with his buffalo.

136 *Ploughing in a Paddy Field*
Stamp from the Qing period (1644–1911). Private collection.

136–137 Paddy fields
Yunnan province, February 2001.

138 *Peasants Returning Home after Gathering Wood*
Detail of an unidentified contemporary painting. Private collection.

139 Countrywoman with an enormous bundle
Shanxi province, February 2004. Returning home, she struggles under the weight of withered corn stems that will be used for lighting and feeding the fire.

140 The patriarch Huineng trimming bamboo
Twelfth century, painting by Liang Kai, Song period (920–1279). Tokyo National Museum.
Ideogram *zhú* meaning "bamboo"

141 Transporting a length of bamboo
Zhejiang province, May 2007.
Bamboo is called "the friend of China." It can reach a height of 100 feet (30 meters) and a diameter of 20 inches (50 centimeters). It flowers once only every fifty or hundred years. When a plant starts to bloom in one place, all the specimens of the same species in the world, whatever their age, begin to flower. Bamboo plays an important role in Chinese daily life: in medicines, to make scaffolding, in cooking, in furniture- and papermaking, as well as in providing utensils for the home. The earliest

rockets were built with sections made of the plant stuffed with gunpowder. Bamboo is also a symbol of long life.

142 *Fisherman Taking a Hook out of a Fish's Mouth*
Painting by Shitao (1642–1707). Shanghai Museum.

143 Fisherman with a bundle of wood
Guangxi province, January 2003.
On the banks of the Xun River, a fisherman who has just finished gathering firewood is astonished to see a "long nose." The "foreign devil" is scarcely less surprised to witness a scene that might have been painted by the monk Bitter Pumpkin (one of Shitao's nicknames) 304 years earlier.

144 *A pig transported in the time-honored fashion*
Paper cutout by twentieth-century artist Chen Zhinong. Private collection.

145 A pig being prepared in a Hebei province village
January 1996.
In the words of *The Three-Character Classic*, a traditional alphabet primer, "the six domestic animals bred by man are the horse, the cow, and the sheep, the chicken, the dog, and the pig."

146 Peasant returning from gathering wood
Shanxi province, stamp, Yuan period (1279–1368). Private collection.

146–147 Village woman
Jiangxi province, December 2004.

On the wall the beginning of a Maoist slogan appears: "People burning trees will be imprisoned" *(shuí shāo shān shuí zuò láo)*. The last ideogram, *láo*, is missing from the photograph.

148 Portrait of a Han farmer
Village of Brilliant Light (Guangming), Shanxi province, March 2007.
In a splendid example of the harmony between man and land, the face of this farmer—whose skin is so wrinkled and creased that looks like a tortoise's—reflects the puckered yellow earth in this region of loess scarred by a thousand furrows.
Ideogram *huáng tǔ dì*, meaning "yellow earth"

148–149 View of the loess country
Shaanxi province, February 2004.

150 Preparation of a pig
Hebei province, November 2002.
As the pig is an omnivorous animal that can feed on domestic and human waste, it is not infrequent to see latrines installed directly above a sty.

151 Drawing on a clay brick from a tomb
Wei era (220–25) of the Three Kingdoms period, Gansu province. 6 ¾ x 14 ¼ in (17 x 36 cm).

152–153 Shepherd with his flock
Returning to the village as evening falls under a menacing sky, Hebei province, January 1996.

154 *Storyteller with Tambourine*
Detail of a terra-cotta from the Eastern Han period (25–220). National Museum of Chinese History, Beijing.

155 Portrait of a Han man
Wuzhen, Zhejiang province, May 2007.

VII WALLS AND DRAGONS

156 The seal character *guān* "meaning "to close"
This seal refers to the hundreds of passes and overland frontiers that mark out the Great Wall from the Yellow Sea to the desert. For example: Shan Hai Guan, known as the "first pass beneath the sky" by the sea and Yumenguan, the "pass of the Jade gate" in Gansu province.

157 Winter at the Ming wall
Jinshanling, January 1997.
This section of the Great Wall of China in a hilly area northeast of Beijing represents one of the most spectacular parts of the gigantic "dragon" that runs from east to west over more than 3,730 miles (6,000 kilometers) through northern China. Measuring from sixteen to twenty-six feet (five to eight meters) high and sixteen feet (five meters) wide, this section, which dates from the mid-sixteenth century, is dotted with countless observation towers.

158 Earthen wall
Bataicun, North of Datong, Shanxi province, March 1999.
This photograph of a stretch of beaten earth wall on the border between China and Inner Mongolia evokes the shape of the "dragon's tail."
Ideogram *lóng* meaning "dragon"

159 Detail of a horizontal scroll on paper of nine dragons by Chen Rong, painter during the Southern Song dynasty
Museum of Fine Arts, Boston.
Chen Rong was famous for his paintings of dragons. The head of this one (executed in 1244) is a match for the photograph opposite depicting the "dragon's tail." In China, the dragon is a very highly regarded animal. The monarch of the waters, it symbolizes the person of the emperor and is still considered to bring good luck.
Photography © 2008, Museum of Fine Arts, Boston.

160 Camel in the snow
Afghan Pamir, September 1967.

161 Painting by Wu Zuoren (1908–97)
Private collection.

162–163 Caravan on the Roof of the World
Afghan Pamir, January 1971.
Following a course along frozen rivers so as to avoid the snowbound passes, this caravan operates not far from the Chinese border at a height of around 2,500 miles (4,000 meters). It ferries winter supplies to the Kirghiz who live on the high plateau where they trade sheep and furs for wheat grown by sedentary populations in the Wakhan valleys.

163 Painting by Wu Zuoren (1908–97)
Private collection.
After a long sojourn on China's western border, the great painter left a masterly testament to the life of the last caravans and nomads of the twentieth century.

164 *Snow on the Celestial Mountains* (Tian Shan)
Painting by Hua Yuan (1682–1756). Museum of the Forbidden City, Imperial Palace Museum, Beijing.

165 Young Mongol camel driver leading his camels through the steppes.
Place known as the Blue Cave, Khovd region, Mongolia, January 1998.

166 *The Nine Bends of the Yellow River*
Contemporary painting by Wang Qi (b. 1918). Private collection.

167 Sangim River at the foot of the Buddhist caves of Bezeklik
Near Turpan, Xingjian, photograph by Romain Michaud, October 1988.

168–169 Horsemen of the steppes playing the game of bozkashi ("goat dragging")
Afghan Turkistan, February 1968.
The men ride the horses of which the Chinese have been so inordinately fond since the Han period that they dub them "celestial." The race continues to be bred by the Turkmen of Afghanistan to this day. The game is a majestic evocation of the thundering hordes of the empires of the steppes.

170 Lassoing a horse
Mongolia, September 1990.
The Mongolian horse, small in stature but with great stamina, is only semi-tame. It was indeed partly thanks to such mounts that Genghis Khan and his armies were able to invade vast tracts of Asia and Europe.

171 Bucking horse in terra-cotta from Tang era (618–907)
Musée Guimet, Paris. Deed of gift, Jacques Polain. © RMN. Photograph by Roger Asselberghe.

172 Terra-cotta funerary statuette dating from the Western Han dynasty (206 BCE–9 CE)
Shaanxi-Xi'an Province Institute of Archaeology. Slender, naked, and armless, this type of figurine has features that are so expressive, they remind one of the Han of today.

173 Portrait of a Han
Photograph by Ji Dalai, our travel companion, Beijing, December 1997.
More than 2,000 years separate this portrait from the terra-cotta figurine.

174 *Hunting Procession*
Detail of a wall fresco from the Tang period, Tomb of Prince Zhang Huai, district of Qianxian, Shaanxi, eighth century.

175 Wind-tattered standards on the fortress of Zhenbeipu
Ningxia autonymous region, March 1996.
The walls of this stronghold have been used as a backdrop for historic films.

176 Portrait of a maidservant
Detail of a wall fresco from the Tang era. Tomb of Li Shuang, district of Yanta, Shaanxi province, eighth century.

177 Portrait of a Han girl
Shaanxi province, March 1988.

As the poet writes:
"Her cheeks are full
As the sun in April,
Her eyebrows curved
Like distant mountains"

Chang Hien, mid-fourteenth century (anthology)

VIII PATHWAYS TO HEAVEN

178 The seal character *dāo* meaning the "Way"
This seal refers to the numerous routes that lead to the Origin, to the supreme Void, to the Ineffable.

179 Tenth-century Statue of Laozi
Near Quanzhou, Fujian province, February 1996.

180 The wide open spaces of Sichuan province
Detail of a painting by Yuan Tao (1739–78). Private collection.

181 Hanging Palace of the Green Cliff (Cangyan Shanquiao Loudian)
South of Jingxing, Hebei province, January 1996. This palace, built on a single arch spanning a ravine over three hundred feet across, was destroyed under the Sui dynasty (589–618) before being rebuilt under the Qing dynasty (1644–1911.) It is covered by a double roof.

182 Branches of flowering plum
Qing period (1644–1911). Private collection.

183 Snowflakes on the goatee of Taoist monk
Wudang Shan, Hubei province, November 2004.
Calligraphy from the *Dao De Jing*, the Book of the Way, beginning of chapter forty-two
The calligraphy means "the Tao begets the One, the One begets the Two, the Two begets the Three, and the Three begets the ten thousand beings."

184–185 Ming-period Temple of Zixiao (Purple Clouds)
Wudang Shan, Hubei province, November 2004.

186 *Bodhisattva*
Detail of a Buddhist mural, Tang era (eighth century) near Dunhuang, Gansu province.

186–187 Woman praying in a small Taoist temple
Chongwu, Fujian province, February 1996.

188 Portrait of an eighty-four-year-old calligrapher
Hunan village, November 2003.

189 One of the nine *arhat* or *luohan*, disciples of the Buddha
Wall painting in the Buddhist White Cloud Temple (Baiyunsi), Shanxi province.

190 *Monk Practicing a Martial Art*
Print of unknown date and source. Private collection.

190–191 Pupil from a Taoist school of martial arts—*gōng-fu*
Temple of Zixiao, Hubei, November 2004. Demonstration of traditional moves in one of the Wudang Shan styles.

192 *Hermit with His Dog*
Undated mural, Temple of Zheng Guo, seven-and-a-half miles (twelve kilometers) east of Pingyao Shanxi province.
Calligraphy of the Buddha (*Fo*)
Buddhist temple, Zho Zhuang, Jiangsu province.

193 Buddhist monk and his dog greeting a visitor
Hermitage known as "Little Rest", Cave of the Green Dragon (Qinglong Dong), Zhenyuan, Guizhou province, March 2001.
Despite the sign on the left that warns "Do not disturb," it is hard to say who welcomes the visitor more warmly, the monk or the dog.

194 Spiritual master reading a sutra
Lamasery of the Divine Light, Xindu, near Chengdu, Sichuan province, March 1996.
The Sanskrit expression shows the most important mantra of Tibetan Buddhism in Chinese calligraphy: "*Aum mani padmé hum*," which translates as "*Om*, treasure of the Lotus, *hum*."

195 *The Pleasures of Reading Alone*
Contemporary painting by Wang Jianan. Private collection.

196 Head of a limestone bodhisattva from the Northern Wei period (386–564)
Sculpture from Shandong province. Private collection.

197 Portrait of a young Han woman
Yangshuo, Guangxi province, November 2004.

198 Monk executing a gesture of greeting
Limestone sculpture from the Northern Wei period

(386–564), Maijishan Caves, in the Gansu. The monk is Kasyapa, a Hindu who became a disciple of the Buddha (*arhat*).

199 Buddhist Monk making the sun salute
Mount Taimu Temple, Fujian province, February 1996.

IX MOUNTAINS AND WATERS

200 The seal characters *shān shuǐ* meaning "mountains" and "waters"
These seals were chosen in the spirit of the Chinese tradition of landscape painting.

201 Chinese landscapes (*shān shuǐ*) are mountains and waters
The famous karst relief of southern China in the region of Guilin, Guangxi province, with the River Li snaking through the uplands, November 2004.

202 *The Song of the First Shoots of Spring Underfoot*
Painting by Ma Yuan (1140–1230) from the Southern Song period (1127–1279). Museum of the Forbidden City, Beijing.

203 Peaks of the Wulingyuan
Shentang Wan region, northwest Hunan, November 2003.

204 Rocky peaks in Wulingyuan
Hunan province, April 1999.

205 *The Huashan Mountains at the End of Fall*
Upper half of a vertical painting scroll from the Ming period (1368–1644) by Lan Ying (seventeenth century). Shanghai Museum.

206–207 *Mountains and Pines in Spring*
Painting from the Northern Song period (960–1127) ascribed to the artist Mi Fu (1051–1107). National Palace Museum, Taipei, Taiwan.

207 Peak of the Yellow Mountain emerging from a sea of clouds
Huang Shan, Anhui province, November 1997.

208 *Mount Lu*
Vertical silk scroll by Jing Hao (870–930). National Palace Museum, Taipei, Taiwan.

209 The Chinese mountain at Zhangjiajie
Hunan province, April 1999.
Chinese calligraphy of the word *tiān* meaning "sky"

210–211 Mist drapes the Yellow Mountain (Huang Shan)
November 1997.
The magnificent scenery changes, as if by magic, from minute to minute.

212 Waterfall at Jiuzhaigou
Sichuan province, November 1999.

213 Waterfall at Huang Shan
Painting of the Qing period (1644–1911) by Mei Qing. Private collection.

214 *Fisherman Using Cormorants on the River Li*
Painting by Xu Beihong (1895–1953). Private collection.

215 Fishing with cormorants on the River Li
Yangshuo region, Guangxi province, December 2002.
Calligraphy from an extract of *The Crane Pavilion,* a poem by Cui Hao from the Tang period (618–907)
"Where is the land beyond the setting sun, Wave drowned in the mist, man of melancholy?"

216–217 Falls on the Yellow River at Hukou ("the bottleneck")
March 2007.
The river forms the border between the provinces of Shanxi and Shaanxi.

218 *Autumn Waves*
Painting by Ma Yuan (1140–1230), Southern Song period (1127–1279). Private collection.

219 Waves on the Yellow River (Huang He)
Jiaxian, Shaanxi province, March 1998.

220 Taoist print from the nineteenth century in cinnabar raised-ink
England, library of the University of Durham. This *yin-yang* in the form of fire (*hyang*) and cloud (*yin*) symbolizes the phase of transformation of vital energy.

220–221 Sea of clouds and pines, Yellow Mountain (Huang Shan)
Anhui province, November 1997.

SOURCES FOR THE ILLUSTRATIONS

The authors would like to thank the librarians, museum curators, antique dealers, and private collectors who generously agreed to collaborate on this project. Sources of the images reproduced in the present volume—from museums or private collections—are indicated in the corresponding captions. As many of the paintings reproduced are dispersed in museum collections throughout China, the originals have sometimes proven difficult to track down. The author and publisher therefore have not always been able to provide exact sources for the works, some of which were reproduced from copies and from rare photographic documents. In accordance with standard practice, all rights are reserved by the rights holders of the works in question.

BIBLIOGRAPHICAL SOURCES

page 5

Pascal, Blaise. *Thoughts*, trans. W.F. Trotter. New York: Collier, 1909.

pages 52, 134

Seaton, J.P., ed. *Shambala Anthology of Chinese Poetry.* Boston: Shambala, 2006.

page 68

Michaux, Henri. *A Barbarian in Asia*, trans. Sylvia Beach. New York: New Directions, 1949.

page 112

The Complete Works of Chuang Tzu, trans. Watson Burton. New York: Columbia University Press, 1968.

page 178

Rawson, Philip and Laszlo Legeza. *Tao: The Chinese Philosophy of Time and Change.* New York: W.W. Norton & Co, 1984.

Additional Sources in French
(translations by David Radzinowicz)

page 37, 52, 78, 84, 189

Cheng, François. *L'Écriture poétique chinoise.* Paris: Éditions du Seuil, 1977.

pages 38, 128, 136

Cheng, François. *Entre source et nuage.* Paris: Éditions Albin Michel, 1990.

pages 90

Cheng, François. *Sagesse millénaire en quelques caractères: proverbes et maximes chinois.* Paris: Éditions You Feng, 2002.

pages 142

Cheng, François. *Shitao ou la saveur du monde.* Paris: Éditions Phébus, 1998.

pages 115

Dan Yang. *Sages écrits de jadis.* Paris: Éditions du Cerf (Patrimoine chinois), 2006.

pages 24, 119, 130, 160, 167, 174, 205

Demieville, Paul. *Anthologie de la poésie chinoise classique.* Paris: Éditions Gallimard UNESCO (Connaissance de l'Orient), 1969.

pages 181

Li Bai. *Florilège.* trans. Paul Jacob. Paris: Éditions Gallimard (Connaisance de l'Orient), 1985.

pages 66

Lo Ta-Kang. *Homme d'abord, poète ensuite: présentation de sept poètes chinois.* Neuchâtel: Éditions de La Baconnière, 1949.

pages 30, 46, 62, 92, 106, 134, 164

Roy, Claude. *Trésor de la poésie chinoise.* Paris: Éditions Le Club français du livre, 1967.

pages 211

Ryckmans, Pierre. *Les Propos sur la peinture du Moine Citrouille-Amére.* Paris: Plon, 2007.

pages 89

Stočes, Ferdinand. *Neige sur la montagne du lotus: chants et vers de la Chine ancienne.* Arles: Picquier poche, 2006.

pages 124, 198

Verdier, Fabienne. *L'Unique trait de pinceau.* Paris: Éditions Albin Michel, 2001.

ACKNOWLEDGMENTS

We would like to offer our profound thanks to all those who, too numerous to mention by name, have helped us on our great Chinese adventure, and most especially:

Anne and Édouard Adamantides,
Christine and Nicolas Ajacques,
Aurélie Arff,
Alain Arrault,
Anne and Pierre Barroux,
Charles Chauderlot,
Chen Dasheng,
Christine Cornet,
Monique and Michel Culas,
Francis Deron,
Mitchell and Marvin Farkas,
Patrice Fava,
Marion and Stanley Gartner,
Sylvain Giaume,
Valentine and Christophe Gigaudaut,
Huang Qinghua,

Cyrille J.-D. Javary,
Ji Dahai et Cécile,
Jean-Pierre Lafon,
Christian Lamouroux,
Hélène and Bernard Larose,
Jean-François Lequy,
Alice and Hervé de Malliard,
Yulin and Jean-Yves Merlet,
Pierrette and Jacques Meniel,
Christiane and Jean-Claude Michaud,
Véronique Mondon,
Odile Pierqin and Tian Li,
Shu Roger,
John Stucky,
Sun Hongwei,
Bernard Terminet Schuppon,
Patrizia Van Daalen,
Wen Hengmin,
Xu Hao,
Zhang Mu Liang,
and Tara and Jean Zimmermann.

We would especially like to thank Ji Dahai for his active participation in this project.

We also thank the charming team at Flammarion: Sophy Thompson, Gaëlle Lassée, Corinne Trovarelli, Coralie Salmeron, and our designer whom we have come to value especially, Juliane Cordes. As well as the friendship and invaluable help of Colette Véron. Finally, we would like to thank the photoengraver Daniel Regard for his expertise.

CHRONOLOGY OF CHINESE DYNASTIES

LEGENDARY DYNASTIES

Xia 2100–1600 BCE

Shang 1600–1027 BCE

HISTORICAL DYNASTIES

Zhou 1027–221 BCE
Spring and Autumn period
722–481 BCE
Warring States period 453–221 BCE

Qin 221–206 BCE

Han (Eastern and Western) 206 BCE–220 CE

Three Kingdoms 220–65

Jin 265–420

Southern and Northern dynasties
420–589

Sui 589–618

Tang 618–907

Five Dynasties 907–60

Song (Southern and Northern)
960–1279

Yuan 1279–1368

Ming 1368–1644

Qing 1644–1911

CONTEMPORARY CHINA

Republic of China 1912–1949

People's Republic of China
1949–present

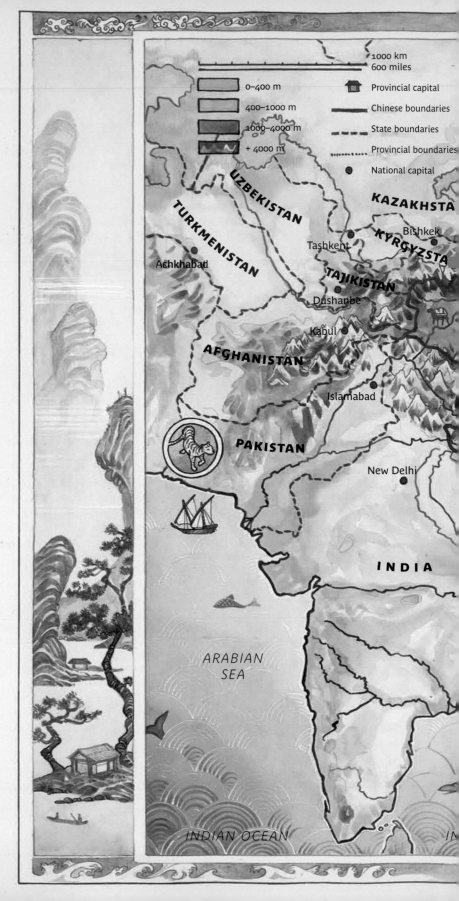

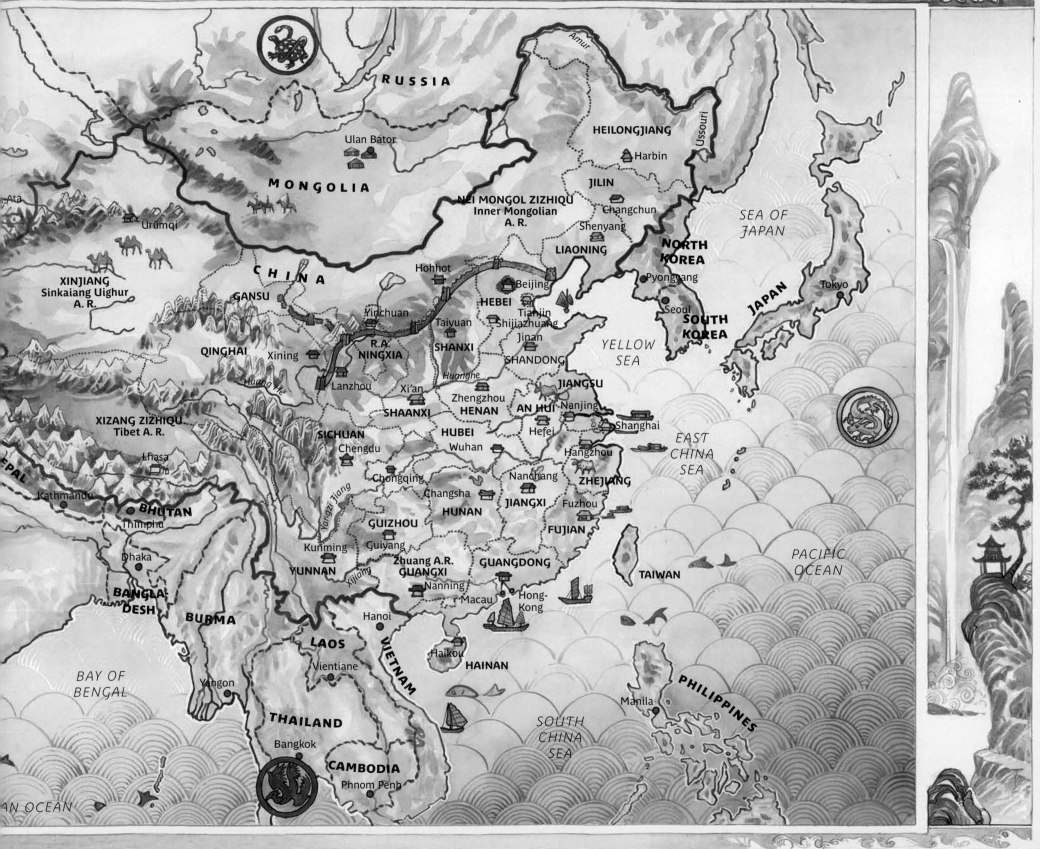